DATE DUE

AP 17 '06			
OC 3 06			
DE - 8 '11			

TWAYNE'S WORLD AUTHORS SERIES

A Survey of the World's Literature

Sylvia E. Bowman, Indiana University

GENERAL EDITOR

GERMAN LITERATURE

Ulrich Weisstein, Indiana University

EDITOR

German Dadaist Literature:
Kurt Schwitters, Hugo Ball, Hans Arp

(TWAS 272)

TWAYNE'S WORLD AUTHORS SERIES (TWAS)

The purpose of TWAS is to survey the major writers —novelists, dramatists, historians, poets, philosophers, and critics—of the nations of the world. Among the national literatures covered are those of Australia, Canada, China, Eastern Europe, France, Germany, Greece, India, Italy, Japan, Latin America, the Netherlands, New Zealand, Poland, Russia, Scandinavia, Spain, and the African nations, as well as Hebrew, Yiddish, and Latin Classical literatures. This survey is complemented by Twayne's United States Authors Series and English Authors Series.

The intent of each volume in these series is to present a critical-analytical study of the works of the writer; to include biographical and historical material that may be necessary for understanding, appreciation, and critical appraisal of the writer; and to present all material in clear, concise English—but not to vitiate the scholarly content of the work by doing so.

German Dadaist Literature:
Kurt Schwitters,
Hugo Ball, Hans Arp

By REX W. LAST

Hull University, England

Twayne Publishers, Inc. :: New York

FOR

HAMISH RITCHIE

Introduction

There is no lack of general surveys of Dada and the other movements in the twentieth-century European *avant-garde*, but there has been very little examination in depth of the individual artists belonging to German Dada. The present study concentrates on three major figures of Dada—Kurt Schwitters, Hugo Ball, and Hans (Jean) Arp—who made the most substantial and significant Dadaist contribution to German literature. It is hoped that this book will increase interest in, and understanding of, these three artists in particular and of the phenomenon Dada in general.

Quotations from primary sources are given in the original and are immediately followed by an English version. Quotations from German and French secondary sources have been rendered into English. All translations are mine.

I owe a considerable debt to scholars who have preceded me in this field, and their work is acknowledged at the appropriate point in the text. But I wish to single out for particular mention the following names: Gerhardt E. Steinke on Ball; Friedhelm Lach and J. Elderfield on Schwitters; and G. C. Rimbach on Arp.

I also wish to acknowledge my gratitude to Mrs. I. Wolff for permission to quote from my published translations of Arp's poetry; and to Mme Marguerite Arp-Hagenbach both for permission to quote from Arp's poetry and for her generosity in providing me with much valuable published and unpublished material. I am also grateful to Stan Jones and Dr. Alan Best for reading the manuscript and making valuable suggestions for improvements.

This book is respectfully dedicated to Professor J. M. Ritchie in gratitude for his advice and encouragement over the years.

<div align="right">

Rex W. Last

</div>

Hull University, England

Contents

Chronology

1887 Born in Hanover on June 20.

1909-1914 Attends the Academy of Art, Dresden.

1914 Return to Hanover.

1917 Brief period of military service; then work in industry.

1918 Contact with *Der Sturm*.

1919 *Anna Blume* (which contains his most famous poem "An Anna Blume") published by Christof Spengemann. First exhibition in *Sturm* gallery with Klee and Molzahn. Contributes to Spengemann's *Der Zweemann*; begins contributing to *Der Sturm*.

1920 First one-man exhibition at *Sturm* gallery.

1921 Participates in the hundredth *Sturm* exhibition.

1922 New edition of *Anna Blume*. Also published *Memoiren Anna Blumes in Blei* and in *Der Sturm, Franz Müllers Drahtfrühling*.

1923 *August Bolte*. First issue of his journal *Merz*.

1924 First *Merzbau*, Hanover. (Destroyed in air raid, 1943.)

1936 Represented in exhibitions in the Museum of Modern Art, New York.

1937 Moves to Norway. Second *Merzbau*, Lysaker. (Burned down, 1951.)

1940 On the invasion of Norway takes refuge in England.

1941 Release from internment; residence in London.

1945 Moves to Ambleside.

1947 $2,000 grant from Museum of Modern Art, New York, for work on his last *Merzbau* on Cylinders Farm.

1948 Dies June 7. Buried in Ambleside.

HUGO BALL

1886 Born in Pirmasens, February 22.

1906 Enters University of Munich.

1910 Studies at Max Reinhardt School in Berlin.

1911 *Die Nase des Michelangelo*.

1913 Director of Munich Kammerspiele. Meets Emmy Hennings. "Der Henker" published in the first issue of *Die Revolution*.

1914 *Der Henker von Brescia.* Enlists; rejected on medical grounds. Visit to Belgian front turns him against war.

1914- Work on manuscript of *Tenderenda der Phantast* (finally
1920 published in 1967).

1915 Goes to Switzerland with Emmy. His friend and collaborator Hans Leybold dies in battle.

1916 Birth of Dada. Founding of Cabaret Voltaire.

1918 *Flametti oder vom Dandysmus der Armen.*

1919 *Zur Kritik der deutschen Intelligenz.* Friendship with Hermann Hesse.

1920 Marries Emmy Hennings.

1923 *Byzantinisches Christentum.*

1924 *Die Folgen der Reformation.*

1927 *Hermann Hesse. Sein Leben und sein Werk.* September 14 dies in Tessin.

1946 Publication of diaries *Die Flucht aus der Zeit.*

1948 Death of Emmy Hennings.

HANS ARP

1886 Born in Strasbourg, September 16.

1889 Sophie Taeuber, born in Davos on January 19.

1904 First poems published.

1905- School of Art in Weimar.
1907

1908 Stay in Paris.

1908- Stay in Weggis, Switzerland.
1910

1911 Co-founder of the *Moderner Bund.*

1912 Exhibits with the Blaue Reiter.

1913 Participates in the Erster Deutscher Herbstsalon. Contributes to *Der Sturm.*

1915 Moves to Zurich from Paris. Meets Sophie Taeuber.

1916 Participates in Cabaret Voltaire and the Zurich Dada movement.

1919- Involved with Cologne Dada. Collaborates with Max Ernst.
1920 Participates in the notorious Berlin Dada exhibition.

1919 *Die Wolkenpumpe. Der Vogel Selbdritt.*

1920 Involved in Paris Dada.

1921 In Tirol with Paul Eluard, Ernst, and Tristan Tzara. All involved in publication of *Dada Intirol Augrandair Der Sängerkrieg.*

1922 Marries Sophie Taeuber.

1923 In Hanover with Kurt Schwitters.

Chronology

1924 *Der Pyramidenrock.*
1926 Settles in Meudon, Paris.
1930 First *papiers déchirés.*
1937- Sophie Taeuber edits *plastique.*
1939
1937 *Des Taches dans le Vide.*
1938 *Sciure de Gamme.*
1939 *Muscheln und Schirme.* Co-author of *L'Homme qui a perdu son Squelette,* published in *plastique.*
1941 *poèmes sans prénoms.*
1942 In Switzerland again.
1943 Sophie Taeuber dies in Zurich on January 13.
1946 Return to Meudon. *Le Siège de l'Air.*
1948 *On My Way.*
1949 First journey to the United States.
1950 Second journey to the United States.
1953 Sculpture *Shepherd of the Clouds* for Caracas University.
1954 *Behaarte Herzen. Könige vor der Sintflut. wortträume und schwarze sterne.* International sculpture prize at the Venice Biennale.
1955 *Auf einem Bein. Unsern täglichen Traum. . . .*
1957 *Le Voiler dans la Forêt. Worte mit und ohne Anker.*
1958 Third journey to United States. Retrospective exhibition at the Museum of Modern Art, New York.
1959 Marries Marguerite Hagenbach. Chooses Solduno as his second home. *Mondsand.*
1960 Chevalier de la Légion d'Honneur. *Vers le Blanc infini.*
1961 *Sinnende Flammen.*
1962 Large retrospective exhibition at the Musée National d'Art Moderne in Paris, and elsewhere.
1963 *Gesammelte Gedichte I.*
1965 Honorary citizenship of Lucerne. Bundesverdienstkreuz and Star. *Das Logbuch des Traumkapitäns.*
1966 *Le Soleil recerclé.* Dies in Basle on June 7.

CHAPTER 1

The Rise and Fall of Dada

TO GIVE a book the title *German Dadaist Literature* would seem to be highly suspect on a number of counts. It might well be contended that what is being considered here is neither German, nor Dadaist, nor literature; and perhaps the most immediate objection is to the use of the term "literature," which implies both that the writings of those who sailed under the flag of Dada can be treated in isolation from their other creative activities, and also that these writings, once isolated, are really worthy of being called "literature," when the evident intention of most of these *avant-gardists* was to desecrate the temple of the arts, to produce only "antiliterature," and to mock the whole tradition of German—and indeed Western—culture. And this leads on to the second objection: the word "German" surely offers terms of reference too restrictive for a movement which sought to break down not only artistic, but also national, barriers. But can Dada be called a true movement, in the sense that Romanticism and Naturalism were? "Dadaist" seems to imply "Dadaism" as a respectable general term in the literary canon, whereas the sons of Dada consistently denied that they formed a movement in any conventional sense of the word.

In defense of my title, however, it must be stated that the myth has been cultivated in France that Dada was an almost exclusively French phenomenon; and one, moreover, that was hardly more than a juvenile prelude to its more substantial successor, Surrealism, which gave credibility to the *avant-garde* and a theoretical framework within which to operate. Dada, it is claimed, was totally devoid of intellectual or artistic coordination, a negative and nihilistic transitional phase which existed entirely on the surface. This is a myth that

15

badly needs exploding, and not only because the promised Surrealist breakthrough into the inner space of the subconscious mind has largely proven a disappointment.

As to the objection relating to the application of the term "literature," it must be admitted that although written material will be taken as the focal point of the present study, there are both hybrid forms—such as sound poems and concrete poems—and also close correspondences between the verbal and the visual arts. But the nature of the interconnectedness of the graphic, plastic, and written works is such that it is indeed possible to isolate one without prejudice to the others. In other words, the different media of expression are complementary rather than mutually dependent.

The most substantial reservation in relation to the literary status of Dada concerns the question of "antiart." In this context, it is much too easy to confuse "antiart" with "nonart." If the more familiar term "antitheater" is related to the contemporary *avant-garde* Austrian dramatist Peter Handke, for example, it naturally implies rejection of tradition and convention, but it equally implies an awareness by both dramatist and audience of the theatrical past. "Antitheater" does not signify the death of theater in any shape or form, but rather an unexpected or shocking development which moves in such a startlingly new direction that it seems that the dramatist is turning against everything the theater stands for, instead of just against a large number of preconceptions and received ideas about the role of the theater. It is, therefore, at least worth examining the question of "antiliterature" in the same light, instead of merely accepting the Dadaists' own propagandistic and provocative utterances on the subject.

Equally, the question of "Dadaist" as a viable term should be considered from the same point of view; that is, that Dada is an "antimovement" in the same way that it is "antiart." In fact, it was from many points of view an extremely good, if not exemplary, example of a collective in which the individual subordinated himself to the common cause and sternly refused to indulge in what has been called, in a quite different context, the "cult of personality."

I *Toward a Critical Approach*

The phenomenon of Dada is only now beginning to be regarded with a due measure of objectivity; for it is remote enough in time for most of its major participants to have passed away. The time for rose-colored reminiscence or mutual recrimination is all but over, and the extremism appears now quite moderate by comparison with some of its enfants terribles, Neo-Dada, the Happening, and Pop Art.

But there is still a tendency for critical reaction to polarize: on the one hand, there are those who maintain that Dada is quite literally beyond criticism, that is, that it is not susceptible to the normal processes of critical analysis; on the other, Dada tends to be studied with unsmiling and high-minded seriousness as a kind of mystico-religious manifestation. The truth lies somewhere in between.

Like other German literary movements in the first three decades of this century, Dada has suffered from the absence of a steady and organically developing influence on subsequent movements and has also been deprived of an uninterrupted growth of critical studies. The intervention of Nazi rule in Germany and its subsequent spread into adjacent territories did far more than create a temporary break in the cultural tradition. The concept of "degenerate art" and the exhibition held under that name in 1937 paralleled the scattering and destruction of much irreplaceable material, particularly in the visual arts. Not only that; the artists themselves were forced either into silence or emigration, and the fate of those who were of Jewish origin or of left-wing persuasion was particularly harsh. After the collapse of 1945, Germany was not able simply to pick up the threads of the past: a whole generation had grown up in relative ignorance of Expressionism, Dada, and Surrealism, fed, as it was, on a diet of approved literature which served the purposes of the state and, as contemporary Socialist Realism in the eastern half of Germany painfully demonstrates, such art is not always of the highest caliber.

Gradually, however, books on Dada of a descriptive and autobiographical nature began to appear. They now represent something of a small growth industry, if taken in conjunction

with studies of Surrealism. But, in contrast to Expressionism, the growing number of editions, reprints, and anthologies is not matched by a body of substantial critical literature. At least part of the blame lies with the comparatively narrow circle of former Dadaists and Surrealists who have, so to speak, "cornered the market" in their own past. There are too many general and uncritical retrospective studies and far too few analyses in depth.

These general books have done little to advance our knowledge of the phenomenon Dada, however much they may have produced in the way of new facts and unpublished material. The reason is only partly that Dada has been all too commonly regarded as a mere adjunct of Surrealism or Expressionism, or that the movement was avowedly antiart and antiestablishment. The main reason underlying critical unwillingness to venture into Dada is that its creative products appear either to defy conventional techniques of literary criticism or to be frankly below the level at which they might be regarded as "art" at all. What is the critic to make of Man Ray's *Hammer,* a toilet seat fastened to a vertical board and encircling the word *"marteau"* (hammer), or—to retain the lavatorial context—of Marcel Duchamps's *Fountain,* the urinal signed R. Mutt and submitted to a New York art exhibition in 1917? Unmodified ready-mades like these may represent the outer limits of the movement and may indeed be conceived with motives which are not entirely artistic and creative, but their ineptness in the face of Hans Arp's *Forest,* or Max Ernst's *Une Semaine de Bonté,* in which original nineteenth-century etchings are turned into the base for collage applications, seems to indicate that it is not the technique, but the technician, that is at fault. Ernst's visions are of enormous power and emotional intensity: they take received reality and, by means of modest alterations, generate a new reality which one half of the mind knows is impossible, but which the other half accepts as genuine because the same illusionism is retained as that from which the original etching or etchings derived their artistic validity (on however banal a level). This technique appears again, in a different guise, in the illusionistic pictures of Magritte, such as *The Companions of Fear* or *Perpetual Motion,* where, as in the case of the former, plants are metamorphosed into birds and vice versa

(Max Ernst, too, is preoccupied with such transformations), or as in the latter, a perfectly acceptable and "normal" visual format is disturbed by an anomaly which is depicted with as much realism as the rest of the picture: a weight-lifter has one of the ends of the dumbells he is holding as his head.

In the visual arts there is more than enough critical background available for reasonably sound value judgments to be arrived at if, for example, *The Fountain* is to be compared with *Une Semaine de Bonté;* but this is not so readily done when it comes to the written word. What, for example, is to be made of the following:

> ombula
> take
> bitdli
> solunkola
> tabla tokta tokta takabla
> taka tak . . .[1]

Little serious groundwork has been done on poetry—and it really is poetry—of this kind; the assumption is that nothing more needs to be said about it except that it is what is known as a "sound poem," is nonsensical, and was "performed" at the Cabaret Voltaire, the birthplace of Dada. Lines like these now seem to wear the aspect of one of those old *Punch* political cartoons which presumably were funny once, but have now lost all topicality and relevance. The joke staled decades ago, and in any event the quality of the material is not sufficient for it to be regarded as art.

One of the principal tasks of the present study is an examination of the more important of these poems, including Hugo Ball's "sound poems," from one of which—"Totenklage"—the lines above were taken. In order to do this effectively, it is necessary to broaden the context of the poems by tracing their origins in the writer's earlier work. It is not enough to examine them in the light of the activity of a few short months in Zurich; these may have constituted a time of literary rebellion, but the men—and women—who composed such works did not leave their past lives and personalities at the border when they entered Switzerland.

Dada was not merely a short-lived literary and artistic outburst in one specific place at one specific moment. Hans Richter is indulging in special pleading when he claims:

It is . . . true that, around the year 1915 or 1916, certain similar phenomena saw the light of day (or night) in different parts of the globe, and that the general label of "Dada" can be applied to them. But it was only in *one* of these that the magic fusion of personalities and ideas took place which is essential to the formation of a movement.[2]

The fact is that works which can be described as Dadaistic were being composed at the turn of the century and continued to appear until the 1960's. The climactic point of the movement may have come in 1917, but it did not exist only at that point. In fact in the first of his "Dada-Sprüche," Hans Arp, the most distinguished and consistent of all the Dadaists, claimed that Dada reached some way back into the past: "Bevor Dada da war, war Dada da" (Dada was there before Dada was there).[3]

II *The Prehistory of Dada*

A "new" artistic movement never represents a complete break with the past, however vocal its claims in that direction may be; and Dada is no exception to this rule. Dada may have been, in one sense, an exuberant explosion of artistic talent in revolt; but the ingredients of the explosive mixture had existed since the beginning of time and had not infrequently caused small flashes in the past. But only the particular circumstances leading up to and including the decade of World War I provided the right recipe for the eruption into international prominence of this strangest of artistic phenomena.

Many writers and artists from Rabelais to Alfred Jarry, from Clemens Brentano to Christian Morgenstern, have been claimed as precursors of Dada and in such a context the name of Lewis Carroll is never far from being the center of discussion. The exact nature of these affinities is, however, not readily definable. It is impossible to establish a precise genealogy for Dada. Brentano, for example, may have been a substantial inspirational source for Arp, but he is not demonstrably so in the case of Ball, where

Nietzsche was the crucial influence. The Rabelaisian range and vitality at work in *Gargantua* and *Pantagruel* can certainly be regarded as a prefiguration of Dada in a rather general sense; but, on the same terms, these works can equally be claimed as ancestors of Surrealism in the same kind of tradition as Hieronymus Bosch. The list of precursors for Surrealism is as long as that for Dada, if not longer.[4] As for Carroll, it is quite true that he exercised the minds of many who were involved with Dada: as recently as 1970 Max Ernst produced illustrations to the *Hunting of the Snark*, but the kind of imagination and intent underlying Carroll's work does not point to a direct ancestry of Dada.

Carroll is the most obvious example of a creative writer who outwardly is a clear precursor of Dada and Surrealism but who, on closer examination, is revealed to have little in common with them. This "Victorian with a kink"[5] wrote supposedly "Protosurrealistic" poems which have, however, been shown to be largely parodistic rather than untrammeled flights of the artistic imagination into the surreal. The Jabberwocky, seemingly a prefiguration of Dada, is in fact satirical, and draws on "the feeling and atmosphere" of a poem "The Shepherd of the Mountains" from the German of Fouqué which appeared in *Sharpe's Magazine* in the year 1846.[6]

This did not prevent the Dadaists and Surrealists from complicating the issue by somewhat self-consciously scanning the past for forebears and lighting enthusiastically upon the verbal antics of Carroll. This may well be a parallel to the more celebrated case of Edgar Allan Poe and the French Symbolists, in which the American poet seemed to undergo more of a transformation than a translation; for, although Carroll may demonstrate symptoms congenial to the Surrealists—"it might even be . . . that Alice's falling down the rabbit hole symbolized the descent into the subconscious which the Surrealists were constantly pursuing"[7]—it is taking parallels a little too far to conceive of him as a wild revolutionary, as did Louis Aragon, who called him "a *saboteur* in so strong a citadel of Western culture as Christ Church Common room."[8] What tends to be overlooked but is a far more significant parallel is the coexistent dual personality of Dodgson and Carroll, a Jekyll and Hyde situation not

uncommon among the Dadaists, and one to which attention
will subsequently be drawn.

 The problem is partly one of definition: on the one hand, it is
all too easy to regard any work which indulges in metamorphosis
through the agency of the creative imagination as Dadaistic,
from Alice's words "You're nothing but a pack of cards!" to Gui-
seppe Arcimboldo's *Market Gardener*,[9] a portrait compounded
entirely of market produce, with carrots for hair and flowers
for eyes. And indeed such transformations can be unearthed
in the most unlikely places throughout the history of creative
art. Equally problematical is the issue of demarcation, that is,
the question whether a given work or artist is an antecedent of
Dada or its neighbor, Surrealism. Both movements can, for
example, lay claim to primitive art—African, Eskimo, Mexican,
and so forth—as a primary source, as can Expressionism. The
situation is much more confused when it comes to the actual
practitioners of Dada and Surrealism. One particularly awkward
individual among many in this respect is Max Ernst, who made
the transition from one movement to the other. His famous
series of collages, *Une Semaine de Bonté*,[10] is both central to his
own work and on the borderline between the two trends. The
collage technique, deriving from Cubism, seems to blend the
chance operations of the *papier déchiré* developed most success-
fully by Arp with the Surrealist transformation of the trivial to
capture the "original breath of reality,"[11] and, dominating all
else, there is Max Ernst's incisive intellectuality and his resolute
independence which seemingly run counter to both movements.

 In looking back at those who have been claimed as the pre-
cursors of Dada, it becomes evident that they foreshadow
certain specific elements of Dada rather than span a substantial
area of its whole range in a less developed form. Negro and
other non-European primitive art reflects the anticivilization
and anticultural constituents of Dada; Brentano embodies the
mystical fusion with the spiritual world; Rabelais demonstrates
the virtuoso flights of creative imagination; and Carroll employs
wit and "nonsense." All these are features characteristic of Dada,
but it cannot be said that without these specific antecedents
Dada would never have existed or would have taken a substan-
tially different course. A similar observation in the context of

Surrealism was made in the preface to an exhibition held at the Bibliothèque Nationale in Paris which displayed some predecessors of Surrealism:

The organizers of this exhibition have no intention of giving the impression that Surrealist art has always existed. But there have always been in existence a whole range of diverse tendencies which, when brought together, clarified or taken to their logical conclusion, reflected certain features employed by the Surrealists.[12]

Dada drew on the same kind of sources and exploited them in a similar fashion.

III The Artist, Society, and the War

"If I wanted to take flight again, where should I go? Switzerland is a bird cage, surrounded by roaring lions."[13] These words by Hugo Ball epitomize the dilemma of the creative artist at the outbreak of World War I. The options open were few indeed, and not very palatable: to rally round the flag, either in the flesh or in one's art, or to become a refugee. Either action would mean a betrayal: of art, or of one's audience. And as a consequence the creative artist felt himself forced into an impossible situation, superfluous and unable to exercise any influence on the world-shattering events unfolding about him. Prosenc underlines the sense of emptiness in these words:

An artist from one of the belligerent nations who had not enlisted became aware of his utter meaninglessness. His elitist position, which, despite all disturbances and questionings of educational and artistic ideals, had remained intact, had been surrendered to a social group outside the cultural hierarchy, namely, the army. Any artist who did not put himself at the disposal of the ends of propaganda had become superfluous and suddenly found himself surrounded by a society which was manipulated down to the last detail. He was able no longer to exercise the least influence over it, since his means of support, the group, had also ceased to exist. Thus he was faced with the question of whether to go underground or emigrate.[14]

In the early years of this century, the gulf between artist and society had widened to the point at which it had become unbridgeable. At the same time, society itself became more and

more disunited. Instead of art and public, there was now a series of artists and "publics," all minorities.

A new brand of bohemian emerged, an artist able, by virtue of the increasing number of publishers and journals, to earn a living within a nonconformist setting. The free-lance artist and writer had become a reality. But the achievement was made at considerable cost: a permanent rift with society and at best an ambivalent reaction from a divided audience that responded with a blend of knowledgeable connoisseurship, interest, and overt hostility.

The history of German literature from Naturalism until the 1930's is closely linked with the history of bohemian elements centered upon a specific meeting place (usually a café) and formed around a single strong personality. A kind of "alternative society" emerged, based upon personal relationships, not economic considerations; on artistic, not financial and social status. Men such as Herwarth Walden and Hugo Ball emerged as leaders of these groups, which were composed of frequently discordant and contradictory elements; but, as will be seen later in the course of this study, Dadaists and other artistic revolutionaries were much more united in what they opposed than in what they actually stood for, except in the broadest possible terms.

Within the context of such a group, artists were able to develop unhindered by the normal cares and responsibilities of the average citizen; but it is significant that for many the bohemian phase was only one stage in their artistic development. In fact, the importance of the corporate life of the bohemian and the *avant-garde* has been much overstressed, particularly with respect to the leading figures to emerge from their ranks: Arp retained his individual style and philosophy despite his involvement with Dada, Surrealism, the circle around the Expressionist journal *Der Sturm*, the *Blaue Reiter* painters, and his frequent collaborative efforts with other writers and artists; Schwitters remained, essentially, a solitary individual proceeding along his own private path; and even the organizer and leading light of Zurich Dada, Hugo Ball, was primarily seeking his own personal salvation in the midst of the din and publicity of the Zurich movement.

Despite the fact of their coming together, the more substantial members of the *avant-garde* were, at bottom, isolated individuals confronted with the insoluble problem of making a meaningful personal stand against the overwhelming weight of an industrialized society gone mad with lust for war. They had come together principally as an act of mutual protection against the outside world.

These men and women were neither artists seeking rehabilitation nor outsiders trying to return to the fold of conventional society; they were content to stay out, to live on their own terms. The links between these artists and society being sundered, the crucial question arises as to what role the artist is to play if he has forfeited his traditional function as a guide and communicator, an essential element in the social fabric, helping to hold society together and reinforce its aims and convictions.

Two main answers emerged: either the artist became even more withdrawn and escaped into the inward-turned elitism of the *Sturm* circle; or he became aggressive and turned against his public, as did the Dadaists. At least they retained a link with society at large, even if only a somewhat negative one. One suspects that much of Dada was counterproductive, insofar as there is nothing a middle-class audience enjoys more than to be insulted; the insults actually draw them together and reinforce their convictions.

Dada tended to take on a political complexion, although much of the leftist revolutionary talk and peddling of manifestos should not always be taken at face value, as will be seen in the case of Schwitters's "revolutionary" prose pieces. The idea of revolution was as much an object of mirth as it was part of the aspirations of some Dadaists.

Heterogeneity is one of the principal characteristics of Dada, and this is certainly true of the Zurich group, with some of whose members this study is largely concerned; as Kreutzer states, "Dada is the product of the bohemian and as full of contradictions as the latter."[15]

IV *The Birth of Dada*

A cartoon in a Swiss newspaper from World War I depicts a street scene in Zurich. A crowd is staring at an unfortunate

individual, and one person is saying: "Do you see that fellow everyone's looking at? That must be one of the locals."[16]

Emigrés headed for Switzerland in large numbers when war broke out and in the months and years that followed. Switzerland is a country with a long tradition of tolerance and neutrality, and the hope of the émigrés was that they would be able to pick up the threads of the life, particularly the cultural life, that had been so suddenly interrupted in Germany and elsewhere. Of course, Switzerland was not the only target country, nor was it just from Germany that an exodus took place. But Switzerland was the principal objective, and Zurich became the focal point of émigré life and activity. Journals were produced and groups formed, most of which were short-lived and had little or no wider impact. The café life which had characterized the prewar artistic world persisted in various Zurich cafés, the most famous of which was the Café Odéon, where the Dadaists met regularly after a lunch which, in an allusion to their reduced financial circumstances, Arp described as "for most of us a symbolic act."[17]

As for the Swiss, who seemed threatened with being engulfed by this foreign bohemian tide, they appear to have largely ignored their strange antics. As Hugo Ball explained in a letter to August Hofmann, "The Swiss seem to be more interested in yodelling than Cubism."[18]

From the various groupings and regroupings of émigré artists, one group—Dada—emerged to dominate all others and continued to exercise a significant influence on the development of Western art and literature until the present day. And indeed many of its erstwhile members claim (with some justice) that subsequent manifestations are essentially derivative and do not begin to bear comparison with the initial flowering of Dada.

The origins of the name Dada are shrouded in mystery; there are different claims to the title of inventor or discoverer of the appellation. Richard Huelsenbeck claims that the word was discovered by himself and Hugo Ball in February, 1916, while they were searching in a French-German dictionary for a good stage name for a lady singer. Arp, on the other hand, claims that Tzara invented the word: he even specifies the date and time of day.[19] The truth may never be known; what is important

is that the word "Dada" emerged as the trademark for the group, a word which may have been either coined or an *objet trouvé*, but a word, nonetheless, which contains within itself many of the key features of the group. Dada has a deliberately antiart connotation; it has different meanings in a variety of languages and thus underlines the international nature of the group. The word also has an attraction as a sound pattern, reflecting both the experimentation of Dada and its rejection or rationality; and in its childish sound, it challenges the contemporary adult world and suggests a withdrawal from reality.

In an academic tradition in which comparatists are still a lowly race among literary scholars, it is not surprising to find that the French literary scholar's view of the movement is radically different from that of his German counterpart. Even now it is possible for a book to be written by a French academic with the title *The Poetry of Dada and Surrealism*[20] in whose index no mention at all is to be made of names like Arp, Ball, Richter, or Huelsenbeck. Zurich is referred to in passing as the place from which Tzara came in 1919. But it nonetheless remains a fact that Dada was born in Zurich and flourished there for some considerable time before transplanting itself elsewhere.

The history of Dada is too familiar to bear repeating in detail,[21] but it is necessary for the purpose of the present study to give in broad outline an account of the rise and fall of the movement.

In February, 1916, Ball established the Cabaret Voltaire in a bar in the Spiegelgasse in Zurich. The cosmopolitan and heterogeneous nature of life in wartime Zurich is underlined by the fact that, in the same street, a gentleman by the name of Lenin was temporarily resident. In his study of Dada, Richter points out ironically that the Swiss authorities were "much more suspicious of the Dadaists, who were after all capable of perpetrating some new enormity at any moment, than of those quiet, studious Russians."[22]

Ball chose the title of his place of entertainment with some care: "Cabaret" stressed the informal, mixed-media nature of the performances; and "Voltaire" was an assertion of political unorthodoxy. The object of the exercise was to provide both a platform for the creative artist in exile and a channel of communication with the public at large.

The Cabaret Voltaire became progressively more experimental, *avant-garde*, and extreme. There was music, dancing, singing, recitals of strange, wild poetry, and exhibitions of Dada art. Early prominent members included Hugo Ball and Emmy Hennings, Hans Arp and Sophie Taeuber (both couples subsequently married), Tristan Tzara, Marcel Janco, and Richard Huelsenbeck. Dada publications also began to appear (thus the journal as a form continued to fulfill its traditional role of a rallying point for a cultural minority), mostly as collaborative efforts by members of the group.

The Dada revolt was by no means restricted to Zurich: in 1915, a form of Dada had manifested itself in the United States; in Hanover, Kurt Schwitters was plowing his lone furrow, a brand of Dada which he called Merz; in Cologne Max Ernst was engaged upon a more rigorous and intellectually conscious kind of Dada; and when the original Zurich band departed from Switzerland, they took the good news of Dada with them to Berlin, where Raoul Hausmann, Johannes Baader, and the Herzfelde brothers were active (here Dada took on a more overtly political character), or to Paris where Dada ultimately transformed itself into Surrealism.

There have been many—too many—general surveys of Dada, which broadly cover the same ground, perhaps unearthing the odd new fact, but occasionally also generating more heat than light, particularly in the case of individuals like Tzara, whose personality and creative abilities are the object of some dispute.

Even in the case of a study limited to German Dada, it is tempting to remain on a descriptive and historical level, for the material now available is indeed more than sufficient for the ardent scholar seeking to fill several full-sized volumes. But the time is more than ripe for a shift of emphasis, not for the sake of approaching the subject from a new angle, but because the very nature of Dada demands a certain line of attack which has hitherto not received due attention.

As suggested earlier in this introduction, Dada held together as a movement, or series of movements, not on the basis of allegiance to a common ideology but as a collective of individuals come together as human beings within a community with common general aims and aversions. Thus, a certain distortion

will inevitably arise in studies which concentrate first and foremost on the movement as such and give only secondary attention to the individuals involved, who are usually examined only insofar as they relate to Dada. Ball, as will be seen later, is an extreme case of a writer only a fraction of whose work tends to be referred to in the histories of Dada. There is little hint of his important critiques of the German intellectual tradition or of his excellent study of Hermann Hesse, let alone the fact that he wrote a dissertation on the subject of Nietzsche. All these events fall outside the Dada time span and are neglected if not altogether ignored. But they are crucial to an understanding of Ball's creative personality, the reasons for his involvement in Dada, and the kind of Dada he fashioned for himself.

Emphasis in the past has tended to be placed on a movement in which a variety of individuals were involved and to which they contributed according to their lights or various talents. The objective of such an approach is to arrive at a composite picture of Dada, a definition in fairly precise terms of what it is and how it works, on the assumption that Dada can be positively defined in the same way that studies of individual involvement in Romanticism or Expressionism can arrive at a broad generalization in the definition of the movement concerned.

It is the contention of the present work that this is not a profitable exercise in the case of Dada, that the nature of Dada is such that it is only possible to define it in abstract terms negatively with any real precision. This does not mean that Dada is nonexistent, but rather that it is a living organism rather than an artistic abstraction and that it is inextricably bound up with the individual creative personality. Dada is part of the fabric of the individuals concerned in the movement; it cannot be separated from either their personalities or their views about the nature of life and the state of Western civilization.

In order to arrive at some kind of in-depth picture of the Dadaist as artist and personality, it is necessary to examine in detail the work of a limited number of key writers, rather than indulge in a superficial survey of a score or more individuals who might qualify for attention.

The three artists who have been singled out here for this detailed attention—Schwitters, Ball, and Arp—have been selected

on the basis of the quantity and quality of their Dadaist writings (with more stress on quantity in the case of Schwitters), as well as on their general appeal as artistic personalities. It is hoped that an analysis of their life and work will allow a view of Dada to emerge which affords some insight into the nature of the phenomenon without seeking to obscure its essential complexity and individuality.

CHAPTER 2

Kurt Schwitters:
The Merz Artist from Revon

EACH OF the Dadaists approached the practical business of creating a work of art—or nonart—in his own unique fashion; although all pursued the same, or at least closely related, objectives, each chose his own unmistakable and distinctive angle of attack. The very lack of uniformity was, in itself, a sign both of their positive strength and richness of ideas and of the fact that they had joined common cause as much in reaction to external circumstances as from the impulse of powerful inner drives.

Kurt Schwitters was perhaps the most carefree and adventurous of all the Dadaists whom the present study discusses in detail. If Ball is the Dadaist of cosmic gloom, and if Arp is the childlike admirer of the wonders of the natural world, Schwitters may be designated as the childish figure of the movement, playing with cosmic fire, unaware of the dangerous forces he was meddling with.

A wire sculpture from World War II affords an apt illustration of this point. Schwitters picked up a piece of concrete with wire embedded in it from a bomb-wrecked house. He was on his way to the French Institute in London at the time and took the object with him. Once there, he did not give his full attention to the distinguished speaker—the occasion was the celebration of the tercentenary of the publication of Milton's *Areopagitica*— but instead concentrated on the object and "was bending it into a space-sculpture while Mr. E. M. Forster was delivering his speech."[1] Schwitters was taking a shattered fragment from a war-torn world and refashioning it, taming it and rendering it harmless, and endowing it with magical qualities remote from the harsh realities of bombing raids and mass destruction. Like Marcel Duchamp, he was taking an object ready made, but

31

instead of simply rendering it useless by depriving it of its context, Schwitters translated it into art and thus belied the object itself. The process would surely have been castigated by his friend Arp, who, in his collection of poetry *Sinnende Flammen*, warned against the insidious attempts on the part of the products of the technological and atomic age to make themselves appear quite harmless and domesticated.[2]

Schwitters was an inveterate picker-up of the leftovers of civilization, some of which were none too savory. In conversation with the present writer, Marguerite Arp-Hagenbach recalled how Schwitters once wrapped a chamber pot, which had clearly seen better days, in brown paper and tied it with string. He then carried this around Paris with him and simply gave it to someone who evinced interest in the package.

The objects which he picked up found their way into collages —Merz pictures—which look shiny and attractive in color reproductions but are essentially drab and untidy. They lack vigor and direction and, above all, conviction. However much the cognoscenti of the art world may seek to obscure the issue in fine phrases, there is no question that Schwitters's pictorial works, with the exception of his typographical experiments, when set alongside parallel experiments by artists of the caliber of Ernst, Picasso, or Arp, lack authority and conclusiveness. There is an air of "take it or leave it" about them which renders it difficult for the critic to approach and judge what appears to be a large number of incomplete visual and written works— incomplete in the sense that Schwitters broke off work at the moment when he himself was personally content with his achievement. Communication and putting a message across do not appear to be primary concerns of his, and he seems not to have made the effort of reaching out to the reader or gallery-visiting public.

For all that, there is equally no doubt that the name of Schwitters is known outside the specialist sphere, much more widely than that of Arp, who is by far the greater artist. Schmalenbach's large-scale study has been rendered into English,[3] and throughout 1971 a lavishly catalogued Schwitters exhibition toured Germany and Switzerland.[4] Schwitters' work is at least superficially more attractive and approachable than that of any

other Dadaist, although, in the last analysis, it may lack real depth and significance.

I A Life of Merz

Kurt Hermann Eduard Karl Julius Schwitters was born in Hanover on June 20, 1887. He was an only child and was brought up in exemplary middle-class fashion in a city dominated by middle-class sentiment and aspirations.[5] In the lives of many errant Dadaists, one city has come to dominate and mean more than any others: in the case of Ball, Zurich became the peak of his aspirations and the location of their ultimate disappointment; for Arp, Strasbourg and its cathedral left an enduring impact; and for Schwitters, Hanover—which he later rechristened "Revon"—became both a cornerstone of his life and the butt of his satire and antibourgeois mirth. He may have pilloried the city of his birth but was unable to shake himself entirely free from it. Schmalenbach points out that Schwitters's rebellion "had all the colors of the very world it was attacking";[6] and, although Käthe Steinitz says of Schwitters that "he was simply incapable of being conventional,"[7] she nonetheless records, without contradicting the statement, that "someone called Kurt Schwitters the most international petty bourgeois in the world; his daily life lacked any kind of elegance."[8]

Schwitters's father had worked his way up in the world, sold his business, purchased houses, and lived off the proceeds. A more prosperously middle-class example would have been hard for Schwitters to find. Never in the best of health, he seemed to need the security of this background, yet at the same time he was filled with a deep revulsion against what middle-class society had engendered. Perhaps this is why he turned his back on any form of political involvement. At any rate, he was more than typical of his generation of artists (particularly of August Stramm, whose work was to exercise a considerable influence on him) in that he lived a kind of dual existence, part "normal," middle-class, tolerably successful in the practical world, and part *avant-garde*, the crazy artist hurling abuse at bourgeois society and spurning its standards.

Between 1909 and 1914, Schwitters studied at the Academy of Art in Dresden, where he learned his craft as an artist. At the

Academy, Georg Grosz—along with Otto Dix the most vicious of the Expressionist satirists—was Schwitters's contemporary. Schwitters seems to have borne up under a regime of representational art and attention to technical detail far better than Arp. The solid background in the theory and practice of art which he gained at the Academy enabled him to earn a living as a commercial artist (a valuable source of income in the many lean years he was to face); but as far as creative work was concerned, Schwitters's time there did not tempt him into a position of complex and esoteric theorizing (despite his subsequent involvement with *Der Sturm*). His point of departure could not be more straightforward: "Liberation became the focal concept of Schwitters's art. At first it was liberation from entanglement in his own emotions, from spiritual depression and melancholy."[9] This starting point was later developed into the notions associated with the term "Merz," but even then the theoretical framework did not assume a substantially more complex structure.

In 1914, with the advent of war, Schwitters returned to Hanover, and in the following year married Helma Fischer, after an engagement which lasted six years. In 1917, he was called up for military service, but after a couple of months his unsuitability forced him into an office position. Schwitters campaigned for his release, after which he entered industrial service near Hanover as an engineering draftsman. It was during this period that he became fascinated by mechanical shapes and the paraphernalia of technology which can be seen to figure so prominently in his subsequent work.

Schwitters was repelled by war, and he saw the end of World War I as offering the possibility of a new beginning. He sought out other like-minded artists (the conception of Schwitters as a totally isolated figure is erroneous) and began to publish his work. The crucial break came in Berlin, where he was given the opportunity of exhibiting his works in the *Sturm* gallery in January, 1919; and in the same year he began to write for the journal *Der Sturm* itself, becoming one of its most substantial contributors.

In 1919 he also contributed to Christof Spengemann's periodical *Der Zweemann*, and in Spengemann's book series called "Die Silbergäule" he published the collection of prose and

verse which was to render him both famous and notorious, not just within the Dadaist movement, but far beyond: *Anna Blume.* Schwitters was now also producing abstract visual works. He was extremely active and enthusiastic and soon enjoyed a vast acquaintance and correspondence with other *avant-garde* writers and artists throughout the world.

It was in 1919, too, that he found his own voice and coined the term "*Merzkunst.*" Its derivation is well known and frequently referred to: Schwitters took part of the appellation "*Kommerz-und Privatbank*" which he found on a scrap of paper, and used it as the title for an art form which based itself on the compulsive collection of all manner of rubbish and the creation of works, both visual and written (there is as close a relationship between the two in the case of Schwitters as there is in the case of Arp), on the basis of collage, an attempt to create a new synthesis from the discarded fragments of things spawned by industrialized society.

Merz (with its subdivisions Merz theater, Merz poem, Merz picture, and so on) tends to be applied as a general descriptive term for the whole of Schwitters's creative output; indeed, Schwitters himself established the precedent for this practice, but it should be recognized both that a substantial part of Schwitters's work (for example, "Die Zwiebel"[10]), is not exclusively Merz, and also that two of his most important critics, Lach and Schmalenbach, rightly limit the main period of Merz to the years 1919-1922.[11] However, it should equally be recognized that Schwitters continued to produce Merz works right up to his death nearly a quarter of a century later.

In the immediate postwar years, Schwitters met many fellow Dadaists, notably Tzara and Hausmann, who stimulated him to write sound poems, and—the most important of all—Arp, a similar figure in many ways, a man who also stood on the sidelines of the European *avant-garde,* participating in the artistic revolution, but preferring to go his own way rather than follow the noisome leadership storming the artistic barricades.

Schwitters was something of an entrepreneur as well as an artist, and in 1923 he produced the first issue of his own journal *Merz* (which, according to Käte Steinitz, owes it origin, in part at least, to his need for something to barter with),[12] the last

issue of which appeared in 1932. In 1924 he began work on his
first *Merzbau* (which was subsequently destroyed in an air raid).
The *Merzbau* is a kind of inverted, self-replicating sculpture.
Schwitters took over a room and began to disguise its shape
and fill out its interior with all manner of strange constructs.
The observer finds himself "inside" the sculpture, so to speak,
within a context of largely geometrical shapes growing from the
floor, the walls, and the ceiling. Schwitters worked on his first
Merzbau for a decade, and the curiously vulnerable forms ulti-
mately spread over two floors of the house. As Lach points out,
the *Merzbau* is the closest realization of Schwitters's ideal of
artistic synthesis, the *Gesamtkunstwerk*, "as painting, sculpture
and architecture grow together in a totally new manner to form
a work of art of considerable impact and bizarre imaginative
power."[13] Schwitters produced a second *Merzbau* in Lysaker,
Norway, which survived his death, only to be destroyed by fire
in 1951.

In 1936 Schwitters was represented in the two important
exhibitions held at the Museum of Modern Art, New York:
Cubism and Abstract Art, on the one hand, and Fantastic Art,
Dada, Surrealism on the other. He was also represented in
another exhibition, inclusion in which was something of a mixed
blessing at the time, namely, *Entartete Kunst*, the 1937 touring
exhibition organized by the Nazis to demonstrate the corruption,
or even insanity, of "modern art."

At the beginning of the same year, Schwitters had left Ger-
many for Norway, where he took up residence near Oslo and
began work on the Lysaker *Merzbau*. When Norway was invaded
in 1940, he was forced to move on, this time to England, where
he was interned for seventeen months. On his release, he settled
in London; after the war, he established what was to prove his
last home in Little Langdale, in the Lake District. On Cylinders
Farm, Langdale, he was able to start work on his third and
final *Merzbau* by a fellowship granted by the trustees of the
Museum of Modern Art. The *Merzbau*, which was never com-
pleted, occupied the interior of a barn.

In 1946 Schwitters collaborated with Hausmann on a planned
journal, *PIN*, which did not come to fruition at the time because
of a shortage of funds.[14]

Schwitters died on January 8, 1948, and his remains were buried in Ambleside cemetery.

II *"Die Zwiebel"*

Schwitters's written work falls into three main categories: a relatively brief span under the influence of August Stramm, during which he swiftly abandoned the stern Futurist-inspired discipline of *Sturm* art theory; Merz theory and practice; and concrete poetry. Our survey of his development as an artist begins with an early work, one of his first contributions to *Der Sturm*, called "Die Zwiebel," which exhibits many of the principal characteristics of Schwitters's art and underlines the essential unity of his output. "Die Zwiebel" is a short prose piece (about 2,500 words) which begins with a rather startling sentence, whose content would seem, at first glance, to exclude or render extremely unlikely the possibility of first-person narration: "Es war ein sehr begebenwürdiger Tag, an dem ich geschlachtet werden sollte."[15] (It was a most eventful day, on which I was to be butchered.) The narrative continues by explaining that the butcher has been duly booked to appear, that the king is present in person, and that a telephone is at hand in case it should prove necessary to summon medical assistance—not to succor the butchered one, but in case one of those witnessing the proceedings should feel unwell and faint. Four attendants, two male and two female, are standing in readiness. Such is the content of the opening paragraph.

The style of the piece is simple and direct, the tone flat and unemotional. The atmosphere, indeed, is one of cheerful anticipation; the first-person narrator is unruffled and curiously detached. The last sentence of the paragraph underlines this self-depersonalization, the detachment of mind from body: "Es war mir ein angenehmer Gedanke, daß diese beiden hübschen Mädchen mein Blut quirlen und meine inneren Teile waschen und zubereiten sollten."[16] (It was pleasant for me to think that these two pretty girls were to whisk up my blood and clean and prepare my innards.) The ritual which is about to take place has strong sexual overtones; the scene is being set for some kind of perverted flogging-and-copulation-surrogate sequence for the discriminating voyeur (the chief witness being the victim himself).

As the narrative progresses, the style becomes denser and more intense, staccato and Stramm-like. At the same time, Schwitters tends to introduce short words and phrases in parentheses, which either add another trite perspective and a commentary on the action or seem—like the soap commercial: "auch etwas Seife (Sunlight)"[17]—utterly irrelevant.

The preparations continue: the princess arrives clad in virginal white and in a flurry of non sequiturs. The increasingly compressed style and the violent imagery rub shoulders with banalities reminiscent of Jacob van Hoddis, whose work was an important formative influence on Schwitters.[18] One such example of bathos occurs shortly after the princess's arrival: "Wie schön, daß sich das Wetter an Ihrem Schlachttage hält, daß der Schlächter per Rad zu Ihnen fahren kann."[19] (How nice that the weather is holding on this, the day of your butchering, that the butcher can ride over to you on his bicycle.) In a text like this, which is constituted of conflicting styles, and in which the various elements are allowed to stand in contrast without any attempt being made to bring them all together, it is difficult to determine which, if any, is the dominant tone, as ambiguity and interaction are themselves its raison d'être.

The sequence of events portrayed in "Die Zwiebel" could be either an ecstasy of cosmic pain, a low-key satire, or a trivialized depiction of suffering, depending on which of the styles was dominant; but what in fact dominates here is the conflict between each of these possibilities. The upshot is that the experienced event is, so to speak, rendered harmless and deprived of its potency in any one direction by the strong centrifugal forces at work. The piece is removed from the sphere of reality, a charade in which the reader, like the chief participant, is forced into the role of the outside observer. The moment of execution, for example, is treated by the first-person narrator as an excellent opportunity for a piece of virtuoso acting which is duly greeted by a round of applause.

The sense of play mingled with a fascination for the grotesque and the unequivocally repulsive is typical of Schwitters at this period. The unpleasantness is deliberately canceled out by parenthetical irrelevancies, but it is not easy entirely to obliterate the unsavory sensations engaged by a passage like the fol-

lowing, in which the king, having drunken of the sacrificial victim's blood, expresses an interest in tasting his eyes:

Runde Kugeln innen glatten Schleim sprangen aus die Augen sanfte Hände voll entgegen. Auf einem Teller Messer Gabel servierte man die Augen. (Schwerhörige und ertaubte Krieger erhalten kostenlos Rat und Auskunft.) Austern Augen senken Magen schwer.[20]

(Round balls smooth slime within leapt out the eyes toward soft hands. On a plate knife fork the eyes were served up. [Soldiers who are hard of hearing or deaf can obtain free advice and information.] Oysters eyes sink stomach heavily.)

The eyes do not appear to suit the king's palate, for he swoons. While the doctor is fumbling around in the king's vitals, seeking to effect a cure, the whole process of butchering appears to have reached both its climax and its limit, for it now goes into reverse.

First the victim's eyes pop back (gently) into his head and "infolge der mir eigenen inneren magnetischen Ströme"[21] (as a result of my own internal magnetic currents) the whole scene unfolds backward like a film run through the projector in reverse:

Der Schlächter berührte die Wunde in meiner Seite mit dem Messer, stach tief hinein und zog das Messer hinaus, und—die Wunde war zu.... Dann sprang der Schlächter mit einem gewaltigen Ruck zurück.[22]

(The butcher touched the wound in my side with the knife, stabbed in deeply and withdrew the knife and—the wound closed.... Then the butcher jumped back with a mighty bound.)

Once more, the application of this technique intensifies the unreality of the whole sequence, at the end of which the victim has more or less recovered, with no scars and no noticeable ill effects. But the situation depicted at the end of the narrative is not the status quo: the victim now becomes the dominant figure. The princess falls at his feet, pleading with him to save her father; but he is adamant that the king will remain dead. The narrative closes with these words:

Als die Flamme durch die Löcher in den Bauch des Königs schlug, explodierte der König. Das Volk aber brachte ein Hoch auf mich aus. (Sozialismus heißt arbeiten.)[23]

(When the flames burst through the holes in the king's stomach, the king exploded. But the people cheered me. [Socialism means work.])

When the onion ("Zwiebel") of the title has been peeled and then reassembled, some changes are inevitably wrought. Chief among these is the downfall of the king, for which the way has been prepared throughout the text by parenthetical references to capitalism and socialism. The political message seems so obvious that it hardly bears repeating; what is significant, however, is the question of the seriousness with which this symbolic overthrow of the monarch is regarded by the poet. Reference has already been made to the fact that Schwitters seeks to remove the pain from the situation, to titillate and amuse rather than repel and horrify (although his predilection for the grotesque often leads him inadvertently in this direction), but this, of itself, does not exclude the possibility that the political message is serious in intent.

However, the content of "Die Zwiebel" is as ambiguous in nature as the style, for the death and reconstitution of the victim could also be seen as a commentary on the birth of the Expressionist New Man. The ideas are borrowed from the "classical" Expressionist notions regarding renewal, best exemplified in the dramas of Georg Kaiser, where man is depicted at various stages on the path to the Ideal: the chaos of the old; purification and denial of the self; spiritual rebirth as the New Man; and dedication to the struggle toward the Ideal, which (it is hoped) is the synthesis of the transient and immanent spheres. In Kaiser, the failure to realize this end is essentially tragic (although commitment itself is both noble and ennobling); in "Die Zwiebel" the supposed renewal is, in fact, simply a reversal to the status quo with no changes within the individual himself. There is another aspect of renewal and commitment which Schwitters here refers to, and that is the attainment of the Ideal through sexual union. Finally, any political euphoria which may be sensed at the overthrow of the king is swiftly dulled by the last sentence of the text; the people, now so jubilant, will have to work under socialism at least as hard as before and without the glamor of the monarchy and its attendant splendors.

"Die Zwiebel" is a confusing piece (and deliberately so), in

which the meaning or meanings are, in fact, subordinated to fantasy, the delight in play and in sparkling flights of the imagination. It is unfortunate that Schwitters was not equal to his self-imposed task. Instead of creating a rich and varied world, his imagination was evidently limited, his range restricted, and his vision myopic. Thus, the reader rapidly gains the impression of having entered a private, somewhat narcissistic fantasy world of recurring images and a mind preoccupied with sexual perversion.

Schwitters has a penchant for nicknames—Tran, Merz, Erika,[24] Anna Blume, and the like—but the concepts associated with these are both limited and inflexible. In fact, he reiterates the same formulas until they become mere cliché formulations. Typical examples of this are the notions of "whipping" and "fish."

"Die Zwiebel" contains the phrase "oben stachelt Fisch in der Peitscheluft";[25] in the poem "Nächte" the same line occurs, only slightly modified: "schlank stachelt Fisch in der Peitscheluft."[26] In "Mordmaschine 43" there is a variation: "Schlank stachelt Fisch den Karpfen grün";[27] and in "Stumm" there is a modification on the themes of "fish" and "sky": "Der Fisch stirbt in der Luft."[28] As these restricted patterns recur insistently, their repetition becomes more and more monotonous, and the inspiration begins to flag. For Schwitters is merely ringing the changes on the limited set of stock phrases, not opening up new unexplored regions of the imagination.

Nonetheless, Schwitters and his work have exercised a considerable attraction although the intellectual demands made upon the reader or observer are far less rigorous than those imposed by many of the other *Sturm* contributors, notably figures like Blümner and Friedländer (Mynona). Schwitters's work does not present a continuum of theory and practice, of world view and created objects. It is, on the contrary, escapist and insulated against the world outside.

III *Schwitters and Stramm*

The insulation of the created object is most glaring in the case of Schwitters's earliest works (that is, excluding an initial Neo-Romantic phase),[29] the poems written in imitation and

admiration of August Stramm for Christof Spengemann's journal *Der Zweemann*[30] and subsequently for *Der Sturm*.[31] It should not be concluded that Schwitters was merely following in the footsteps of Stramm's eccentric staccato verses. The exact nature of the relationship between the two poets can best be demonstrated by comparing and contrasting a poem by Stramm with one in a similar vein written by Schwitters. The most famous and most widely anthologized Stramm poem is the celebrated "Patrouille":

> Die Steine feinden.
> Fenster grinst Verrat.
> Äste würgen
> Berge Sträucher blättern raschlig
> Gellen
> Tod.[32]

> (The stones foe.
> Window grins betrayal.
> Branches throttle
> Mountains bushes exfoliate rustling
> scream
> death.)

This is a typical Stramm product, a poem consciously worked over and compressed on four distinct levels: first, the overall length is severely restricted to six lines (all of Stramm's poetry, with a few exceptions, both special cases, follows a similar pattern); the length of each line is rigorously controlled (frequently being held to a single word); and the individual word is deprived of prefixes, suffixes, and inflexional endings ("feinden" instead of "anfeinden"; "Berge" as a potentially adjectival form; "gellen" instead of "gellenden"). Finally, the poem itself is progressively intensified and compressed (the physical appearance of many of Stramm's poems is clearly that of a pyramidal shape—or a series of such shapes—with the point facing downward), culminating in the single word "Tod," which both concludes and summarizes the action. Everything in the poem is directed toward the single purpose of demonstrating the dehumanizing horrors of war. Stramm, it is true, places image

alongside image in a kind of verbal collage, allowing each to comment on the others without losing its separate character or identity. At the same time, the images are balanced in such a way that there is a taut and clearly marked progression. Although there is no reference within the text to specific individuals—in fact, the exclusion of such a reference suggests nature turned against itself in an orgy of self-destruction—the poem conveys both the fear which holds the patrol in its grip, their ambush, and their destruction. The objects presented in successive lines follow the eyes of the patrol, starting down on the ground and then moving higher and higher until the machine-gun fire knocks them to the ground. The poem focuses on stones, then on the flash of sunlight on a window, branches slashing at the soldiers faces, and finally "mountainous" bushes spitting bullets that bring screaming death.

"Patrouille" possesses a rigorous and totally consistent structure and development; a carefully evolved technique is consciously and deliberately applied to a specific and clearly defined end which agrees with Stramm's philosophy.

Stramm's poems are among the most vigorous and dynamic creations of Expressionism, and there is no doubt that Schwitters greatly admired him and recognized his importance: "Stramm was the great poet. We owe *Der Sturm* a great deal for making Stramm known. Poetry itself owes Stramm a great deal."[33] But there is also no doubt that Schwitters's Stramm-like poems are highly selective in their borrowings:

> Zagt ein Innen
> zittert enteint
> giert schwül
> herb
> Du
> Duft der Braut
> Rosen gleißen im Garten
> schlank stachelt Fisch in der Peitscheluft[34]
>
> (An inside hesitates
> trembles un-oned
> lusts sultry
> bitter

you
scent of the bride
roses glisten in the garden
sleekly fish stabs in the whip air)

Superficially, this extract from "Nächte," the first poem which Schwitters published in *Der Sturm*, bears a strong resemblance to the principal characteristics of Stramm's poetry as outlined above. It is highly compressed, the words are deprived of their articles and endings, and the fifth line represents a culminating point, which seems to be all the more significant when it is noted that, of the sixty times that the word "Du" occurs in Stramm's poetry, it appears as the single word on the line on no less than twenty-two occasions. There are also many other correspondences in vocabulary.[35] Nor is it surprising that there are parallels with Stramm's poems "Zwist"[36] and "Trieb,"[37] which share with "Nächte" the theme of sexual intercourse.

But in Schwitters's poem the centrifugal forces are by far the stronger. If the plurality of styles in "Die Zwiebel" directed attention away from the act and meaning of the central figure's ritual slaughter, this poem, too, is not concerned with sexual union in its cosmic significance (this is the theme of Stramm's poems on the subject). Schwitters is taking the actions and emotions of love as the basis for artistic experimentation. Stramm marshals alliteration, assonance, and striking imagery to the purpose of heightening and intensifying the impact of the poem, but each of Schwitters's images has a considerable degree of independence from the rest of the poem and also a different frame of reference. The line "Rosen gleißen im Garten," for instance, owes its existence only partly to the associations sparked off by "Duft" in the previous line. It stands primarily as a separate image conditioned by the initial sounds of "gließen" and "Garten"(in the same way that the following line is dominated by [ç]) and by the erotic image of roses, which appears elsewhere in his work, for example, in the poem "Senken schwüle," and more general images associated with flowers, their blossoming and fading, which pervade not only his work but which constitute a significant element in Expressionist imagery at large.

Schwitters's poetry also lacks the forward impetus of Stramm's.

"Patrouille" is impelled along by its inner logic to the cul-
minating word "Tod"; but in Schwitters the lack of strong links
between one line and the next (indeed the occasional nonsense
line bearing no relation to the rest of the text at all) and the
absence of a focal or culminating point lead to the suspicion
that the relationship between the two poets is neither as strong
nor as profound as might at first sight seem to have been the
case.

In this respect, it is significant to note that, in his contribu-
tion to *Der Sturm,* of which his brief eulogy on Stramm forms
part, Schwitters's comments on Stramm are immediately fol-
lowed by a definition of abstract poetry. The implication is
clear. Schwitters is primarily concerned with Stramm's tech-
nique: he leans heavily on all his technical devices of compres-
sion and his Futuristic breaking of syntactic bonds. But any
references there may be to similar themes—the erotic and cosmic
union, or war and its dehumanizing effect—are coincidental
because, as has been shown in the case of "Die Zwiebel," it is
not the subject matter that dominates but the manipulation of
the separate constituents of the poem in an endeavor to create
an abstract pattern that is removed from the pain of existence
into a private fantasy world.

At one time or another, most Dadaists have been accused of
writing or creating constructs devoid of meaning in which
arbitrary play is the sole detectable consistent feature. In the
majority of cases, the accusation is manifestly false, as will be
seen with regard to Ball and Arp; but Schwitters comes close
to being proven guilty on this score.

IV *Schwitters and Merz*

It seems curious that, despite general critical insistence on
the difference between Expressionism and Dada, the two move-
ments rubbed shoulders in many of the leading literary journals
of the time. In *Der Zweemann,* edited by Christof Spengemann
and predominantly Expressionist in tone and outlook, a declara-
tion by Schwitters on Merz painting appears[38] as does a Dadaist
manifesto signed by a galaxy of Dadaists.[39] Schwitters himself
did not go through a clearly marked and distinct Expressionist

period—his Stramm-like poems were published concurrently with the first Merz works—although he owes his reputation and "discovery" (particularly as a visual artist) almost entirely to *Der Sturm*, the journal which, under Herwarth Walden, promulgated the most exclusive and esoteric brand of Expressionism. Arp, too, appears in the pages of *Der Sturm*, despite the fact that he is highly critical of Expressionism and the concept of the great artist;[40] and in the Dadaist manifesto in *Der Zweemann*, Hausmann, Tzara, Huelsenbeck, Ball, Arp, Otto van Rees, Friedrich Glauser, and others joined forces in a violent attack on Expressionism and its failure to bring about the promised regeneration of art.

The massive weight of scholarship bearing down on Expressionism and Dada tends to crush out of existence the simplest facts, which become lost under a vast superstructure of critical theory; and the simple fact is that the common point of departure meant far more than the specific goals being pursued. Jones underlines this fact in his article on Schwitters's relationship to *Der Sturm*:

The link between Dada anti-idealism and the positive "Sturm"-ideal can be seen as an indirect result of the total negation of all conventions and rules in art by the Dadaists. The destructive impulse left a vacuum; but it also gave the artist the total freedom essential to the creation of the absolute work of art. Schwitters's work is a clear illustration of the successful amalgamation of the art-ideal of *Der Sturm* with the positive "spin-off" from Dada.[41]

And the particular brand of Dada that Schwitters discovered for himself was "Merz."

In his preface to *The Picture of Dorian Grey*, Oscar Wilde asserts that art is useless. Schwitters has stood this declaration on its head: for him, the useless is art. He defines Merz in "Die Merzmalerei" (first published in *Der Zweeman*, subsequently reproduced in *Der Sturm*, shorn of the last paragraph),[42] where he asserts that Merz is abstract, that he gathers the leftovers of society—bits of wood, metal, old tickets, fragments of newspapers for his Merz pictures, and clichés, advertisements, shreds of language for his poems—and creates by withdrawing the

materials from their context and treating them as shapes or patterns.[43]

Unlike Arp, Schwitters was not seeking to take an object or word out of its cliché-ridden existence in order to set it in a new, meaningful context, but simply in order to liberate it from all contextual considerations, to remove it from reality into a world of private references and associations. In a dialogue entitled "Ein solider Artikel,"[44] which is conducted between "I" and "The Doctor," among all the interpolated parenthetical irrelevancies a fundamental unwillingness to explain Merz, although that is the ostensible object of the exercise, can be detected. Merz is something which exists in Schwitters's imagination and is thence transferred by him to canvas or paper; but overzealous analysis may damage or even destroy Merz. In this awareness, Schwitters takes a malicious pleasure in obscuring the real issues.

This obsessive private world of Schwitters is illustrated by an anecdote (an accretion of such little tales, all sworn not to be apocryphal, has formed about the biographies of most Dadaists), related by Hausmann, who found Schwitters one evening outside groveling on the ground, looking for something amid a pile of pieces of paper. Schwitters explained his presence thus: "It struck me that I just have to slip a piece of blue paper into the left lower corner of my collage 30B1, I won't be a moment."[45] This view of Schwitters as the contented, self-contained artist, utterly wrapped up in his own work, is underlined by Hausmann's statement that "Schwitters was of an harmonious, undivided disposition, and allowed nothing to disturb or deter him."[46] Schwitters peopled this private world with strange figures like Alves Bäsenstiel, Franz Müller, and Auguste Bolte, but the most celebrated of all is a woman, Anna Blume. Schwitters's poem addressed to this lady is his best-known work, "An Anna Blume" first appeared in *Der Sturm* in 1919,[47] and subsequently in book form with other, additional texts.[48] The poem has been widely anthologized and has been the object of considerable critical attention.

Heselhaus as an interpreter is typical of the generally tentative and unambitious approach of most critics toward it; he goes little further than giving a straightforward description of

Merz. He restricts himself to calling "An Anna Blume" grotesque, but he does stress the fact about the Merz poems that "they were by no means as arbitrary as might be thought, but like the Anna Blume poem had their own consistent Merz-unity."[49] This theme of unity is taken up by Thomson, who takes the rather surprising view that the poem is held in a state of balance, in which ambiguity is the key to its significance. "The reader . . . can either dismiss the text as a nonsensical hoax, an anti-poem, or he can think of it—though with some reservations—as a unique blend of the nonsensically comic and the poetic."[50] The major weakness of Thompson's argument derives from his insistence on comparing and contrasting every bit of "An Anna Blume" with Stramm (why just Stramm?), which leads him into far wilder realms of speculation than those he accuses Last and Middleton of invading.[51] These two at least make no exclusive claims for their intepretations, recognizing that "meaning" is only one aspect of the poems they are examining. Middleton's close reading of a Schwitters poem (if "close reading" can be applied to a poem consisting entirely of numbers) does at least make the crucial point that Schwitters is taking the banal constituents of the technological society and using them in order to transcend reality: "These deadly designs are answered by Schwitters in this poem with an art of animation which reveals miracle in banality, and which retrieves the breath of human life from the orifices of the robots."[52] Carola Giedion-Welcker also stresses the magical and poetic qualities of "An Anna Blume" in particular and Schwitters's poetry in general.[53] And, although Schmalenbach refrains from anything approaching a detailed interpretation of the poem, he does make two important points: first, that Schwitters's poem was not just a *succès d'estime,* but was actually well known and not far short of being a "popular hit"; second, that the poem attacks "petty bourgeois sentimentality."[54] As an advertising copywriter, Schwitters knew how to strike the right note to attract the reader's attention (and "An Anna Blume" does read rather like a zany advertisement for this strange product); and, as has been pointed out earlier, he was half a prisoner of his middle-class background, despite the fact that his artistic activities led him to move among the front-line troops of the *avant-garde.*

The observations of Middleton, Giedion-Welcker, and Schmalenbach serve to set "An Anna Blume" much more meaningfully in its context than Thomson's simplistic notion of ambiguity, which, like Lach's interpretation, insists too exclusively on the parodistic features of the poem: "The texts are consciously distorted into nonsense as parodies of the language of the *Sturm*-lyrics."[55] The poem is a prose poem; and, like much of Schwitters's Merz material, it is far less arbitrary and spontaneous than appears at first sight. The apparent spontaneity is more attributable to Schwitters's combinatory skill than to any kind of automatic writing.

It falls into three clearly marked sections, each headed by an apostrophe to Anna Blume, which contains the phrase "ich liebe dir" (I love you—"you" being dative rather than the normal accusative). This has been hailed as an attack on grammar, but it is much more likely to be a deliberately strange (grammatical) case which echoes in the mind until it comes across its rhyming word at the end of the poem, "Tier" (animal).

The three sections, of approximately equal length, each concentrate on a specific attribute or aspect of the beloved. The first section states the poet's (or the lyrical self's) devotion to Anna Blume. The second concerns her appearance, her clothes and color; and the third deals with her animal presence and sexuality. The poem opens thus:

O du, Geliebte meiner siebenundzwanzig Sinne, ich liebe dir! —Du deiner dich dir, ich dir, du mir. —Wir?
Das gehört (beiläufig) nicht hierher.
Wer bist du, ungezähltes Frauenzimmer? Du bist—bist du? —Die Leute sagen, du wärest,—laß sie sagen, sie wissen nicht, wie der Kirchturm steht.

(O thou beloved of my twenty-seven senses, I love to thee! —Thou of thee thee to thee, I to thee, thou to me. —We?
That [by the way] does not belong here.
Who art thou, innumerable lady? Thou art—art thou? People say you are—but let them talk, they do not know how the churchtower stands.)

The hyperbolic tone is maintained throughout, as are the weird metaphors and other devices with their bathetic effect: they

include references to the perfection of the circle, because the name Anna is a palindrome, and the deliberate parallel between Anna Blume (Anna Flower) and the Romantic ideal of the "blue flower," symbol of mystical aspiration toward the infinite. But, typically, Schwitters is not content with straight borrowing: his heroine is green, blue, yellow, and red all at once.

The declension of the second-person singular personal pronoun is, so to speak, a verbal *objet trouvé*, which both reflects the lover's characteristic repetition of "you" and leads to the equally conventional questioning of the durability and strength of the relationship. Typical of Schwitters, this central issue is brushed aside. The repetition of the personal pronoun is, it is true, close to Stramm, and there are a few other traces of Stramm's techniques; but again imitation, if it is that at all, goes no further than that. There is none of Stramm's intensity of meaning and no quest for cosmic union.

Anna Blume herself, a simple homespun maiden, is a parody of the girl of every clean-living young man's dreams. She is described as if she were the miracle ingredient in some grotesque amorous compound. The utter banality of Anna Blume, coupled with the bliss of definitely noncosmic union which her limp little bourgeois body offers, makes it evident that Schwitters's poem is not sympathetic to the *Sturm* ideal and the esoteric realms inhabited by its high priests. But there is no consistent case being argued: although a highly organized poem, it nonetheless lacks dynamism and a sense of progression. It is essentially a haphazard gathering of independent units, and the lack of focus and consequent abstraction of the poem is closely allied to that noted earlier in the case of "Die Zwiebel."

Lach compares "An Anna Blume" with Hans Arp's "Kaspar ist tot," which latter in common with many other interpretations of the poem he regards as a parody of a dirge or lament. Even if this funereal interpretation were correct, there would still be essentially very little in common between the two poems, except for the rather superficial correspondence that both concern figures endowed with magical abilities. The differences far outnumber and outweigh any points of comparison: Arp's elegy on a lost harmony is a coherent, developing statement in which parody, if it exists at all, is only a general reference to a con-

ventional form, and one which in no way seeks to devalue or mock the form itself;[57] Schwitters's poem, on the other hand, is not trying to make a political, sociological, cosmic or any other kind of point. There is no message being put across, nor is parody a principal element. In this respect, too, "An Anna Blume" follows the example of "Die Zwiebel" by withdrawing from reality into a private world; and if the poem is to be subjected to a consistent interpretation, it would be more appropriate to consider it in terms of personal rather than historical issues, that is, with respect to the schizophrenic state of its author, a man torn between *avant-garde* and petit bourgeois, with two most incompatible souls raging within his breast.

V *Revolution in Revon*

Many of the principal features of "An Anna Blume" reappear in Schwitters's uncompleted novel *Franz Müllers Drahtfrühling* (*Franz Müller's Wire Spring*). It was begun in 1919, but only the first chapter, bearing the title "Cause and Beginning of the Great and Glorious Revolution in Revon," was actually completed, and published in *Der Sturm*.[58] It was also translated into English for *Transition*.[59]

"Revolution" is a dangerous and tempting word to encounter in a title, particularly of a work composed at a time of revolutionary disturbances; but here again Schwitters removed himself from political and social reality into his own world. And once more he uses a strict and highly developed form. As Elderfield in his stimulating paper on *Franz Müller's Drahtfrühling* points out:

The only political party Schwitters ever supported was one he invented himself: the *KAPD* (*Kaiserliche Anna Blume Partei Deutschlands*). His lack of interest in politics is well known, and his version of revolution is predictably irreverent. But, as in much of his work, whether literary or artistic, there exists a duality between what he himself called a "nonsensical" content and a precisely controlled form.[60]

The narrative begins with the simplicity of a fairy tale.[61] A child is asking its mother about a man standing there and doing nothing. The question is repeated with several variations. The

man standing there is himself questioned, but he makes no reply. A stranger, Alves Bäsenstiel from "Die Zwiebel," is also present. A couple, Herr Doktor Leopold Feuerhake with his wife, joins the crowd. This pompous pair also questions the reason for the man's presence and apparent lack of mobility. Every time his name is mentioned, Doktor Feuerhake acquires new appellations until his name has grossly inflated itself to "hochwohlgeboren Herr Doktor Friedrich August Leopold Kasimir Amadeus Gneomar Lutetius Obadja Jona Micha Nahum Habakuk Zephanja Hagai Sacharja Maleachi Feuerhake,"[62] editor of the Revon newspaper.

All those present, notably Alves Bäsenstiel and Doktor Feuerhake, condemn the man; for them, his inexplicable presence constitutes a grave affront to public order and the fellow is a criminal and a disgrace. But then, the narrative is suddenly interrupted:

Hier läßt der Autor zunächst ein selbstverfaßtes Gedicht folgen. . . . Und nun folgt zunächst wieder der Anfang dieser Geschichte.[63]

(At this point the author introduces a poem written by himself. . . . And now there follows once more the beginning of this story.)

Thus, instead of taking up the narrative at the point at which he had left it when he embarked on the poem (which has absolutely no relevance to the rest of the text), Schwitters returns to the beginning of the story, produces a précis of the action described so far, and then proceeds to quote the poem once again, this time with some minor variations.

To borrow a phrase from science fiction jargon, it seems as if Schwitters were caught in a time-loop; but he extricates himself by pointing out that the story has been repeated for the cogent reason that he wishes to make it unambiguously clear to his readers that a man is actually standing there doing nothing.

At this point, Anna Blume appears:

Anna Blume? Jawohl, geliebter Leser, dieselbe Anna Blume, von hinten wie von vorne A-N-N-A, aber es war noch vor der Zeit, als Steegemann sie verlegt hatte, sie war noch nicht einmal im "Sturm" erschienen, geschweige durch den deutschen Blätterwald mit Anmer-

kungen der Redaktionen gehetzt. Sie war noch so gut wie unbekannt. (Zur Erhöhung der Betriebssicherheit ist bei der Bergfahrt die vordere Hälfte, bei der Talfahrt die hintere Hälfte stärker zu besetzen. Jeder Mißbrauch wird strafrechtlich verfolgt.)[64]

(Anna Blume? Yes indeed, dear reader, the selfsame Anna Blume, A-N-N-A read forward and backward, but this was before the time she was published by Steegemann; she had not even appeared in *Der Sturm*, not to mention the thicket of German papers through which she was chased with observations from the publishers. She was still practically unknown. [To increase the safety of operation the front half is to be more fully occupied during the journey up the mountain, the rear half on the journey down. Abuses are punishable by law.])

The parenthetical irrelevancy reminds the reader at once of Anna Blume's function as the mascot of Merz, as does a brief quotation from "An Anna Blume," which pursues her like a leitmotif whenever she is mentioned. She sees the man standing there (now called Franz Müller) with far greater clarity than the others present:

Der Anzug war auch etwas eigenartig. Anna Blume dachte dabei etwa an die Merzplastiken des Autors. . . . eine wandelnde Merzplastik, d.h. der Mann wandelte ja garnicht, der Mann stand.[65]

(The suit was also something of an oddity. It reminded Anna Blume of one of the author's Merz sculptures. . . . a walking Merz sculpture, that is, the man wasn't walking at all, he was just standing there.)

The others present fail to see in Franz Müller anything but an obstruction in a public place; they do not recognize that he might be a work of art. Alves Bäsenstiel is particularly wrathful; he denounces the man's presence in a long speech in which a kind of fugue is played on the theme "The man stands." The police are summoned, and since this is a case of an inoffensive and harmless individual causing no violence and posing no danger, an officer of the law agrees to come and apprehend the villain. He addresses the man. For a little while, nothing happens.

Da geschah das Unerhörte. Der Mann wandte den Kopf zur Seite. Schreck wühlte Augenlichter zischen Eingeweide.[66]

(Then an amazing thing happened. The man turned his head to one side. Terror raged eyesights hiss bowels.)

The sudden change of style to the Expressionist grotesque seeks to mock the absurdity of the situation rather than parody Expressionist style itself; it is taken a stage further when a child is crushed to death between two fat lady spectators and some of the shorter members of the crowd take possession of the corpse in order to stand on it so that they can the better observe what is happening.

And then the ultimate horror occurs: the man actually walks away. Wild panic breaks out. More people are crushed to death, and the officer of the law stoically notes down the proceedings in legalistic jargon. A crippled youth runs through the streets proclaiming the glad tidings consequent upon the man's moving, namely, the outbreak of the great and glorious revolution in Revon.

Franz Müllers Drahtfrühling is Schwitters's most competent and consistent piece of prose writing. The work is supposedly a fragment, but the narrative, as presented in *Der Sturm*, seems to reach the limit of its development and certainly does not break off in mid-action, despite the optimistic note at the end: "Fortsetzung folgt"[67] (to be continued). It has the, by now familiar, strictness of form, here very highly developed. Schwitters operates by a process of repetition with variation, which has the effect of causing the action to move at an uneven pace, even jolting backward in time on occasion. As in "Die Zwiebel," points of crisis are postponed, and when they appear, the reader's attention is split or distracted from the central issue. Elderfield draws the proper conclusion from this situation: "Now, why all this diversion and repetition? It could be argued that it heightens suspense by delaying action. But Schwitters's side-trackings are so assertive that one cannot but conclude that he was as much interested in the form of what he wrote as what he actually said."[68] Schwitters was very preoccupied with technical considerations, and the underlying reason emerges clearly if Elderfield's argument is taken one step further.

The time structure of *Franz Müllers Drahtfrühling* is complex, and so is the alternation of different stylistic levels. But Schwit-

ters also operates with an intricate pattern of shifting points
of view, ranging from detached omniscient narrator through
intrusive first-person narrator to outbursts of lyricism. The re-
sult of this constantly switching standpoint is to generate a state
of confusion about levels of reality in the same way that the
structure produces an inchoate temporal progression. And the
combined effect of this polyvalency of style, time, and viewpoint
is to produce within the reader a sensation of alternating in-
volvement and detachment, of being everywhere and nowhere—
in effect, of inhabiting and exploring Schwitters's own private
world of the imagination.

The more the texture of the narrative is examined, the more
complex and consciously worked out it proves to be. Words,
phrases, and whole sequences are laid out in a linked chain, in
which the individual elements appear in this order of progres-
sion: a a b a b b c b c c d. Words become structural elements
pure and simple. Nowhere else in his work does it emerge more
clearly than here that Schwitters's notion of "word play" is
radically different from that of other Dadaists like Arp. Arp
employs diverse aspects of the meanings of words to produce
a punning effect, the object of which is to rejuvenate worn-out
concepts and engender new and spontaneous relationships (for
example, "habemus papam habemus mamam").[69] In the whole
of *Franz Müllers Drahtfrühling*, there are only two puns of any
significance, neither of them central to the work;[70] it is, rather,
the structural role of words and phrases that is crucial. This
comes across most forcibly in Schwitters's use of bold type to
underscore moments of crisis ("Da geschah das Unerhörte")
or for words or phrases with particular importance for the struc-
ture of the narrative ("bravo" from the crowd, or the individual
expletives directed against the motionless Franz Müller). Else-
where, the use of language is extremely conventional with the
exception of the Expressionist outbursts. And even here Schwit-
ters is not violently experimental: the Expressionist style is only
one of several styles—fairy tale, officialese, the language of adver-
tisements, etc.—which he borrows.

Schwitters creates a magical realm divorced from reality, one
with a lesser degree of nastiness than that prevailing in "Die
Zwiebel." It is peopled with strange characters, like Doktor

Feuerhake with his voluble, much-fainting wife. Anna Blume appears to be even more ethereal than elsewhere, for in this narrative she is as yet unknown, not having been "discovered" and made famous.

Schwitters is evidently fascinated by people, their quirks and oddities; and he seems to collect idiosyncrasies just as he collects different styles, pieces of paper, string, and so forth. He even "collects" Hanover, translates it into Revon, and thereby creates a kind of latter-day Seldwyla, Gottfried Keller's immortal hicktown.

The lack of focus generated by this wide range of constituent elements renders an unambiguous interpretation of the meaning of the motionless Müller and his audience somewhat difficult. The central figure is subjected to a variety of approaches, but the only person who is capable of understanding him is Anna Blume, who is placed there by Schwitters in order that the reader might have her insight into Müller's true nature. The other figures are totally uncomprehending and react in a panic-stricken fashion when he moves; but Anna Blume is able to recognize him as a Merz construct, a harmless creation which wishes only to be left alone.

Müller is not a political figure; Schwitters has "collected" the notion of revolution from contemporary events and exploits it here simply as still another weapon in his campaign against the art critics. But even this is not done in deadly earnest. Elsewhere in *Der Sturm* he pokes fun at the scholar and critic of the art world; in one extremely witty article entitled "General-pardon an meine hannoverschen Kritiker in [*sic*] Merzstil" (General pardon to my Hanover critics in Merz style), Schwitters mockingly recommends patent blinkers, which are light, fit easily, and are simple to use.[71] But he is essentially unruffled by critical incomprehension (and one suspects that he would be more than a little bewildered to find himself the object of serious investigation in terms such as the present study offers) and prefers to play happily with his own invented figures in the Revon he has created for himself. As Elderfield observes: "While his methods of working could not help but make reference to his times and their social and political dilemmas . . . Schwitters

but used his outer environment to make for himself a personal and absurd abstract world."[72]

VI *Sound Poetry and Concrete Poetry*

Schwitters's creative work continued broadly along the lines of "Die Zwiebel," "An Anna Blume," and *Franz Müllers Drahtfrühling*, in his novel *Auguste Bolte*,[73] which appeared under the *Sturm* imprint, and in his Merz stage pieces.[74] But there is one important aspect of his work which has yet to be discussed, namely his contribution to the development of sound poetry and concrete poetry.

The dividing line between these two lyric forms (which are partly literary, partly musical, and partly visual in nature) is difficult to determine: perhaps the most straightforward definition is that, while one appeals principally to the ear and the other to the eye, both employ the word (or part of a word or group of words) as a physical object, not as a conveyor of meanings and associations.

In his statement on Merz painting, Schwitters states that the pictures of Merz painting are "abstract works of art,"[75] and he applies the same epithet to Merz poetry. In his foreword to the book *Anna Blume*, Schwitters defines abstract poetry as a form which "sets values against values. One might also say 'words against words.' "[76] (In the German, Schwitters relates the two concepts by means of the word play between "Worte" and "Werte.") Thus he is concerned with the interplay of forces, the tensions created by verbal and visual structures, whose constituent elements have been deprived of significance because they have been "abstracted" from their context. Schwitters underlines this proclivity by writing poems in which the elements themselves are abstract. The following is an extract from one such poem:

$$
\begin{array}{ccccc}
 & 25 & & & \\
25, & 25, & 26 & & \\
26, & 26, & 27 & & \\
27, & 27, & 28 & & \\
28, & 28, & 29 & & \\
31, & 33, & 35, & 37, & 39^{77}
\end{array}
$$

In a commentary on this poem (for Schwitters gives it this name, incorporating its "first line" into the title: "Gedicht 25"), Middleton talks in terms of "patterning and unpredictability,"[78] that is, in relation to a structure whose parts have meaning only by virtue of their relationship to that structure as a whole. Schwitters, he is arguing, is not so much concerned with "25" or any of the other numbers as a cipher, a numerical value, or a quantity with an extrinsic significance (like a magic or lucky number), but as a visual element in a visual pattern, one which hovers between conformity and predictability on the one hand and arbitrariness and chaos on the other. The impact of the poem derives from this conflict between expectation and what actually appears on the printed page.

This manipulation and exploitation of the reader's search for order and pattern is one of the key characteristics of sound poetry and concrete poetry. An absolutely regular pattern would be dull and complete chaos would be bewildering—hence it is possible for the artist to operate between these extremes in order to achieve his desired effect. All too often, Schwitters succeeds only in stimulating without satisfying, asking questions and setting up tensions which he has no intention of resolving. The end product, in such cases, is irritation and alienation on the part of the reader, a frequent response by anyone scanning Schwitters's abstract poetry. Despite the fact that he states in one of his aphorisms, bearing the general title "Banalities from the Chinese," that "Every beginning has its end,"[79] it is evident that here, as elsewhere in his work, the tendency is for Schwitters to lay down his pen (or scissors, or paintbrush, as the case case may be) when he has satisfied himself, without reference to the possible response of others. Schwitters may be scathing in his attacks on his critics,[80] but it cannot be said that he goes out of his way to avoid critical censure.

The reduction of the constituents of a poem to the role of building bricks permits Schwitters to approach his central aspiration, namely the uniting of art forms and the destruction of barriers between one form and another. Shapes, words, and sounds all become interchangeable at the point at which they lose their contextual significance. Much of Schwitters's work was written for recitation, notably the *Ursonate,* a long sound

poem which has some of the appearance of a musical score and which follows in the tradition of the simultaneous poem.

Schwitters involved himself in the whole range of what might be termed "nonverbal" poetry, but it is in the typographical field that his professional interest created the most substantial impact. All his work in this area was of a high order. In his covers for issues of his journal *Merz* and elsewhere, he exploits the medium with restraint, preferring simplicity of outline, an unornamented typeface, heavy ruled lines, black-edged inserts, and—a favorite device—a block of type at right angles to the main direction of the text. The professionalism of these designs stands in stark contrast to the ineptitude of some of his "straight" poetry, particularly the later material written in England.[81] There is no doubt that Schwitters's technical skills were more visual than literary, particularly the skill of composition and the way in which the eye is guided clockwise round the covers of his *Merz* journal. The long contribution to *Der Sturm,* which bears the title "Aufruf (ein Epos),"[82] is a typical mixture of "straight" prose and such typographical experimentation.

Schwitters takes this experimentation a stage further in his stamp pictures, in which an impression of a section of type is employed as part of the design, similar in fashion to certain works by Max Ernst. In "The Critic" (1921),[83] a mixture of type impressions and line drawings presents a visual and verbal picture of a critic: his hair, for example, is composed of repeated impressions of "Der Sturm," and the words "Herwarth Walden" stream in a long line to or from one corner of the critic's mouth. Here Schwitters has arrived at a fusion between pictorial and written statement, a point at which the two are in such a state of balance that it is impossible to categorize the resultant work as either a drawing with typographical elements or a concrete poem with some line drawing.

In a sense, the visual has always tended to dominate with Schwitters: even in the case of the Stramm imitations, the poet was as much concerned with the physical shape of the poems as with their Futuristic rejection of the conventional restraints imposed upon language. The visual pattern generated by the written word often parallels and excites an aural response, as in this poem called "Fury of Sneezing":

Tesch, Haisch, Tschiiaa
Haisch, Tschiiaa
. . .

Happapeppaisch
Happapeppaisch
Happa peppe
TSCHAA![84]

Although hardly a poetic masterpiece, this little poem clearly illustrates Schwitters's overriding concern with shapes and patterns and his avoidance of the inevitable personal and emotional associations generated by traditional lyrical poetry.

The sound poem, which Kreutzer rather tartly, but perhaps not wholly inaccurately, dismisses as a "Pyrrhic victory over language,"[85] has a fairly short pedigree. Although a variety of related forms can be traced back over several centuries,[86] Schwitters, together with Raoul Hausmann, must be regarded as one of the real innovators of this form.[87] A poem by Paul Scheerbart, dating from 1897,[88] and a similar one by Morgenstern, composed a few years later,[89] are frequently cited as standing at the head of the sound poem genealogical tree, but they are only isolated phenomena. The sound poem proper took shape under the influence of the Futurists and their call for the liberation of language from grammatical and syntactical restraints. It should, however, not be forgotten that many other Dadaists tinkered with this type of poetry; and Hugo Ball's important set of sound poems will be the object of discussion in the next chapter. Schwitters can also be regarded as a pioneer of concrete poetry, despite the fact that the general impression seems to be that the form did not exist before Eugen Gomringer.[90]

In all of these experimentations on the borderlines between different established art forms, Schwitters constantly pursues his aim of withdrawal from reality into a magical, charmed world in which the cares of the present are a tedious irrelevancy.

VII *Conclusion*

In an essay on Schwitters written shortly after his death, Arp records that he instilled meaning into life by "the metamorphosis of the visible and tangible world into the abstract and absolute."[91]

Schwitters's work is a retreat from reality into this private world of shapes and patterns. He was a true eccentric who lived for himself alone, utterly unorthodox in his conduct, yet constantly looking over his shoulder at the bourgeois world he so despised and sought to escape from. He was never at ease with officialdom and bureaucracy, the visible exterior of the capitalist industrialized world. Themerson notes that Schwitters's "British passport was granted him on the day before he died."[92] It was certainly a document of little relevance to him; perhaps extracts from it might have found their way into one of his poems, or pieces of it into a picture.

CHAPTER 3

Hugo Ball:
A Man in Flight from His Age

O F all the Dadaists, Hugo Ball was the one whose life was the most fraught with physical deprivation and inner tension, and torn between the most violent extremes. And yet, at first sight, it appears somewhat surprising that this should be so, for the usual image of Ball is that of a man reveling in the artistic revolution, rather than of an individual borne along upon a tide of conflict and emotion which he was powerless to control.

To look at most studies of Dada and the *avant-garde* to date, it would seem almost compulsory to introduce the Zurich movement through Ball's recitation of the first sound poem in the Cabaret Voltaire (despite the fact that the claim to the title of first sound poem is more than a little suspect). In a contemporary illustration, Ball is pictured uncomfortably clad in cardboard between music stands upon which the script of the poem—written in red—reposes. His legs and body are encased in colored cardboard tubes; about his shoulders there hangs a kind of cardboard poncho; and the whole creation is topped by a blue-and-white-striped hat. In this eccentric uniform Ball intoned his "first" sound poem to the horrified citizens of Zurich, who were hardly expecting such strange entertainment.

But this picture of Ball the extrovert on the makeshift stage in the Spiegelgasse—something of a comedown for a man who had once studied at the Max Reinhardt school in Berlin—represents no more than a fraction of the truth and, because it is a partial picture, actually distorts the truth.

The real Ball was a tragic figure, a man who took many years to come to terms with the harsh facts of life; and in his final escape into religion he admitted perhaps by implication that he was essentially incapable of facing the world.

I *A Life of Searching*

Ball was not born into circumstances which might seem to have guaranteed him literary greatness. He was the fifth of six children—he had two brothers and three sisters—of whom one of the latter was destined to take the veil. Ball entered the world in Pirmasens on February 22, 1886. His father was a wholesale shoe salesman, a withdrawn individual who was by no means successful in his profession. His mother was a deeply religious woman, and hers seems to have been the decisive influence upon the young Hugo, both in the positive and negative sense. Positively, Ball inherited a profound religious awareness; but this was countered by a sensibility which bordered on the emotionally unstable, as his biographer-widow, Emmy Ball-Hennings, somewhat effusively recalls in her introduction to her husband's diary, *Die Flucht aus der Zeit*:

Above his little iron bedstead there hung a picture of the Sistine Madonna, at whose feet reposed two little angels on cushions of cloud, dreamily gazing down from heaven upon the tiny earth beneath. Where their wings were, there could be found the marks of little Hugo's lips. He never neglected to stand up in his bed of an evening in order to wish the angels a good night. . . . This practice, so he told me, also enabled him to make observations on his own growth rate, for with his young lips he was able to reach the cloak of the Virgin when he was seven, and her dress too, without having to stretch himself unduly or stand on tiptoe.[1]

There is something obsessive about Ball's childhood religiosity which was to set the pattern for the rest of his life and to have such a crucial and dominant impact upon his creative period.

Much has been written in general terms about the alienation and spiritual malaise of the creative artist in this century, and it is significant just how often this general state can be traced back to a specific imbalance in the personal development of the individual artist rather than to wider historical circumstances. In Ball's case, the imbalance was particularly severe, and the compensation was equally violent. As Steinke records, his own dark fears and profound insecurity led him into pathological behavior: "At night when he was put to bed, he was beset with

fears that he would never see his loved ones again or that he would get lost in the dark. He always begged his mother to hold his hand and even at the age of twelve demanded that all the members of the family assemble around his bed until he fell asleep."[2] His academic career, which ended when he left grammar school at the age of fifteen, was average without being remarkable in any way. He was yet another in a long line of creative artists whose school reports on his competence in his native tongue gave little hint of his later work as a writer. At school, he was undoubtedly inhibited in his personal and social development by the fact that he was a Catholic child in a predominantly Protestant area,[3] but it is clear that Ball was destined, from the very beginning, to be in a minority of one, so to speak, for nearly the whole of his life.

When he left school, it was to take up an apprenticeship in the leather industry, a career he had not sought and which he heartily disliked. But his parents' wish was that he should go out into the world and earn his keep rather than pursue his academic studies any further; and so, once more, the imbalance of his life was heightened. All day long he would work in uncongenial employment, and at night he overcompensated with avid reading. It was at this period that he came upon the writings of Nietzsche, which exercised upon him an influence no less shattering than the discovery of Kant by Kleist—with whose cosmic gloom Ball had more than a little in common—in the previous century. Now Ball made his first efforts at writing poetry and drama.

He set his sights on the university as both a means of escape and of fulfillment; and, after a period of intensive effort, he returned to school, where he matriculated in record time. The fall of 1906 found him at the University of Munich, embarking on studies which were to continue until 1910. Despite this abrupt change of direction, his parents apparently continued to give him moral and financial support. While at the university, he wrote a dissertation on Nietzsche (which remained incomplete and unpublished); sought to counter a certain Jewishness in his appearance by a not particularly successful cosmetic operation on his nose;[4] and penned a vicious black satire, *Die Nase des*

Michelangelo, the nose of the title having been put out of joint by Torrigiano.[5]

Having so far achieved very little, Ball determined on a theatrical career. To him, the stage was the arena in which the great social and philosophical battles had been waged in the past, and were now once again being fought in earnest. It was on the stage that Ball saw the possibility of giving practical expression to the Nietzschean revolution which had taken place within his own spirit. And in this respect, the "fearful, cynical drama"[6] of Frank Wedekind, which so closely paralleled his own convictions, was the strongest influence.

Once again—and not for the last time—Ball was taking his fervent beliefs to their logical conclusion and beyond. In 1910 he became a student at the Max Reinhardt school of acting and directing in Berlin. His new enthusiasm was total: "Between 1910-1914 the theater was everything to me: life, society, love, morality. To me the theater signified elusive freedom."[7]

As an actor, Ball was a failure. Predictably, he lacked the ability to distance himself from the characters he was portraying, and in this respect his Nietzschean subjectivity became his own worst enemy. So he turned, instead, to directing, and in June, 1913, he was trying to keep the Munich Kammerspiele on an even keel financially. Like so many artists of his generation, he drifted out onto the fringes of conventional society, frequenting the cafés which were so symptomatic of a society in which the artist and intellectual found himself more and more pushed to one side and at odds with the establishment.

In the famous Berlin Café des Westens—pilloried by opponents as the "Café Größenwahn" (Megalomania Café)—he met Richard Huelsenbeck; but far more significant was his encounter in the Simplicissimus Café in Munich: there he heard and was introduced to the cabaret performer Emmy Hennings.

As the account of Ball's earlier years would seem to presage, and as an examination of his works will shortly demonstrate, Ball's relations with the opposite sex—where they existed at all—were hardly normal and balanced. Emmy Hennings, however, was an exceptional woman. She exercised a fascination over him which was to endure for the rest of his life; for, although the two were both drifters on a uncertain tide in search

of personal fulfillment, she had acquired maturity and had been hardened, rather than weakened, by experience. Thus it was that she became the dominant partner, and perhaps it is not too far from the truth to state that, in Emmy, Ball at last found a surrogate for the mother who had failed to recognize that her son had inherited the full measure of her own intense subjectivity.

Emmy Henning's life had been far more adventurous and filled with greater adversity than Ball's. A previous marriage had failed, and after wandering about Europe she had finally found herself in Munich. She was a gifted woman with a considerable talent for the theater, as a conventionally overwritten piece in *Die Aktion* indicates,[8] and some minor abilities as a poetess.

Convinced that the war was the cleansing fire which would purge society of its manifold ills, Ball—in a typical fit of passionate enthusiasm—enlisted in 1914, only to be discharged because of a weak heart. With the total commitment to the current obsession which was characteristic of him, he repeatedly sought reenlistment; and after repeated failure, he actually went to the front line in Belgium, where he was utterly shaken by the nastiness of the reality of war. "What has been unleashed there," he wrote in his diary, "is no less . . . than the devil himself."[9] Once again Ball's personal state coincided with the general climate of the hour.

Ball had been much influenced by Franz Pfemfert, editor of *Die Aktion*, who had published his work, and in that journal and those who wrote for it he found a prop for his own disillusionment: "P. and the close members of his editorial circle are radical opponents of the war and antipatriots. They clearly know more than someone like me who, up to this time, has had no dealings with practical politics. . . . And my own patriotism does not go so far as to approve of war even if it is unjust."[10] Ball's sense of rootlessness and the essentially negative nature of the position in which he found himself was intensified by the fact that the Kammerspiele had been obliged to close; Emmy too lacked employment, as the Simplicissimus was under new management which did not require her services.

In May, 1915, the two artists, with little prospects and no money, went to Switzerland, where they faced immediate trouble with the police, and in the long run severe poverty. At one

point in his diary, Ball recalls that in Geneva he "sat by the lake near an angler and envied the fish the bait which he cast at them."[11] A further blow came in 1915 with the death in battle of Hans Leybold, Ball's friend and collaborator, which set the seal on Ball's utter repugnance at the war and despair for the future.

Ball's reduced physical circumstances meant a further drain on his limited mental reserves, and the more unpleasant life became for him, the more he withdrew into the inner world of his imagination, nourished by a heady mixture of Baudelaire, Wilde, and the German mystics.

Gradually some of his former associates began to appear in Zurich, thus at least alleviating his sense of isolation. Then came the founding of the Cabaret Voltaire and the birth of Dada, which Ball exploited in order to plunge himself further into the depths of his own subconscious. Suffering a nervous breakdown largely as a result of his artistic experimentation, he withdrew for a while, returned briefly into the Dada limelight, and then turned his back on Dada once and for all. He became a journalist in Berne for the bi-weekly *Freie Zeitung*, and he also worked for René Schickele's magazine *Die weißen Blätter*. In 1919 he and Emmy became friends with Hermann Hesse, a close friendship which for Ball was to end only with his own death, shortly after he had written a biography in celebration of Hesse's fiftieth birthday. Ball died on September 14, 1927, in Tessin. Emmy, who finally became his wife in 1920, survived him by many years and died in 1948.

II *Ball's Creative Span*

By any standards, Ball's published work is not voluminous. Two plays, two novels, and four other full-length works are supplemented by a handful of poems and articles in contemporary literary journals. Of these productions, only the Dada poems are known at all well; the rest can be described at the very least as obscure. Yet it is a highly significant body of writings for all that, because it both demonstrates what consequences the Dadaist tenets of art and philosophy hold for an individual of uncertain temperament and unstable personality, and it also

goes some way toward explaining why Dada is generally held to be totally negative and nihilistic.

In order to trace the path Ball took in his descent into a private void of his own making, an experience shared by many of his contemporaries, it is important to follow the stages which led him to Dada and beyond to his reconversion to Catholicism, which tore him from the brink of insanity and almost certain suicide. A study of his earlier work further serves to demonstrate just how strong are the links between Expressionism and Dada, especially in what might be described as the "early stages"—not in the historical sense, but in relation to the mental attitude on the part of the creative artist.

Both Dada and Expressionism were in revolt against the morality of contemporary Germany, and both took as the point of departure the rejection of all authority and all the principles upon which society was founded. Having rejected all this, the next—and crucial—stage is the decision of where to turn now, what solutions, if any, there are, and what stand the artist should take.

Those who were honest with themselves also recognized that if a new and substantially different form of society were postulated as an alternative to the status quo, this projection would inevitably remain an unfulfilled aspiration. Here Ball's nihilism emerges in all its blackness, and there can be few individuals even in such a despairing generation whose attitudes could have been so uncompromisingly negative and totally without hope.

III *The Bleak Expressionist*

In a brief notice on the appearance of a collection of poems by Klabund, Ball stresses Klabund's roving spirit to the exclusion of all else: "Klabund has within him the spirit of adventure, that is to say: the realism of the uninhibited."[12] And he opens his diary *Die Flucht aus der Zeit* with a description of the mood of the age which illuminates his affinities with Klabund's restlessness:

A kind of industrialized fatalism rules over all and accords to each individual a specific function, whether he will or no. . . . The church can be seen as a "salvation machine" of little consequence, literature

as a mere safety valve. . . . But the deepest question . . . runs like this: is there anywhere a force strong enough and, above all, vital enough to bring about a change in this state of affairs?[13]

This is no unfamiliar pattern for the artist in this century. Ball expresses deep gloom at the present state of the civilized world, in which even those last repositories of hope and idealism, the church and the creative arts, have become trivialized and institutionalized in the great leveling down of humanity, and he seeks some way out, a force or power of some kind—of any kind—potent enough not simply to destroy the old world, but to create a new one. To borrow a term from current parlance, the "alternative society" is not enough. What is demanded is an "alternative cosmology." Thus Ball formulates, in his own terms, the dilemma of the artist, demonstrating that his premises are no different from those of his contemporaries. But the path he is about to travel, the way out he is to take, will lead him into a vicious circle of despair and exaltation. The spiritual development of Hugo Ball, as reflected in his works, is frighteningly close to that of the drug addict who experiences one "bad trip" after another, but, having irreversibly rejected the world beyond the self, finds himself with only one way to go, downward toward ultimate self-destruction.

The first group of Ball's works to be considered is a set of lyric poems published in *Die Aktion, Die Revolution,* and *Die neue Kunst* before Emmy Hennings and Ball emigrated to Switzerland. Their discussion can conveniently be divided as follows: a description of their chief characteristics; Ball's contribution to *Die Revolution*; and the poems composed in collaboration with Hans Leybold. It should be stressed that this does not imply the analysis of three separate stages of his work but, rather, of different levels at the same stage. The two events of the outbreak of war and the death of a close friend in battle did nothing more than intensify attitudes of pessimism already deeply embedded within him. What these events did cause was his recognition that his own creative work needed to take on a more extreme form—and it was then that his next, Dadaist, phase can be said to have begun.

But to turn to the general characteristics of these poems pub-

lished in two of the leading and one of the most notorious literary journals of the day: they are in many respects typical of the flood of verse produced in what Peter Scher in *Die Aktion* somewhat hyperbolically, but not wholly inaccurately, called "the age of the lyric."[14] Many of these poems give an overwhelming impression of *déjà lu*, as is perhaps inevitable at a time when so many poets were repeating the same limited set of themes so frequently; but they are not without some originality, not to say idiosyncrasy, in expression.

The opening stanza of a poem not published in Ball's lifetime, but dating from the early war period, "Das ist die Zeit,"[15] demonstrates both this attribute and the poet's indebtedness to the kind of poetry which Georg Heym had written, both in its simplicity and directness, and in the conflict between the precise utterance and the horrors expressed:

> Das ist die Zeit, in der der Behemoth
> Die Nase hebt aus den gesalzenen Fluten.
> Die Menschen springen von den brennenden Schuten
> In grünen Schlamm, den Feuer überloht.
>
> (Now is the time in which the Behemoth
> Its snout above the salty tide does show.
> The people leap down from the burning boats
> Into green slime lit in the fire's glow.)

Presumably the monster is an eclectic borrowing from the Old Testament, and not the actual creature who "eateth grass as an ox,"[16] for the biblical animal is clearly of the fresh-water variety.

The poem advances a series of statements consequent upon the rising up of Behemoth and ends with an oxymoron: "Ein schwarzer Sonnenschein/ Hängt wie Salpeter überm Höllentiegel." (A black sunlight/ Hangs like saltpeter over hell's crucible.) All this seems to be a blend of "Der Krieg" and "Der Gott der Stadt," both by Heym, which gloomily predict the consequences of liberating the dark forces lurking beneath the thin surface layer of civilization, the "forgotten toys"[17] of cities and countries now being smashed as if by some demented child. In Ball's poem, however, tensions are even more acute, and the scene even more horrific and grotesque, as is shown by the red flames against the green slime at the close of the first stanza.

The greatest tension is that between violent action and stillness, for Behemoth "rises up," men "leap," and the flames "flare up high." All is violent movement, especially in the second half of the poem where rabid angels destroy all in their path. And then, suddenly, above them hangs a black sun, motionless, the only point of reference in a world of agony and chaos. All that is certain is that the former source of all life and energy, the sun, has died, and that oblivion is inevitable. The impact of this "negative" image—and that not simply in the photographic sense—is intensified by the form, a comfortingly traditional but essentially delusive framework—because it is with a sense of considerable shock that the reader realizes that the poem is couched in that most conventional of forms, the sonnet.

It is significant that in the poem Behemoth, war, is not an alien visitor from another planet, but rises up from the depths of the sea, from the inner oceans of the mind, like the gray and menacing snout of a submarine. The devastation it wreaks is swift and total. Behemoth is both subjective and supernatural: it is a product of the individual mind, but comes to dominate it. Ball is concerned with the impact of these forces from within on a world whose population has summoned them into being without recognizing the destructive energies that have been unleashed. This interplay between transience and immanence is also the subject of a poem from *Die Aktion,* "Der Gott des Morgens."[18]

In lush imagery replete with strongly erotic overtones, the poem describes the God of morning reveling in the waking day:

> Der Morgen erwacht und schreitet aus grünlichen Toren,
> von Schaum gebaut.
> An seine Brust anklammert sich ein verfrühtes Möwenpaar
> Mit klatschenden Schwingen.
>
> (Morning awakes and strides out from doors of green,
> foam-built.
> A pair of early gulls cling to his breast
> With a clatter of wings.)

The poem is self-indulgent and precious, but demonstrates the power of Ball's Expressionist style in the now familiar violent verbal forms, the use of fire and garish illumination:

Er schmettert den Stab auf das Felsengelände
Und rosane Brände werfen aufbrausend Entzündung weit
 in die Ferne.

(He smashes the rod down on the rocky regions
And flaring up pink fires send flames shooting far in
 the distance.)

At first sight, an extravagant description of the first rays of the
sun lighting up the plain from the hills, these words express
the vehemence of the deity coming in the guise of the rising
sun. This is hardly the conventional new dawn of hope; taken
in isolation, the following lines could simply be an expression
of divine exultation, yet the helplessness of man is clear enough:

Die Fenster und die Fassaden der Wolkengebäude stehen
 in Flammen.
Die Länder und Städte der Menschen schlafen noch wie
 vergessenes Spielzeug.
Über die Ebene schürfet des Gottes Schuh auf rollendem
 Perlengestein.

(The windows and fronts of the cloud-buildings are aflame.
The countries and cities of man sleep on like forgotten toys.
Across the plain the God's shoe rakes across rolling pearl
 stones.)

Returning to nautical imagery, Ball asserts that the God's coming
is an event to be regarded at least with awe, and possibly with
fear; the deity is impatient, for the earth as it is no longer
satisfies him. "Ungeduldig tanzet der Gott"—the God dances
impatiently. It is not enough for him that the day advances
toward him like a pleasure boat, but he must ride it like a hunts-
man, and the steed itself becomes his quarry.

But it was in *Die Revolution* that the most significant, most
extreme, and most pessimistic of these early poems was to appear.

IV Die Revolution *and* Der Henker

In its layout, contents, audience, and aspirations, *Die Revolu-
tion* was using a formula which had proven tolerably successful

elsewhere. It was even given the best of launchings by the police authorities, who confiscated the first issue because of alleged obscenity in Ball's poem. By current standards, the poem would hardly raise an eyebrow in the politest of circles, but it is nonetheless the most powerful item in the first number of this journal, which only managed to survive five issues between October 15 and December 20, 1913.

Die Revolution was a child of its age. It shared a violently antiestablishment title with better-known journals like *Der Sturm* and *Die Aktion;* the blend of articles, extracts, and poetry is also almost identical; and there is, in *Die Revolution,* the same paradox of a demand for popular revolution on the one hand, and on the other alienation from the broad mass of people. Esthetic exclusiveness rubs shoulders with revolutionary demands; but any disputes among the artists and intellectuals of the day evaporate in the face of a threat from outside (for example, trouble with the censor or political discrimination); ranks close and a united front is maintained against the suspicion and incomprehension of the world at large.

It is against this background that Ball's poem "Der Henker" should be considered.[19] It reflects the violent antipathy of the creative artist and intellectual toward contemporary society, and the fear that the Western world was inevitably and inexorably hurtling toward the final catastrophe. The woodcut by Richard Seewald on the front cover of the first issue, beneath the red title "Revolution" which sprawls across the top of the page—itself bearing the same name—depicts a rigid line of soldiery shooting down a milling crowd, from which a banner bearing the legend "Freedom" is being held in the air. The buildings seem to be collapsing, and the message is clear enough: society has become so materialistic and frightened of the intangible human qualities that the spirit of man is, itself, in grave danger of being crushed by its own mechanistic constructs. And Ball's poem supplies the verbal accompaniment to Seewald's visual expletive.

It is easy enough to dismiss "Der Henker" as an inchoate, rambling, and immature piece, the sole purpose of which appears to be a wallowing in wild erotic fantasy with blasphemous overtones, both of a particularly nasty kind; and it is presumably this aspect of the poem which drew official attention toward

it, rather than any weighty political sentiments it might express. The final judgment of the critic may not be entirely positive, but it would be overhasty to dismiss a line like the following as an undisciplined and juvenile outburst lacking any restraint: "Als dein Wehgeschrei dir die Zähne aus den Kiefern sprengte . . ." (When thy cry in labor wrenched the teeth from thy jaws . . .). Hyperbole is a crucial element in the literary currency of any age where revolutionary sentiment comes to the fore, and this line could almost have been written by a "Stürmer und Dränger" like Friedrich Maximilian Klinger. No movement has been more extreme in its language than Expressionism, particularly in its literary journals. As if to corroborate this statement, there appears an apt illustration of this mode in the form of a short contribution in the same issue of *Die Revolution* by Hans Harbeck, celebrating the centenary of the birth of the practical, as well as literary, revolutionary, Georg Büchner (1813-37). It opens—and closes—with these words: "Georg Büchner's life shoots skyward like some splendid rocket and of a sudden breaks up in the very midst of its greatest splendor into a handful of ashes! . . ."[20] Literary extremism of this nature is to be found everywhere in the front lines of the contemporary *avant-garde*; and the less sympathetic the world at large became, the louder and more hysterical the voices grew.

"Der Henker" is colored in this way; but it is also marked by a note of desperation so characteristic of Ball. For, underlying his general despondency at the state of the world, there arises, once again, Ball's private fear of the world within the self. As Büchner's despairing protagonist, Woyzeck, said, "Every man is an abyss, and it makes you dizzy to look down into it."[21]

Ball's poem is set in a brothel where the dwarf syphilis—a typical piece of compressed imagery—lurks. Its first two stanzas depict a savage coupling between a prostitute and her client. The experience is not couched in a conventional narrative form, but hurled at the reader in a series of statements which neither form a complete and cogent whole, nor relate to one another in a sequentially logical manner. In fact, the imagery in one line may contradict that found in the next, as in the case of "moon," thereby underlining the intense subjectivity of the experience:

Dein Leib ist gekrümmt und blendend und glänzt wie
der gelbe Mond
deine Augen sind kleine lüsterne Monde.

(Your body is hunched and glistening and glows like
the yellow moon
your eyes are tiny lusting moons.)

The language is marked by extravagant and exotic imagery
which concentrates on the erotic qualities of the woman:

deine Hand eine Schnecke, die in den blutroten Gärten
voll Weintrauben und Rosen wohnte.

(your hand a snail, dwelling in bloodred gardens filled
with grapes and roses.)

Ball's work is characterized by an extreme and ambivalent
attitude toward women: the veneration of saintly feminine
purity has already been encountered in the description of his
childhood osculations of the Madonna portrait; and at the other
end of the spectrum there is a brand of unpleasantness which
finds its most forceful expression in what Steinke rather too
generously—and not too accurately—dubs "expressionistic love
poems"[22] which appeared in 1913 in *Die neue Kunst,* another
journalistic venture by the publisher of *Die Revolution,* Heinrich
Bachmair.

These five poems begin with a two-part poem entitled "Die
weiße Qualle," ("The White Jellyfish") a powerful evocation
of the strong attraction and repulsion engendered by the erotic
impulse in one whose background and level of maturity inhibit
a balanced and positive response. There is more formal control
here than is the case with "Der Henker": the first part of the
poem has seven three-line stanzas, the second three three-line
and the same number of four-line stanzas, which results in an
equal number of lines in each of the sections, and a general
sense of balance, although the length of the lines in the second
part of the poem is somewhat reduced. The language is exotic,
and the imagery is bold to the point of bravado. The first part
of the poem concludes with a magnificent example of a controlled

description of violent emotion, in which the word "Wahnsinn" appropriately holds a central position:

> Du hast deine Fingerspitzen mir an die Schläfen gesetzt.
> Ich taumle hernieder, von Wahnsinn getroffen, und zittre
> im Fallen.[23]

> (You have placed your finger tips upon my temple.
> I reel down to the ground, struck down by madness, trem-
> bling as I fall.)

Less successful, perhaps, is the subsequent comparison between breasts and battlements:

> Deine Brüste stehen da wie die Tortürme
> Einer bestürzten Stadt, die den Feind erwartet
> Aus der Ebene.

> (Your breasts jut out like the gate towers
> Of an affrighted city, that awaits the enemy
> From the plain.)

Here the key word is "Feind." And at the end of the poem the poet addresses the woman in these terms:

> Du bist nur ein Schrei noch,
> Ein in Musik gebrochener. Und du wirst Worte finden...

> (You are no more than a cry,
> Broken by music. And you will find the words...)

"Madness," "enemy," and "cry" all point to an extremely subjective individual solely concerned with the impact of the experience upon himself, and his impact upon the experience. The woman does not exist as a human being, but as an object of his lust, as a cry of mingled ecstasy and pain created by *his* virility, *his* ruthless violence. Perhaps in itself this is not untypical of one area of Expressionist art, but, when linked with the other extreme of adoration of the woman as a divine and untouchable creature—and here, too, the woman becomes

an object—it can readily be seen that Ball's attitude is far from normal. Attributable to childhood experience, that is, to his parents' unawareness of his own sensibility, there had remained within him a particularly acute form of arrested development which inhibits normal relations with the world beyond the self and intensifies the introversion of the individual. It, in turn, further restrains proper relations with the world outside. That Ball was able to enter into an apparently full and lasting relationship with Emmy Hennings underlines just how far this remarkable woman was able to act out not just the normal feminine roles, but also that of substitute mother to a child inside the frame of a man.

This personal state both mirrors and parallels the experience of others who were moving toward Dada by a variety of paths: Ball was by no means alone in his growing sense of detachment from the world beyond the self and a consequent need to place greater demands on the inner self. But the significant factor is that what has so far been shown of Ball's personality does not give much room for hope that he would be adequate to the enormous and increasing burdens that such subjectivity imposes. The philosophical background and personal consequences of these burdens will be discussed shortly: for the present, it is sufficient to note that Ball's personal path was fully attuned to the *Zeitgeist*—he was moving in the same direction as many German intellectuals and artists of the time.

All was not despair, however, and occasionally a note of optimism creeps in, as in the poem "Der Verzückte," which comes from the same quintet in *Die neue Kunst*:

> Und manchmal überfällt mich eine tolle Seligkeit.
> Alle Dinge tragen den Orchideenmantel der Herrlichkeit.
> Alle Gesichter tragen an goldenen Stäben zur Schau ihr
> innerstes Wesen.
> Die Inschriften der Natur fangen zu stammeln an, leicht
> zu lesen.[24]

> (And now and then a wild blissfulness comes over me.
> Everything bears the orchid mantle of splendor.
> Every face parades its secret heart on golden rods.
> Nature's ciphers start to stammer, to be easily read.)

In these less clouded moments, life seems to regain its meaningfulness, but it is significant to note that these extreme expressions of joy and despair occur in Ball's poetry as early as 1913, whereas his contemporary Arp did not give way to such violent polarity until the closing years of his life.[25]

"Der Verzückte" could hardly be called a love poem, nor could the last of the quintet, "Das Insekt," which is a vicious and cleverly written attack upon a society in which humanity has become devalued to the point at which individuals are mere insects. Their God becomes a deformed, jellyfishlike monstrosity:[26]

> Seine Beine sind lang wie die Lotfäden, die von den
> Schiffen herunterhängen
> In die finsteren Meere.[27]

> (His legs are long like the lead lines that hang down
> from the ships
> Into the dark seas.)

This closely resembles the architectonic seascapes of Alfred Mombert, but here the cosmos is no positive force offering fruitful interaction between the individual and the infinite; it is rather a cancerous growth coming from within, poisoning and destroying the mind. Suffering heightens the receptivity of the senses, and Ball aptly expresses the inversely proportionate relationship in the insects between such sensibility and physical magnitude in these terms:

> Wahnsinnig sind sie vor zuviel Empfindlichkeit. Sie zucken
> vor Schmerzen bei jedem Hauch.

> (They are mad with an excess of sensitivity. They twitch
> with pain at every breath.)

As a commentary on Western civilization immediately before the outbreak of World War I, "Das Insekt" is a substantial poem and one which unjustly languishes in near-oblivion.

Thus the poems from *Die neue Kunst* elucidate the intensify-

ing polarity in Ball's work, never more violently expressed than in the context of his relationship—or rather lack of relationship—with women.

Returning specifically to "Der Henker": the adjectives in the first two stanzas of this poem are all concerned with fierce color and light. In order of appearance, they are "red," "bright," "flashing," "yellow," "lustering,"[28] and "bloodred." And they cast an appropriately lurid glow upon the frantic sexual activity taking place in the brothel. The balance between the first two stanzas reflects the male and female elements: the opening stanza concentrates on the "I," the poet, the active partner; the second describes in passive terms the "you," the female. Behind the extravagant imagery and unbridled lust there is an organizing poetic craftsman at work, channeling the described experience into some kind of formal pattern. Throughout his work, Ball imposes formal discipline on his poems, as if the framework of the created work offered the sole remaining points of reference in a world of utter chaos. And, indeed, it will be seen later that in the Dadaist sound poems, the formal pattern is virtually all that remains. Ball is inevitably moving toward incoherence, and ultimately the poem becomes a hollow shell echoing with a jangle of half-understood sound. "Der Henker" represents a stage along this path, in which the feeling of detachment from the world beyond the self has become acute but not yet critical.

In these two opening stanzas, the poet seeks for fulfillment and meaning; and he finds these objectives elusive and illusory. Even though it is, in a sense, inevitable that, having sought in vain within himself, he should turn outward, the abrupt change of context at the commencement of the next stanza, although in itself a fairly typical Expressionist device, comes as a considerable shock to the reader. Ball is true to his own extremism in turning from the violently erotic to the sublimely religious, but fulfillment is to be found in neither:

> Hilf, heilige Maria! Dir sprang die Frucht aus dem Leibe
> sei gebenedeit! Mir rinnt geiler Brand an den Beinen herunter.
> Mein Haar ein Sturm, mein Gehirn ein Zunder
> meine Finger zehn gierige Zimmermannsnägel
> die schlage ich in der Christenheit Götzenplunder.

(Help, Holy Mary! For the fruit that sprang from thy womb
blessed be thou! A lustful fire courses down my legs.
My hair a storm, my brain a tinder
my fingers ten greedy carpenter's nails
which I strike into the heathen plunder of Christendom.)

The parallel structure of the opening statements in this extract
serves to indicate the brutal contrast between them. The sexual
violence of the poet is also a protest against a corrupt civiliza-
tion. The hands smashing into the idolatrous spoils, given the
Christian context, can only be a reflection of Christ casting the
moneylenders out of the temple, jumbled together with a
reference to Christ, the carpenter, and the nails on the Cross.
But it is the poet, not Christ, who is the moralist striking out at
the evils of the world. In the brothel, love is traded for money;
and this is as perverse as usury in the temple. The central line
of the stanza has strong associations with the "wrath of God."
The theology may be a little suspect, but there is no mistaking
the message: religion has become deflated, or is, itself, a fraud,
and the supposed spiritual constituent is a chimera. Religion is
the tool of materialism. The juxtaposition of Mary's pain in
childbirth with the beginnings of Christianity as a vast financial
corporation makes this all too evident:

Als dein Wehgeschrei dir die Zähne aus den Kiefern
 sprengte
da brach auch ein Goldprasseln durch die Himmelssparren
 nieder.

(When your labor-cries smashed the teeth from your jaws
a hail of gold rattled down through heaven's roof-beams.)

Christianity is itself corrupt; Christ is not the God of love but
of material things. Ball, the former Catholic, has turned against
the religion of his childhood. As Steinke in his interpretation
of the poem aptly puts it, "Nietzsche's proud announcement that
God is dead is a mild assertion in comparison with Ball's shock-
ing blasphemy that Christ lives as the god of lustful greed."[29]
Nor do the angels bring tidings of great joy and peace to all
mankind, but they bear salvers flashing with the glint of money.

Ball does not make it clear in the poem whether or not religion itself is a fraud or whether man has turned it into such, for he is concerned with the description of visible results rather than with past causes. There is no sense of historicity here.

The final two stanzas of the poem relate a bitter sequence of cause and effect. When Christ came into the world, not as a Savior but as a golden idol, all nations and religions—"Heiden, Türken, Kaffern und Muhammedaner"—are united in their ecstasy of greed. And the angels of light bring only darkness and anguish.

If the excessive language is left to one side and the content of the poem up to this point is stated in cold terms, what emerges is, first, an obvious antipathy toward organized religion, indeed toward any external formalized structure imposing a scale of rational—logically interrelated—values upon the individual from outside. Institutionalization of a structure spells its spiritual death, as this passage from *Die Flucht aus der Zeit*, which could well have been written by any one of dozens of writers at the time, demonstrates:

Faith in material things is a faith in death. The triumph of this kind of religion is a terrible aberration. The machine gives dead material the illusion that it is alive in some way. It brings material into motion. It is a specter. It combines materials and in so doing shows some measure of rationality. This is why it is death operating systematically and giving the pretense of life.[30]

Here again the violent contrast of life and death appears: forces which are supposedly life-giving are shown to be fatal to man and society alike.

The rejection of external authority common to the Expressionists as a group is traceable in part back to Nietzsche, the impact of whose ideas was regarded by one eminent contemporary critic as very positive in effect:

Nietzsche appears now rather as a force which is keeping German literature in touch with the needs and demands of the actual life of the present and is preventing it—as so often happened in the past, when a healthy realism became a dead letter in Germany—losing itself in the clouds of an unworldly idealism.[31]

This is, of course, heavily dependent upon the qualities of the individual artist, his ability to measure up to the responsibilities of philosophical self-sufficiency. The rejection of external authority came for Ball as a fairly direct result of his encounter with Nietzsche's writings. Hohendahl expresses the dilemma which Ball faces as a consequence of this meeting of minds in these terms:

Ball's interest in Nietzsche ... was linked with an enthusiastic faith in the possibility of regenerating a rationalized world through the medium of intuitive, Dionysian art. Moral and religious values destroyed by Nietzsche's criticism were to be replaced by esthetic values.[32]

Far from being the spiritual life-blood of Western civilization, Christianity appear in "Der Henker" as an evil, materialistic force.

Christ is no longer the Saviour—"Der Erlöser"—but the hangman of the poem's title. Religion no longer holds a valid position, since it has become the slave of lust for material things. In referring specifically to non-Christian religions in the course of the poem, Ball stresses the completeness of his rejection. He also discards the whole concept of a civilization founded upon an absolute scale of external moral values. In their place should come new, subjective values. Again Ball's personal history mirrors the great intellectual developments of the age in his own rejection of Catholicism.

Thus, it is not surprising that Ball was totally involved in "Der Henker," which appears as a personal exclamation against the world in which he found himself. In the poem, Ball is angry, bewildered, shouting obscenities to mask the conflicting doubts within his own spirit. It is as if the rift in his life and work which had been progressively widening had now reached the point at which it was no longer possible to express openly the violently conflicting passions raging within him.

Die Flucht aus der Zeit was written in retrospect, when Ball had returned to the Catholic church, and it is a fairly heavily "censored" account of what took place between 1912 and 1921. At times, the poet is able to distance himself sufficiently from

intensely felt past experience, as when he is describing his performances of his own sound poems in the Cabaret Voltaire. But there are occasions on which he seemingly continues to find the recollection too painful or too embarrassing to put down on paper. The publication of "Der Henker" is one such example. Ball's reference in *Die Flucht aus der Zeit* to *Die Revolution* begins with a curious disclaimer about Seewald's woodcut and its political import and continues by omitting any reference to the reason for which the opening issue was confiscated:

> The title of [*Die Revolution*] stood out in red . . . and the title page included a woodcut by Seewald, with tottering and distorted houses. It is stylistic rather than political in intention; most of the contributors, and particularly my friend L., had little knowledge of politics. Nevertheless, the first number was confiscated, and in the second number there appeared a letter of mine on theater censorship.[33]

At the time, Leybold and Ball were both delighted at the publicity caused by the confiscation and clearly regarded it as a significant event, almost a status symbol, but the fact that Ball here omits any reference to the key role of "Der Henker," while at the same time noting the appearance of a relatively insignificant letter indicates that the recollection was, if not painful for him, at least something he would rather not write about openly in view of his subsequent reconversion.

If interpretation of "Der Henker" rests here, as it has tended to in the past, it would be justifiable to accuse Ball of creating a somewhat confused and hysterical poem which has forfeited its balance and validity because of excessive personal involvement. Ball has always been more than usually caught up in the fabric of his creative works on an intensely individual plane, and it seems that in this poem he has gone too far. However, if the source of the poem's violent imagery is traced in more detail, a dimension and meaning of more general currency emerges, revealing the true place of the poem in Ball's development as a poet.

The intensity of "Der Henker" originates in the religious references which have been noted in general terms,[34] but which can, in fact, be demonstrated quite precisely. It can be a

dangerous game to seek biblical allusions in a poem like this, for the Bible is comprehensive enough to allow plausible isolated cross-references to suit most contexts to be discovered; and, given Ball's background in the Catholic faith, it is not surprising to find that "Dir sprang die Frucht aus dem Leibe/ sei gebenedeit" closely parallels "Blessed is the fruit of thy womb" (Luke 1:42). This is hardly a notable discovery. What is of much more interest, however, is the fact that Ball drew upon two specific sources in the Bible for much of the material in "Der Henker": The Song of Solomon, and The Revelation of Saint John.

In the case of the Old Testament text, Ball is parodying the original, particularly in the second stanza, where there is a sequence of metaphorical statements relating to parts of the body: "Dein Leib ist.../ dein Augen sind.../ dein Mund ist .../ deine Hand [ist]...." This is a direct reference to the technique of the biblical poet: "Thy neck is like... Thy two breasts are like..." (Solomon 4:4-5 and passim).[35] In the biblical text, considerable stress is placed on the purity of the beloved: apart from references to whiteness and fairness, there are direct apostrophizations of "my love, my dove, my undefiled" (Solomon 5:2) and again "my dove, my undefiled" (Solomon 6:9). In direct contrast, it is clear that in "Der Henker" the lady in question is anything but undefiled.

This concept of impurity relates to the substantial sequence of references to Revelation in the poem. The first two stanzas paraphrase Revelation 17:4: "And the woman was arrayed in purple and scarlet color, and decked with gold and precious stones and pearls, having a golden cup in her hand full of abominations and filthiness of her fornication." The woman is "Babylon the Great, the mother of harlots and abominations of the earth" (Revelation 17:5).

Ball compresses the rise and fall of Babylon into the next two stanzas with a large number of confused references to the appropriate chapters in Revelation. Thus, although his starting point is intensely personal, he succeeds in expressing his attitude toward women, his violent rejection of the Catholic church, his hatred of contemporary society, and even his faint hopes for the future in tolerably objective terms. The great whore of Babylon stands for the corruption of urbanized Western

civilization and its dubious morality. The progress of Babylon mirrors the direction in which that civilization is moving, and Ball takes that movement to its logical conclusion in self-destruction. It is crucial to Ball's concept of Western culture that it is not imperiled by any outside agency, but contains the seeds of its own destruction. Christian orthodoxy creates angels, and they, in turn, destroy Christendom, in the same way that Georg Heym's "Gott der Stadt" is created by the city and finally chokes it.[36]

In the last two lines of "Der Henker," a rather faint hope is expressed that a new world might emerge from the ruins of the old, but the tone is ironic, self-mocking, and the opening word of the couplet "da"—used for the fourth time in succession—provides a falsely optimistic conclusion to a sequence of increasingly unpleasant events:

> Da war keine Mutterknospe, kein Auge mehr blutunterlaufen
> und ohne Hoffen
> Jede Seele stand für die Kindheit und für das Wunder offen.

> (Then no maternal bud was there, no eye inflamed with
> blood and without hope
> Every soul was receptive to childhood and the miracle.)

Thus, this strange, violent poem reflects Ball, the man and poet, at a crucial stage of his moving toward Dada: it demonstrates the depth of his feelings and their almost overwhelming vehemence; reveals a growing distortion of language and imagery, which was soon to culminate in the rejection of language itself; and, in these two lines, displays for almost the last time a faint hope for the future, although this hope is couched in terms which could equally well be as parodistic as his borrowings from The Song of Solomon.

V Die Aktion *and the death of "Ha Hu Baley"*

Although *Die Revolution* was initially a success, the journal failed before the year was out; undaunted, Ball and Hans Leybold, who had been editor of the journal, joined forces and

turned to *Die Aktion*, where they found a new outlet for their poetry and a platform for their convictions.

Under the editorship of the enthusiastic radical Franz Pfemfert, *Die Aktion* became the most politically conscious of the leading Expressionist journals and reacted with particular violence to the carnage of World War I. Various issues contained "Verses from the Battlefield," and black-edged inserts announced the death in action of poets and contributors. One of the bitterest editorial comments was inspired by the death of Charles Péguy: "This apostle and teacher has fallen on the field of battle. We lament the death of this great man who was forced to bear arms against us. . . . Charles Péguy lived for humanity and died for the grotesque concept of national honor conceived by the very worst of his countrymen."[37] Ball had begun to contribute to *Die Aktion* well before the outbreak of the war, and his first offering, in July, 1913, also antedates his involvement with *Die Revolution*.[38] It consists of a poem entitled "Frühlingstänzerin," a conventional and somewhat ungainly piece, filled with Anacreontic clichés and self-conscious sexual overtones:

> Wenn deine tastenden Brüste den Atem der Gärten verspüren,
> Heben und senken sie sich, zugespitzt,
> In verworrenen Gedanken.

> (When your groping breasts sense the breath of the gardens,
> They rise and fall, pointed,
> In confused thoughts.)

Such is the delicacy of the soul of this springtime dancer (whose spirit the poet somewhat unseasonably compares to a robin) that it will strike its fluttering wings against the sides of its cage at a sudden word. This is poor stuff and falls short even of the modest standards of the average poem in *Die Aktion*. If there was such a thing as *Aktion* lyric poetry, this is not it.

Ball and Hans Leybold both contributed independently to *Die Aktion*; and when they collaborated on a poem, they assumed a pseudonym based on their names: "Ha Hu Baley." Their joint works do not represent an improvement on Ball's usual level of achievement: they are rebellious and unrestrained in

their imagery and sentiments, self-consciously brandishing terms like "Coitus" and "Sperma."[39] The poems 'strive anxiously for effect, as these two lines from "Der blaue Abend" demonstrate:

Ein Pferd macht müde sich's bequem in einem Vogelneste,
. .
Und schwarzer Violinklang tönt aus dem Asbeste.[40]

(Tired, a horse settles down in a bird's nest,
. .
And the black notes of the violin sound from the asbestos.)

The strange, nonsensical line, intended as one of the portents of impending doom, is followed by the common Expressionist device of synesthesia and a rhyme that Browning would have been proud of.

The blend of triviality and foreboding, so reminiscent of van Hoddis, is not sustained but is abandoned in the last verse, which culminates in a contrived vision of a kind of Jacob's ladder in reverse:

Es lehnen sich die Häuser blond zurücke.
Sind Türme weiße Engel, die entschweben.
Von Himmel stürzt zur Hölle eine Brücke,
Auf der die Toten händeringend kleben.

(Fair, the houses lean far back.
The towers are white angels, soaring away.
A bridge plummets down to hell from heaven,
On which the dead are fastened in despair.)

The extent and nature of the collaboration between Ball and Leybold is not clear; but it is probable that, if Leybold provided the revolutionary ardor, Ball was the creative member of the partnership. The Ha Hu Baley poems are virtually indistinguishable in style from the poems Ball wrote independently at this period; whereas Leybold is more contrived, starker and more intellectual,[41] Ball is prepared to indulge himself, to strive after effect. On occasion, a vivid visual image may ensue:

Eine Baumgruppe wird zum Schlangenbündel und
zischt in den Himmel.[42]

(A clump of trees is transformed into a knot of snakes
and hisses at the sky.)

But, by and large, the poetic expression is too unrestrained and self-indulgent to carry conviction. The cosmic aspirations ultimately amuse and embarrass rather than persuade:

Ich will
Eine neue Sonne schaffen. Ich will zwei gegeneinanderschlagen
Wie Zymbeln . . .[43]

(I wish to
Create a new sun. I wish to smite two against each other
Like cymbals . . .)

But it is not the poems in *Die Aktion* themselves that form the focal point of this period in Ball's creative life span, but rather the further impetus toward Dada given by his exposure to the *Aktion* group and his collaboration with Leybold, as a result of which Ball "was in every way encouraged in his Nietzschean tendencies of rebellion."[44]

The seal was set upon his revolt against contemporary society and his new-found hatred of war with the death of Hans Leybold, which was announced by a black-edged insert in *Die Aktion* at the end of September, 1914.[45] Ball's obituary notice in *Die weißen Blätter* expresses grief and anger but also reflects the crucial impact of Leybold's personality upon him, which was soon to lead him to Zurich, and the founding of the Club Voltaire and Dada itself.

VI *The Secret Alchemy of the Word*

In view of the path he had taken, it is not surprising that a radical artist like Ball plunged into an extreme form of Dada. His vehemence, his determination to conjure up the spirits of the inner world, surpassed that of all the other artists assembled in Zurich. They, too, challenged the same evils that

beset the world, but Ball went much further, for he was also seeking to exorcise the demons within himself.

Reference was made earlier to the performance by Ball of the "first" sound poem in the Cabaret Voltaire in the context of the colorful garb he had assumed and the erroneous impression it has given to some of those looking back at the event of a clownish, superficial figure doing little more than having a splendid practical joke at the expense of the citizens of Zurich.

Ball's description of this much-quoted event in *Die Flucht aus der Zeit* deserves more than mere requotation:[46] it merits close attention, not so much to the novel and sensational elements, nor to the curiosity value of this strange poetry—if it is, indeed, poetry—but rather to the real significance underlying their performance.

In the past, critics have tended to do little more than acknowledge the existence of these sound poems and pass rapidly on to the next subject. Heselhaus calls Ball a practitioner of the sound poem, quotes "Karawane" in full, and makes some brief comments on the content, including the rather dubious assertion that "the dull thud of the elephants' feet is imitated by 'u'-sounds."[47] Brinkmann also quotes the poem, but with even greater reticence.[48] And Steinke merely cites two of the sound poems in part without direct comment.[49] Thus, following critical precedent, the present study initiates its investigation of the sound poems by quoting part of "Karawane":

> jolifanto bambla o falli bambla
> großgiga m'pfa halba horem
> egiga goramen
> higo bloiko russula huju
> hollaka hollala
> anlogo bung
> blago bung blago bung
> bosso fataka
> ü üü ü . . .[50]

In his description of its first performance in the Cabaret Voltaire, Ball refers to this poem as "Elefantenkarawane";[51] and he repeats this statement in *Tenderenda,* where he calls it the "description of an elephant caravan from the universally notorious cycle

'gadji beri bimba.' "[52] Thus, he clearly intends that the poem should have some kind of representational base. It conveys the ponderous, swaying and noisome progress of a string of elephants, and words like "jolifanto" (elephant) and "russula" (*Rüssel* = trunk) give the general impression of the occasional moment of clarity in the midst of a general blur of movement and sound. The quadruple "ü" which comes at the middle of the poem seems to represent the point at which the procession is passing closest to the observer: the crescendo has reached its peak and has become so intense that the experience can no longer be broken up into its constituent parts for separate analysis. It is rather like the howl of positive feedback in a sound system. By the same token, the last three lines of the poem seem to depict the fading away of the caravan, ending with the final dying cadence of elephantine feet fading into the distance:

> tumba ba-umf
> kusa gauma
> ba--umf

An investigation into a phenomenon as unfamiliar and as far away from the traditional territory of the literary critic as this material is should be more broadly based, and a cursory glance at one poem is insufficient.

A convenient group for this purpose is formed by the six sound poems by Ball, all dating from 1916, reproduced in the collected poems edited by Annemarie Schütt-Hennings.[53]

In this collection, each poem has been given a title: "Wolken," "Katzen und Pfauen," "Totenklage," "Gadji beri bimba," "Karawane," and "Seepferdchen und Flugfische." With one exception, these are all meaningful: they relate to animate or inanimate objects, and only "Totenklage" suggests an intensely emotional situation. The other titles suggest an almost neutral, detached observation—with the exception, that is, of "Gadji beri bimba" which, at present, means very little.

The poems range from thirteen to thirty-two lines in length, and with the exception of "Totenklage" and "Karawane" they are divided into stanzas of varying length. They all consist of what might be described as "words," in the sense that, although

hardly a word of these poems is to be found in a dictionary (they could perhaps be described as "anlogo"),[54] they are all pronounceable, although some spellings indicate that it is a collection of grouped sounds that is being uttered, rather than lexical words: "ssubudu,"[55] "ögröööö,"[56] or "o-a-o-ü";[57] while other words pose problems of accentuation: "szagaglugi" or again "laulitalomini."[58] In half of the poems, single, isolated letters appear—as in the "Karawane" extract cited earlier—but these are very much in the minority. There is nothing in the layout of the poems to suggest that their appearance on the printed page is of central importance, although "Karawane" did appear in a version in which each line was set in a different decorative typeface.

When the creative artist breaks such radically new ground, the critic is left with hardly any point of reference. One possible approach is to scan these poems for resonances with other literary and nonliterary written sources. In "Wolken," for example, one line appears vaguely familiar: "elomen elomen lefitalominai"[59] is more than a little reminiscent of "Eli eli lama sabachthani" (Matt. 27:46), from the Last Words.

Another line of attack is provided by the fact that the two parallels with "real" words noted in "Karawane"—"jolifanto" and "russula"—are markedly different from "Elefant" and "Rüssel," and this considerable shift can tempt the critic into seeking correspondences and associations under every syllable. In "Wolken," the word "wolminuscaio" appears twice, and could be interpreted as a fusion of "Wolken" and "Zirrokumulus." In "Katzen und Pfauen" the penultimate stanza seems to be a combination of the name "Pfau" (peacock) and the "miau" of a cat:

> mâ mâ
> paiûpa
> mjâma

In the same poem we come across what appears to be a mock declension of "Pfau" (italics mine):

> siwi *faffa*
> sbugi *faffa*
> olofa *famamo*

In "Seepferdchen und Flugfische," two lines seem to combine splashing and trotting: "ballubasch/ zack hitti zopp." Onomatopoeic associations offer a particularly happy hunting ground in these poems.

Finally, and perhaps inevitably, the "Totenklage" contains both sepulchral references—in "szaga" (*Sarg* = coffin)—and half-recognizable lamentation: "o kla o auw"—which is, in part interjection, in part a mutilated form of "Klage" (complaint, lament).

This is a fascinating and open-ended study which might well lead the investigator far from the poems' original intentions— if there are any—into areas which are remote, to say the least. Apart from the most general associations, it is extremely difficult to distinguish between deliberate allusions on the part of the poet and resonances generated by the reader's inventiveness. "Creative reading," to coin a phrase, may in the case of these poems be part of, or at least not hostile to, the poet's intention; but Ball has given guidance to the reader by making it clear that he had no intention of producing a text consisting of words or word approximations which should encourage a traditional interpretative exercise. These are not experiments in literary cryptography and if some of the words in these poems resemble a known word in the context given by the title, that is enough. Ball is concerned with internal consistency, not with relating "meaning" within the poem to external experience at the lexical level. He is operating with "pure" sound, more or less, attempting to see how far it is possible for a poet to produce nonrepresentational sounds and yet remain positive in emotional effect. His aim is to go beyond the word, to take the word apart and use the fragments—"kla," for example—to arrive at a new synthesis. Ball is trying to arrive at what he calls the "secret alchemy of the word,"[60] and this involves breaking down the base metal of ordinary language with great rigor. The philosopher's stone he is striving for proves elusive, and the experiments he conducts turn out to be dangerous and almost fatal.

Of course, it would be wrong to consider these sound poems in absolute terms. To state that "meaning" is incidental to their true significance does not exclude the fact that, even here, there is a scale: "Totenklage" and "Karawane" are at one

extreme (the "normal" end), and "Gadji beri bimba" at the other.

But even the least abnormal of these poems does not readily lend itself to interpretation on any level. Other considerations apart, it must be recognized that only a fraction of the poems remains, in that they were designed for performance by their creator at a specific time and place in the past which are both irrevocably behind us. But there is sufficient evidence left in the written text for the underlying intention to be comprehended, in broad terms at least.

The first aspect of these poems to be noted is that they are not nonsensical, if nonsense is interpreted not in the colloquial connotation of that which does not fit within a received, conventional framework, but rather as complete randomness. There is very clearly a pattern and inner consistency in these poems, and there are considerable correspondences between one poem and the next as well. As the following lines from "Seepferdchen und Flugfische" demonstrate, the poems exhibit three principal formal features:

> treßli beßli nebogen leila
> flusch kata
> ballubasch
> zack hitti zopp
>
> .
>
> treßli beßli nebogen grügrü
> blaulala violabimini bisch
> violabimini bimini bimini
> fusch kata
> ballubasch
> zick hitti zopp

These are the first and last stanzas of the poem, illustrating the fact that Ball employs repetition, variation, and intensification, three interrelated elements which give the piece some kind of internal consistency.

The poem progresses in a kind of fugal pattern. Thus, the second stanza is a partial reversal of the first (corresponding line numbers in the first stanza are given in brackets:

zack hitti zopp [4]
hitti betzli betzli
prusch kata [2]
ballubasch [3]
fasch kitti bimm

The new material in lines two and five of this stanza derives
from the line or lines preceding: "hitti" appears in line one; the
next word "betzli," which is repeated, is a variant on "hitti" plus
"z" also taken from the preceding line. Similarly, the last line
of the second stanza derives from earlier lines.

The third and fourth stanzas of the poem contain variations of
"zack hitti" and "ballubasch" but still remain within the con-
textual limitations imposed by the initial stanzas. In the final
verse, the mutations of the original elements appear now to have
reached the limit of their development: the first line is an almost
exact repetition of the opening line of the poem, except that
"leila" is replaced by the more powerful plosives and front
vowels of "grügrü." One syllable cluster seems to have reached
a dead end: "hitti" and "bimm" have fused into "bimini," which
refuses to develop and further: "blaulala violabimini bisch/
violabimini bimini bimini"—this explains why these six poems
are relatively short, as are most poems of this nature. For if
control is to be maintained over the constitutents., there are
limitations in permutation and development which must be
observed, or the poem will lose its sense of direction in a maze
of confused sound. Comparative simplicity of outline and
discipline (a rather surprising word to find in a context like
this) in development are prime requirements for this kind
of poetry.

"Seepferdchen und Flugfische" ends with a variation on the
last three lines of the first stanza, which is more positive in its
longer vowels—"flusch" becomes "fusch" (presumably longer),
and "hitti" becomes "hiti"—and rounds off the poem on a note
of climax and finality:

fusch kata
ballubasch
zick hiti zopp

For Ball, these six poems are simply one further step in the direction of utter subjectivity. Now even language has been abandoned in a last, and almost desperate, attempt to conjure up the spirit of the inner world which will bring light and truth back into a world of confusion and blackness. Ball reaches back to the time when language barely existed and communication was effected by means of disconnected sounds which were, as it were, "ions" waiting to be fused into elements and, subseqently, compounds, in order to engender language as we now know it. Contemporary language has become inert; so Ball breaks it down in order to create new, vital and effective forms, which will genuinely communicate.

It is well known that the Dadaists, in their rejection of the Western tradition, became interested in primitive art, particularly in the rhythms and cultures of the African continent. The sound poems make reference to Africa not merely in the fact that they are rhythmical rather than metrical, but also in the use of words like "negramai,"[61] "m'balam" and "m'blama."[62]

Dadaist sound poetry is restless poetry. Despite the preponderance of descriptive titles and the apparent absence of verbal forms, these are poems of violent activity and unceasing search. One thing is played off against another—cats against peacocks, for example, in the titles, and one group of words or syllables against another in the texts. The exploration, however, does not rest on a firm base, but takes place in a world of constant change which offers no security.

There is no doubt that Ball was deeply committed to these poems and totally involved in their creation and performance. This is not only to be seen in the fact that his own name appears, in disguise—"higo" in "Karawane," "ra*llab*ataio" in "Wolken," and in "Seepferdchen und Flugfische" "*ball*ubasch" and "bi*llab*i"—but also in the costume he wore when performing them, and in the underlying purpose of the performance. Ball was dressed as a priest: in *Flucht aus der Zeit,* he refers to his "clerical lamentation,"[63] and in *Tenderenda* records that this bishop's costume is "revered to this day as a fetish by the gentle inhabitants of Hawaii."[64]

Once more the religious is parodied in Ball's lyrical work, as it was in "Der Henker," but here the purpose is not primarily

negative. Ball is reversing the role of the priest who seeks, by the use of certain ritual formulas, to invoke supernatural powers in a different dimension from the earthly plane; but, in doing so, he is affirming, not denying, the validity and power of an ordained functionary with respect to powers beyond human control and understanding. In his eccelesiastical cardboard, Ball is turning to the immeasurable forces within the self, seeking to exploit the patterned sounds of the poems with their half-heard associations in an attempt to bring out the mysteries of the true subconscious self that lurks within. The first of the poems, "Wolken," contains a veiled abracadabra in the word "cerobadadrada," but the incantatory nature of these poems—with the partial exception of "Gadji beri bimba," which will be discussed shortly —goes beyond allusions to such magic words. Elements such as the three primary constituents of repetition, variation, and intensification within a ritual context closely parallel the canticles of responses, prayer structure, and other aspects of the act of religious worship.

Ball, however, does not seem to achieve the breakthrough he is so energetically seeking. He is playing with forces beyond his control, and his fate is much like that of the sorcerer's apprentice; but unlike the apprentice he has no master magician to restore order for him.

Most of the six poems are controlled and circumscribed: "Karawane" presents a sound picture of the approach and passing of a string of elephants, that is, the poem rises to a climax and then dies away; and "Totenklage" is a fairly subdued, long-drawn-out cry of grief which ends with a despairing note of finality: "a—o—auma." But one poem, "Gadji beri bimba," neither has the contextual prop of a "normal" title which predetermines, to some extent at least, the range of association within the text, nor does it stay, as it were, within its own bounds.

The poem consists of three "stanzas," or sections, of diminishing length: the first is seven lines long, and, although the other two stanzas are both five lines in length, the lines in the last one consist of a steadily decreasing number of words, terminating in a two-word final line.

The sense of uncertainty engendered by these strange words is heightened by the lack of meaningful context. Each word

tends to loom very large, especially if it bears some resemblance to a familiar word. Thus, the poem appears to lurch along from one distorting mirror to the next. The effect is both powerful and disturbing, even in a private reading. How much more substantial the impact must have been in the Cabaret Voltaire. The performance of these poems was a very strenuous affair and drained Ball's energies. "The cabaret needs a rest. Daily appearances with this kind of tension are not only tiring, but utterly exhausting. In the middle of all the excitement I started to tremble all over. I simply could not take any more, so I left everything as it was and fled."[65] This kind of self-destructive passion is engendered by the structure of this deliberately experimental poem. It is experimental in the sense that it represents an opportunity for the performer to embark on a search, to "see what happens next" when the depths of the inner world are stirred, and Behemoth awakes.

The stress patterns of "Gadji beri bimba" cannot be ascertained with absolute certainty: Ball, in his account of the poem's performance, states that he began "slowly and solemnly," that there was an ever increasing tension and accentuation of the sounds until, finally, he fell into the singsong voice of the Catholic priest so familiar to him from his earlier days.[66] This is not particularly helpful information, but what does emerge is the importance of the rhythmical pattern of the words. The basic shape of the poem depends on an alternating sequence of stressed and unstressed syllables, that is, on a kind of trochaic form, which develops through a series of dactyls (presumably) and culminates in a single short stressed syllable.

The principal starting point for these rhythmical progressions is the disyllable "gadji" which combines with "beri" to generate a sequence of sound combinations with unpredictable results:

> gadji beri bimba glandridi laula lonni cadori
> gadjama gramma berida bimbala glandri galassassa
> laulitalomini . . .

It is this open-ended approach which renders the poem unique among Ball's six sound poems.

Ball also intersperses other material in an attempt to enrich and vary the patterns and their resonances. There are animal references in "rhinozerossola," "elifantolim" (and "tromata"), and "zimbrabim"; one line is devoted to variations on the place name "zanzibar"; and the African atmosphere of the poem is further heightened by "negramai" and a variety of words which sound like echoes of some tribal tongue: "zimzim urullala zimzim" or again "tuffm im zibrabim." There is even what appears to be a Futurist reference in "velo da bang bang," and, although adulation of the machine might, at first sight, seem inappropriate in the context of the Cabaret Voltaire, Ball is here exploiting the rhythmical throbbing of the engine as a parallel to the Negro rhythms he is summoning throughout the poem. For him the end justified the poetic means. The rhythmical pattern is intensified by the predominance of plosives and fricatives and the absence of sequences of gentle sounds.

The inserted material does not succeed in adding a new dimension. In the last stanza Ball returns to the original formula, but even this proves to have exhausted its possibilities for fruitful development. No new variations and patterns emerge, and the basic constituents "gadji" and "beri" grind to a repetitive halt in a final line which, with its overtones of baby talk, indicates both an intensifying rhythmical monotony, which could culminate in insanity, and also the bankruptcy of Ball's endeavors to exploit his subjectivity on positive ends:

> gaga di bumbalo bumbalo gadjamen
> gaga di bling blong
> gaga blung

Taken together, the six poems show the outer limits of Ball's poetic experimentation, the culminating point of a movement which had begun with "Der Henker" and shifted consistently away from the verbal to the formal, and from the subjective to the incantatory. The greater the degree of experimentation, the more serious Ball himself became and the more he exposed himself to grave risks to his own mental equilibrium. But this cycle should not merely be regarded as a lesson and a warning to others, for the poems are, first and

foremost, the products of a creative mind, not material for a psychological case history. Ball may have been experiencing "a violent shock by trying to seize the magical contents of his unconscious,"[67] but to consider the sound poems purely in terms of Ball's state of mind is to overlook their intrinsic merit and the light they cast on the sound poem as a genre.

But it should not be thought that the sound poems exhaust Ball's ventures into creative Dada poetry. He was too much of an instinctive poet and polished craftsman to be content for long with expressing his powerful convictions in one, limited way. Indeed, Ball also produced "Sieben schizophrene Sonette" and *Tenderenda* in the Dadaist vein.

The schizophrenic sonnets[68] represent another excursion by Ball into the sonnet form, and, as in the case of "Das ist die Zeit" discussed earlier, he once more makes deliberate use of the sonnet, not as part of an homogenous aesthetic entity, but rather contrastively. He is seeking refuge in a traditional formal framework, for it is only from a secure vantage point like this that he felt himself able to give unrestricted expression to his sentiments. In five out of the six sound poems, similiar considerations obtain.

Ball regards himself as a split personality, divided against himself.

> Ein Opfer der Zerstückung, ganz besessen
> Bin ich—wie nennt ihr's doch?—ein Schizophrene.
>
> (A victim of fragmentation, utterly obsessed
> I am a—what do you call it now?—schizophrenic.)

Of these seven poems, which take as their principal theme the alienation of the conscious mind either from the rest of the self or from the world beyond the self, the most important is "Der Dorfdadaist," which shares with the last poem in the cycle entitled—somewhat inappropriately—"Intermezzo" the distinction of not being a sonnet at all; for the latter consists of three six-line stanzas, "Der Dorfdadaist" of four quatrains. The village Dadaist—the name contains more than an echo of Morgenstern's village schoolmaster—is described as awakening

from hibernation to an Anacreontic springtime (a typical touch of ornamentation by Ball):

> Nun sich der Frühling wieder eingestellt
> Und Frau Natura kräftig promenierte . . .
>
> (Since Spring has now appeared once more
> And Mother Nature stalks abroad . . .)

Here again the notion of death and rebirth of the "new man" is parodied in the changing seasons. The reborn Dadaist fashions himself a lute, a makeshift instrument to which he sings a discordant lay:

> Er brüllt und johlt, als hinge er am Spieße.
> Er schwenkt jucheiend seinen Brautzylinder.
> Als Schellenkönig tanzt er auf der Wiese
> Zum Purzelbaum der Narren und der Kinder.
>
> (As if on the rack he roars and yells
> Rejoicing he swings his wedding topper
> Dances in the meadow with cap and bells
> For fool and child to somersault over.)

The parody of a sequence of events, where an individual engages himself in activities which are either inherently meaningless or distortions of normality, is a characteristic form for Dada which Arp uses to very good effect, particularly in the "Schneethlehem" poems.[69] In both "Der Dorfdadaist" and the Arp poems a strict rhyme scheme frames the strange antics; and the individuals concerned enact their absurdities with deep seriousness and a sense of purpose.

The meaninglessness and ineffectuality of the village Dadaist's actions within a stable poetic context should not, of course, be interpreted as madness in the midst of sanity, but as the inevitable consequence of a total environment which, on the surface, appears to make sense but which reveals itself as insane because of its refusal to recognize anything but the material and quantifiable.

Ball's subjectivity does not prevent him from directing his attention here to the world outside, where urban, civilized man continues to act as if he were still in contact with the natural world and part of the continuum of creation, and is totally unaware that his very state of "civilization" has alienated him and rendered him a comic figure in cap and bells.

The undertone of despair remains, at its most poignant, in "Der grüne König," where King Johann Amadeus Adelgreif tries in vain to exploit the riches of the natural world and turn them to the advantage of civilization. The sense of an irretrievably lost world—all the more powerful because the king is oblivious of the fact that it is lost—is neatly expressed in these three lines, which also convey, in objectivized terms, Ball's attempts to find new meaning within the self:

> Man sammle alle Blätter unserer Wälder
> Und stanze Gold daraus, soviel man mag.
> Das ausgedehnte Land braucht neue Gelder.

> (Gather up all the leaves from our woods
> And mint as much gold from them as you may.
> Our widespread lands need new coin.)

VII Tenderenda

The Verlag der Arche is an enterprising Swiss publishing house which, under Peter Schifferli, has been a staunch champion of the Dadaist cause. As it numbers Schwitters, Arp, and Huelsenbeck among its authors, it is not surprising that some of its productions have been somewhat bizarre and aimed at a restricted clientele. One of the oddest books to have appeared under the Arche imprint must surely be Ball's "novel," *Tenderenda der Phantast,* written between 1914 and 1920 but not published until 1967, forty years after the death of its author.

The oddity of the work can be attributed to a variety of causes, not the least of which is the fact that it is designated as a novel. During the period of its composition, Ball moved further away from traditional forms and notions of creative art until he arrived at a point at which the conventional novel had apparently ceased to be a viable form for him. Plot,

character, development: elements such as these are not to be sought in the pages of *Tenderenda,* which consists of three parts divided into a total of fifteen chapters or sections. There is no continuous narrative thread linking one section with the next, and frequently there is a distinct lack of internal consistency within an individual section. The work represents a curious mixture of prose and verse, the total effect of which on the unsuspecting reader must be little short of total bafflement. The question that might legitimately be asked is not whether *Tenderenda* is a novel, but whether it can properly be called a single unified work of art at all.

Each section of *Tenderenda* opens with a short paragraph, set apart from the body of the text, which serves both to deprive the subsequent material of any kind of tension for the reader— the implication is that, as the world is hurtling toward inevitable destruction, no kind of purposeful progression is possible any longer—and also to add yet another level to a text with a complex set of interrelationships between its many shifting points of reference.

At the commencement of the book, a parodistic John the Baptist figure announces the advent of a new God. The very next section depicts the flight of creative artists from the new deity. The time is given as the summer of 1914, and the section concludes with a paragraph of mock signs and portents:

Die Hündin Rosalie lag schwer in den Wochen. Fünf junge Polizeihunde erblickten das Licht der Welt. Auch fing man um diese Zeit in einem Spreekanal zu Berlin einen chinesischen Kraken. Das Tier wurde auf die Polizeiwache gebracht.[70]

(Rosalie the dog was near her time. Five young police dogs were born. At this time, too, a Chinese kraken was caught in a canal of the river Spree in Berlin. The animal was taken to the police station.)

"Machetanz," the dancer of death as it were, comes to a tragic end in the next section because he has not taken "a spiritual stand." The outbreak of war is described in terms of a mad dance; and in "The Red Skies," the first section taking the form of a poem, the progress of the war is reflected in a

childlike folk-song manner; but beneath the naïve exterior can be glimpsed the real horrors taking place:

> Die roten Himmel, mimul mamei,
> Gehen im Magenkrampf mitten entzwei.
> Die roten Himmel fallen in den See,
> Mimulli mamei, und haben Magensweh.[71]

> (The red heavens, mimul mamei,
> By stomach cramp are cleft in twain.
> The red heavens fall into the lake,
> Mimulli mamei, and suffer stomach pain.

The opening paragraph describes the poem as a "landscape picture of upper inferno."

The great urban sprawl of Western civilization now becomes a city of hell: "Satanopolis" is the title of the next section, in which Tenderenda himself appears as the narrator who, in his account, "presumes a knowledge of the characters and the setting, and a familiarity with the appurtenances of the nether world." What he is relating is the trial and subsequent conviction of a journalist: these events are related in a curious blend of satire and grotesque fantasy with strong overtones of the trial of Christ:

"Gib ihn heraus. Er hat Gott und den Teufel gelästert. Er ist ein Journalist. Er hat unser Mondhaus befleckt und sich ein Nest gebaut auf dem Sonnenschirm einer Dame." . . . "Was habe ich euch getan, daß ihr mich also verfolget? Siehe, ich bin der König der Juden." Da brach ein unbändiges Gelächter aus. . . . Und der Herr aus dem Publikum schrie: "Ans Kreuz mit ihm, ans Kreuz mit ihm!"[72]

("Deliver him up to us. He has vilified God and the devil. He is a journalist. He has besmirched our moon house and built himself a nest upon a lady's parasol." . . . "What have I done unto you that you pursue me thus? See, I am the King of the Jews." And they burst out in unrestrained laughter. . . . And the gentleman from the throng cried out: "Crucify him, crucify him!")

Here, as in much of the book, the text is operating simultaneously on several different planes: on one level, there are strong

references to the New Testament description of the trial of Christ; on another, there is a fantasy being worked out of the individual artist who is exposed to a hostile world; and on a third level, which, in many respects, contradicts the two others, the defendent is seen as a pen-pushing journalist who is not one of the favored few working for *Die Aktion* (which is mentioned by name in this section).

The second part of *Tenderenda* opens with another birth, this time in the "Grand Hotel Metaphysics"; and in this building "constructed of rubber and porous"[73] young master Foetus makes positively his first appearance at the end of a grotesque sequence resembling an insane cabaret performance. Among those present, for example, is an individual by the name of Toto, "who possessed this name, but nothing else besides."[74] The introductory paragraph indicates that the section should be construed in terms of the birth of Dada, an event of world-shattering importance, far greater than any contemporary political or military happenings:

Über keine Rede der Herren Clemenceau und Lloyd George, über keinen Büchsenschuß Ludendorffs regte man sich so auf wie über das schwenkende Häuflein dadaistischer Wanderpropheten, die die Kindlichkeit auf ihre Weise verkündeten.[75]

(No speech by Messrs Clemenceau and Lloyd George, no shot fired by Ludendorff caused so much excitement as the frail little band of Dadaist wandering prophets who in their own way announced the coming of a childlike age.)

The next section, "Bulbo's Prayer and the Roasted Poet," marks an intensification of the horror that now stalks the world, and "the greater the horror gets, the louder the laughter becomes."[76]

Part II of *Tenderenda* closes with two "hymns," incantatory prose poems, the first in the form of a prayer or psalm (although the content is hardly prayerful), the second a "parody of the Litany,"[77] in which the good Lord is being asked by the supplicant to deliver him from all manner of strange afflictions.

The final part of the book opens with a kind of funeral service to end all funeral services. The last men on earth are

being interred by the "conductor of putrefaction."[78] The section that follows reproduces "Karawane," one of the six sound poems we have studied; and the emphasis is then placed on the figure of Tenderenda. First a hymn is reproduced which he recites; this is followed by a long fantastical tirade by Tenderenda; and finally "Katzen und Pfauen," again from the sound poems, is reproduced, since these two animals are "Tenderenda's mystic beasts."[79] The work concludes with the "astral fairy tale" of Mr. and Mrs. Goldkopf, coupled with the ballad of Koko, the green god.

Thus, the three parts of this extraordinary work chart a downward progression to ultimate destruction. The choice of a journalist in "journalistic" situations reflects Ball's intense revulsion against any approach to the weighty issues of contemporary life which contents itself with the surface appearance of things. Ball records that before he recited his sound poems in Zurich, he read out "a few programmatic words," in the course of which he stated that "in this kind of sound poem language, corrupted and rendered unusable by journalism, has not been employed. I retreat into the secret alchemy of the word. . . . There is no attempt to create poetry at second hand, that is, to take over words (not to speak of sentences) which have not been newly invented for one's own use."[80] Ball is concerned with fundamentals: the journalist (a metaphor for a far wider section of the community, perhaps even mankind at large) not only fails to decode the mysteries of life, but actually destroys language, the means of decoding, by maltreating it, by exploiting the superficial exterior without reference back to ultimate meanings until all contact with them is lost. While this closing of doors is taking place, the holocaust itself draws inexorably nearer.

Like all of Ball's work, *Tenderenda*—as his observations in *Die Flucht aus der Zeit* make clear—owes its origin to a profound sense of commitment, a close identity with theme and character. Ball lived and suffered with *Tenderenda*, sublimating his own emotional states into the texture of the novel, experiencing the relief of a man recovered from a grievous illness when the work was finally completed. On July 15, 1920, he recorded: "Today I have completed my 'fantastical novel.'

It is to be called *Tenderenda*. . . . Time and again over the past seven years I have played away these words and sentences between doubts and torments. Now the little book is completed, and this is a great relief to me."[81] *Tenderenda* depicts the inner biography of Ball in his Dadaist years; and it is significant that this intensely subjective personal confession was not published in his lifetime, in contrast to *Flametti,* a novel which, in spite of considerable differences, contains an almost identical theme couched in a more controlled and conventional narrative framework.

VIII Flametti: *The Dandy's Decline*

It is something of a relief to turn from a work like *Tenderenda* to *Flametti,* and not simply because the latter is a novel with a clear plot, straightforward narrative, and little in the way of gratuitous excesses. What violence and grotesqueness may be present form an integral part of the situations and emerge directly from the action. *Flametti* is attractive also in that it demonstrates Ball's considerable technical abilities, his versatility in seeking out an appropriate form in which to express himself, and his courage in adopting a traditional narrative pattern and style despite the apparent negation of the novel which *Tenderenda* represented.

Flametti is a modern picaro whose existence ceases to be charmed in the course of the novel. He is the leader, founder and chief performer of Flametti's variety troupe, a small band of artists who entertain in cafés and bars. It is hardly necessary to record that one of these bars is called the "Holländerstübli" in order to recognize that Ball is drawing directly on his own experiences in Zurich. He wrote *Flametti* after his departure from the Dadaist scene there.

The novel was published in 1918 and bears a dedication to Emmy Hennings. Its full title runs: *Flametti oder vom Dandysmus der Armen* (Flametti or the Dandyism of the Poor). It charts the decline and fall of Flametti's troupe, the self-destructive passions of an hermetic group of people unable to relate to any external scale of values. The moment of success on stage, the adulation of the audience, offer the only possibility

of fufillment; but this is a hollow, fleeting sensation, paid for heavily in the disputes and sufferings caused by life in a kind of spiritual and social no-man's-land.

At the beginning of the novel, Flametti's ingenuity is being taxed to the limit, as the financial situation of his troupe is precarious in the extreme. He has sufficient money to pay their wages, but little else. Even to achieve this modest objective, he is reduced to river fishing in order to supplement his funds, as was Ball himself in his early Zurich days. He is also faced with a fine and costs totaling 180 francs for adultery ("eine Konkubinatsstrafe von hundertachtzig Franken");[82] he had cohabited with Jenny, now his second wife, before the divorce from his first wife had been legalized.

Flametti seeks another means of supplementing his income by acting as an agent for Ali Mechmed Bei. His plan is to sell on commission some of the opium Mechmed wishes to dispose of to Jenny's dentist. If the scheme had been successful, he would have employed some of the money to emigrate to Brazil and live the life of a rancher. It does not matter that Flametti has not yet informed the dentist that he is about to become the recipient of this illicit merchandise; for Mechmed refuses to countenance the deal. Flametti then embarks on an enterprise much more within his own normal sphere of action, and one which proves more successful, in the short term at least: he seeks an engagement at the highly regarded Krokodil bar, with the understanding that Rotter, a locally celebrated poet-performer, provide material for the act. The first night of the new show, for which Rotter composes a Red Indian tableau routine, is an outstanding triumph, but the troupe tears itself apart with internal conflicts, and the narrative terminates with Flametti coming to grief in a tangle of debt and legal troubles.

The narrative technique employed by Ball is relatively straightforward: the events are described in simple chronological progression, and there is only one thread of action. The text is dotted with general statements of an explicatory nature, but the tale is largely left to unfold naturally. Occasionally an interlude intrudes which seems to exist as a vignette in its own right, with little direct reference to the rest of the action. The sole complication is the alternation between inner and outer

events, as illustrated here at the point when Flametti comes across Mechmed:

Als er eben gehen wollte, öffnete sich die Tür und herein trat Mechmed.... Ali Mechmed Bei: schon der Name faszinierte Flametti. Eunuchen, Sklaven und Harem wirbelten vor seinen aufleuchtenden Augen, wenn er in heimlichen Stunden den Namen vor sich hinsprach.[83]

(Just as he was about to leave, the door opened and in came Mechmed.... Ali Mechmed Bei: the very name fascinated him. Eunuchs, slaves, and the harem flashed before his gleaming eyes, whenever he uttered the name to himself in moments of privacy.)

The reader is permitted to experience Flametti's reactions to events as well as the events themselves. The technique is simple and familiar but strikingly applied. It should be noted, however, that there is not the least sign of *avant-garde,* let alone Dadaist, techniques. Ball is obviously concerned with the personality of his central figure and his environment, and is too involved with this interrelationship to permit himself the luxury of formal experimentation. In *Flametti,* Ball is depicting Dada at one remove: he is observing Flametti the Dadaist, and not directly participating in the bohemian world.

The setting of the book—both human and geographical—forms an integral part of Flametti's existence. The hero is not an independent spirit capable of living on any terms in any locality. The Fuchsweide district where he lives is a source of spiritual nourishment as well as of material income. Just to walk down its streets gives him a sense of well-being and security; but the security is that of the unstable and immature, a cocoon protecting him from new experience, rather than a springboard for widening his perspectives. But even that security is illusory; it is a world torn in two, where the business conducted and the lives led in the daylight hours are in the starkest contrast to what happens after a romantic dusk settles upon the scene. One incident, which has the ring of a remembered episode in Ball's own past, interrupts the action and serves to underline this dichotomy between night and day. A vehicle breaks down and a crowd gathers. Flametti stops and observes the scene.

"Panne?" fragte er den Chauffeur.

"Panne," erwiderte dieser, eifrig beschäftigt.

Der Schaden war rasch repariert. Die Kinder des Autobesitzers stiegen auf. Der Chauffeur ebenfalls. Einige grunzende Laute der Hupe und der Kraftwagen setzte sich unter dem lauten Johlen der schmutzigen Kinderschar, die sich aus allen Löchern und Winkeln eingefunden hatte, in Bewegung. Die Kinder des Besitzers spuckten dabei von ihrem Sitz aus in weitem Bogen und mit aller Anstrengung auf die Proletarierkinder, die sich hinten angehängt hatten und sich mit geknickten Beinen, trompetend, nachschleppen liessen. Ein Auto in der Fuchsweide, so früh am Abend, war ein Ereignis.[84]

("Breakdown?" he asked the driver.

"Breakdown," replied the latter, busily occupied.

The damage was soon repaired. The owner's children clambered on board. So too did the driver. A few grunts from the horn and the vehicle set itself in motion to the raucous cries of the dirty mob of children which had materialized from every nook and cranny. The owner's children spat from where they were sitting in a wide arc and with all their might at the children of the working class who had hung on behind on their haunches and, bellowing out loud, were letting themselves be dragged along behind. A car in the Fuchsweide, so early in the evening, was an event.)

The unexpected presence of a car at this time of day highlights the strangeness of this double world. The car is like a stranded whale, bereft of its power, glamour, and elegance as part of the magic of nightclub and cabaret. At night, too, the harsh facts of social privilege on the one hand and deprivation on the other tend to be forgotten in the search for pleasure, company, and sensual gratification.

And in no one is this unreal night world more apparent than in Flametti, whose theatrical trade is that of a magician, and who regards himself as something of a dandy:

Hier war was geboten! Hier kam man auf seine Rechnung! Und was ein richtiger Dandy war, der von der Welt etwas verstand, entschloß sich überhaupt nicht, hineinzugehen, sondern die Sache mehr platonisch zu genießen, als Schauspiel gewissermaßen, von außen, als Zusammenklang, mit der überlegenen Intelligenz dessen, den die Realität nur als Widerspruch nicht mehr enttäuschen kann.[85]

(Here there was something worth seeing! Here you got your money's worth! And anyone who was a proper dandy, who knew about the ways of the world, made up his mind not to enter, but to enjoy things more platonically, rather like a drama, from the outside, as an inter- play of harmonies, with the superior intelligence of one who can no longer be satisfied except by the contradictions of reality.)

But Flametti's world is far from that of a person who really knows "about the ways of the world"; he inhabits a twilight realm of make-believe generated by the nightclub and its intoxi- cating atmosphere (in both senses of the word). This is why his quest for money outside the context of his cabaret act does not meet with success, even though his endeavors as an amateur drug peddler would have been spiced with danger. For Flametti, life begins only when dusk falls, when the lights of the bars begin to come on and the evening customers appear:

Und die Fuchsweide dämmerte. Bucklig und winkelig sank sie mit ihren Halbhundert Gassen verschmutzt und im Rauch ihrer Herdfeuer grau in den Abend.

Die Giebel zerschnitten sich hoch in der Luft.

Die Häuser barsten von Feuer und Licht. Die Gasglühlichter und Bogenlampen leuchteten auf. Die Metzgereien und Magazine und Handwerksstätten glühten wie Einkaufsbuden des Teufels.

Man legte die Arbeitsschürzen jetzt ab in den Kellern. Im Hinter- haus, in den Stuben und Giebeln frisierte man sich und machte Toilette.

Los gingen die Grammophone, Orchestrione und das Elektro- klavier. Auftauchten verwegne Gestalten beiderlei Geschlechts vor beleuchteten Spiegeln, unter dem Haustor und auf der Straße.

Auf ging der Mond und in den Konzertlokalen tummelten freund- liche Sängerinnen und früheste Zauberer bereits ihre Stimmen.[86]

(And dust settled upon the Fuchsweide. Bowed and angular it sank grubbily into the evening in the smoke of its hearth fires with its two score or so little back streets.

The roof ends stood out sharply high in the air.

The houses burst with fire and light. The gaslights and arc lamps were lit. The butcher's shops and the stores and workshops glowed like satanic market stalls.

Work-aprons were put down in the cellars. At the back of the shop, in little rooms and garrets people were preening and washing themselves.

The gramophones, orchestrions, and pianolas came to life. Saucy figures of both sexes appeared before illuminated mirrors, at front gates and on the streets.

The moon rose and in the cabaret bars friendly songstresses and the first magicians were already going through their paces.)

This remarkable passage stands out from the rest of the text; its intensity of expression and rhythmical power give it many of the attributes of the sound poem; and the sense of excitement and increasing tension is conveyed with great skill and fervor. There is more than a little poignancy about these lines, in that the coming fulfillment which they promise is both elusive and, essentially, illusory. Ball may be *avant-garde*, but here again he forcibly demonstrates that the *avant-garde* and literary craftsmanship are not mutually exclusive propositions. And although this novel has none of the external stylistic characteristics of Dada, it is nonetheless an important contemporary document of the movement, and one to which virtually no attention has been paid. Ball shows great versatility in choosing the only appropriate tools for the task which lies before him; namely that of describing the rise and fall of an archnihilist and permitting the reader to experience the sensations generated by indulgence in the stimulation of open-ended sensuality for its own sake. Clearly, *Flametti* is very much an autobiographical work, growing out of the self-destructive emotion which ultimately compelled Ball to quit Zurich for the sake of his own sanity. Piling excess upon excess brings no satisfaction, but merely heightens discontent.

The centerpiece of *Flametti* is the depiction of one such evening, the first performance of the Red Indian routine in the Krokodil bar. The evocative description of nightfall in the Fuchsweide quoted above prefaces the performance and establishes the atmosphere of excitement and anticipation; and in the succeeding pages tension is steadily built up. The orchestra in the bar itself plays on, louder and louder; and Ball's description of the notes of the trombone as "Ptuhh dada dada da, umba, umba" stresses the intensifying and violent primitive rhythm underlying his own incantatory brand of Dada performance, as seen in the case of the sound poems. The primitive element is reflected by the fact that the routine they are about to perform is a Red

Indian one, in which Flametti himself plays the role of Chief Feuerschein (Fireglow). Now the sound of the orchestra rises to a climax:

Das Lokal war jetzt überfüllt. Wenn das Orchester spielte, verstand man sein eigenes Wort nicht mehr.[87]

(The bar was now filled to overflowing. And when the orchestra played it was impossible to hear yourself speak.)

As the time for the performance approaches, Flametti is informed that his wife is taking money from their receipts and handing it over to her lover, the pianist Meyer; thus, against a background of a private life falling about his ears, the night comes to its deafening climax. The Indians on stage sing their song, the final verse of which takes on the character of a challenge to the civilized world, a violent threat:

> Und dort oben in dem ew'gen Jagdgebiet
> Singt der Indianer Volk sein Siegeslied.
> Einmal wieder ziehn wir noch auf Kriegespfad,
> Einmal noch, wenn der Tag der Rache naht.[88]

> (And up there in the happy hunting ground
> The Indian people sing their song of victory.
> Once more we embark on the warpath
> Once more when dawns the vengeance day.)

Once more the elemental forces of nature, now killed by civilization, will rise up again from the dead and reassert themselves in an orgy of destruction.

At the end of the novel, after the "Indianer" has been performed for the last time, Flametti goes off to Berne (appropriately enough, taking the night train). The others read of his fate before the law which spells the end of his variety troupe and the end of all his aspirations.

Perhaps it would not be too much of an exaggeration to regard *Flametti* as Ball's *Werther*. In the novel, Ball goes over the ground he himself covered in Zurich, demonstrating to himself the emptiness of his own nihilistic strain of Dada and the

serious threat it posed to his own sanity. Flametti is destroyed by the very forces he claimed to have defeated; and the lesson for Ball is clear.

Flametti marks the end of Ball's Dadaist activities; and it has one significant feature in common with his first published work, *Die Nase des Michelangelo,*[89] a rather indifferent heavy-footed verse drama, a moral outburst against the brutal facts of reality. Both works contain a strong autobiographical element; but whereas *Flametti* is retrospective, *Die Nase des Michelangelo* is, in some degree, prophetic, for the character of Torrigiano and his manifold suffering state in general terms the path Ball was to take in the course of the next decade, culminating in his Flametti-like decline and his subsequent recovery of faith.

IX Flight from the Age

The end of Ball's creative span did not signify a parallel cessation of his activities as a writer. After *Flametti,* he composed two religious and political works: *Byzantinisches Christentum*[90] and *Zur Kritik der deutschen Intelligenz,*[91] the latter subsequently expanded and retitled *Die Folgen der Reformation.*[92] Ball also edited his diaries under the title *Die Flucht aus der Zeit* and wrote the much-praised study of Hermann Hesse.

It is difficult to believe that *Byzantinisches Christentum* is by the same hand which composed *Tenderenda* and the Zurich sound poems. But despite the change of direction, there is a continuous line of development from the one to the other, and a remarkably similar set of preoccupations underlying the apparently vastly different works.

Throughout his life, Ball was preoccupied with religion and religious experience; in *Die Flucht aus der Zeit* he affirms that the boundaries between creative art and religion are fluid: "The liturgy is a poem celebrated by priests. The poem is transcribed reality. The liturgy is transcribed poetry. The mass is transcribed tragedy."[93] And the Zurich sound poems were a kind of intoxicant aimed at permitting Ball, the poet celebrant, to rise to a state of mystical ecstasy and fulfillment. His quest for the religious experience carries over to *Byzantinisches Christentum,* a

book which is concerned with the lives and beliefs of three early saints: John Climacus, Dionysius the Areopagite, and Simeon Stylites. This saintly trio was not chosen at random: each was an ascetic of a particularly severe kind. John wrote *The Heavenly Ladder*, a depiction of the ascetic life in terms of a ladder which the monk has to ascend rung by rung. Each rung represents some virtue or quality to be attained or some vice to be discarded. There are thirty rungs, representing the thirty years of Christ's life before he embarked on his public ministry; and, throughout, the monk is assailed by devils seeking to dislodge him. Dionysius is equally concerned with the upward progress of the soul, but his approach is more negative than John's, and implies even sterner negation of the self: Dionysius's approach is one of removing the human characteristics—the senses, thoughts, powers of reasoning—until the naked soul emerges. If John and Dionysius were theoretical, Simeon was severely practical. He spent his days perched on a column, where his miracles and his ascetic life attracted many pilgrims, to whom he preached. He was also responsible for many conversions. But significantly, he also built even taller columns in order to be able to escape the attentions of the faithful and to devote his life more fully to prayer and meditation.

Ball was attracted to these saints because of their "isolationism," the intensity of their commitment, their extremism, and their rigorously mystical aspirations. As Steinke says, "these lives seem to point to three possible paths to achieving direct union with God,"[94] and Emmy Ball-Hennings's book on Ball does indeed bear the title *Hugo Balls Weg zu Gott* (Hugo Ball's Path to God).[95] But the lives of these three saints also point to *Die Flucht aus der Zeit*, a flight from life, that is, a negative as much as a positive stance.

It was in *Zur Kritik der deutschen Intelligenz* and in *Die Folgen der Reformation* that Ball fully articulated the reasons underlying his flight. He embarks on a scathing attack on the German intellectual, political, and religious heritage. He begins with the impossible monk, Luther, who transferred the weight of spiritual responsibility to the individual. Moving on through time, Ball nods approvingly in the direction of the Romantics, and disapprovingly toward Heine (some of whose qualities he

nonetheless admires). Romanticism "reestablished the links with
the old spirituality of Europe."[96] He continues with a discussion
of Wilhelm von Humboldt, Marx, and Judaism. The book builds
up to a climactic point with a vicious attack on Bismarck:

If the sovereign state is in itself the negation of humanity, and
the Prussian state especially so, because its military, legal, and
theological foundations offer no security for the individual or property,
let alone ideas, then, under the despotic rule of a personality like
Bismarck, it becomes impossible and an affront to the world at large,
which becomes all the greater the less the nation which falls victim
to it shows any awareness of the fact.[97]

Ball also explores the interrelationships between Schopenhauer,
Nietzsche, and Wagner, explaining Schopenhauer's pessimism
as "the disappointment of a fanatical searcher after truth, who
saw through the trickery of an authoritarian world filled with
illusions."[98] He now even turns against his former idol Nietzsche
for his rejection of the divine. Thus, coming after Ball's artistic
revolt, *Byzantinisches Christentum* and *Die Folgen der Reforma-
tion* represent a religious and political assault on his time.

X *Conclusion*

For all the variety of styles and forms which he adopted,
Ball was preoccupied with the same themes throughout his
works. Perhaps his most typical figure is Flametti, a character in
a state of decline and fall, who is caught up in situations which
he becomes progressively less capable of controlling and turn-
ing to his advantage. Like Ball, Flametti is at odds with himself,
out of step with his time, rejecting authority, thrown back on
his own resources, being destroyed by his own subjectivity.

Ball ultimately sought refuge in religion in a last desperate
attempt to retain his sanity. His life was "a constant wrestling
with powers of the spirit greater than himself, in the most
dangerous abyss of life."[99] And for Ball, Dada represented the
culmination of his revolt against external authority, and at the
same time a means of breaking through the surface appearance
to the realms of the spirit beyond. But Dada turned against him
and threatened to destroy him.

Hans Arp:
The Still Small Voice

THE majority of creative artists who, at one time or another, have come into contact with the Dadaist movement went through a distinct Dadaist phase which can fairly readily be isolated and examined as a separate area of their work, and which was usually confined to a limited period of time. In the case of Max Ernst, to take but one example, certain works can be described as "Dadaistic," others as "Surrealistic," and so forth. Despite the fact that guided chance, a characteristically Dadaist procedure, runs throughout the whole of his creative work, Max Ernst was far too restless to be content with exploring in great depth any one brand of artistic expression. In his own words, he was a seeker rather than a finder. There is no common pattern to be discerned in these writers and visual artists: where one moves on in the direction of Surrealism, like Ernst, another gives up art altogether, as did Marcel Duchamp, and yet another returns to the church which he had rejected in his youth, like Hugo Ball. What each of these men does have in common, however, is the fact that, for them, Dada was no more than a temporary resting place on a road that led beyond to a more distant goal which did not necessarily lie within the framework of the creative arts.

For Arp, however, Dada itself turned out to be the goal, although at the time when he found it Dada had not even been named. Once he had discovered a mode of expression appropriate to his artistic insight, he continued to work the same rich vein for the rest of his life, regardless of passing artistic fashions and regardless, too, of political upheavals. Arp did not join Dada; Dada joined him. And long after the little groups of Dadaists had disbanded, when their successors were practicing

116

Pop Art and the Happening, Arp continued along his chosen path.

I A *Life of Art*

Hans—or Jean—Arp[1] was born in Strasbourg on September 16, 1886. It is curious to note that even this simple fact was in doubt for many years: "Hans Arp really was born ... in 1886 and not 1887. I only found this out after my marriage, and it did not appear essential to me to correct all the earlier biographies. But since my husband's death we have been giving the correct date of birth, just as it is recorded on the gravestone."[2] That it "did not appear essential" is indicative of Arp's modesty and his lack of concern for all the fame and publicity which invariably pursues the great artist.

Arp's place of birth in Alsace-Lorraine—which, at the time, had been under German occupation since 1870—meant that he was brought up in a mixed cultural environment. He became fluent in French and German and also in the local Alsatian patois. The fact that Arp felt that "the word is fresher for me in French.... French which I have always spoken gives me the feeling of discovery"[3] does not imply any real imbalance in his knowledge of the two tongues, but rather a difference in his attitude and approach to French. What is surprising is that, outside the ambience of these languages, he was an appalling linguist; when in New York on one occasion he accidentally dropped a watch, and someone picked it up and presented it to him. Arp asked himself a little suspiciously: "'Why is this fellow offering me a watch identical to the one I already have? To sell it to me? A crook, perhaps?' And summoning up his entire knowledge of the English language he snapped: 'Go away.' 'Thank you,' the other replied, pocketed the watch, and vanished."[4] This anecdote has more than a flavor of the apocryphal, perhaps, but it does characterize the linguistic block as well as Arp's astounding naïveté.

The fact that Arp lived on the borderline between Germany and France exercised a fruitful influence upon him: to the east, there were the German Romantics (Brentano, Novalis, and Arnim), and in the west was Paris, the focal point of European

art. For much of his life Arp lived in bilingual or cosmopolitan settings, traveling widely and gathering a wide circle of friends and acquaintances, but Strasbourg itself always fascinated him, and not simply because of its geographical location. Even in his last years he recalled the impact of the cathedral:

> Hatten Sie nicht soeben das Gefühl
> als seien Sie das Strassburger Münster
> das zu einer Schwalbe geworden ist
> und sich in das Bodenlose stürzt.[5]

> (Did you not feel, just now,
> As if you were Strasbourg cathedral
> Turned into a swallow
> And plunging into the void.)

And in *L'ange et la rose* "la cathédrale est un cœur."[6]

Arp's passion for creative art developed at an early age, as this frequently quoted crucial passage indicates:

I remember that as a child of eight I drew passionately in a large book which looked like an account book. I used colored crayons. No other trade, no other profession interested me, and those childish games—exploring the haunts of unknown dreams—already presaged my vocation of charting the unexplored territories of art. It was probably the figures in the cathedral at Strasbourg, my birthplace, which inspired me to take up sculpture.[7]

In 1904 Arp entered the school of arts and crafts in Strasbourg and in the same year sent a volume of poems, which he had entitled *Logbuch,* to the Seemann Verlag in Berlin. Unfortunately, the publishers accepted the volume and then promptly lost the manuscript. Only three poems survived: these appeared in René Schickele's *Neues Magazin.*

One further aspect of Arp's creativity, apart from its compulsive nature, that should be noted is the fact that he regarded himself as a "dreamer."[8] This should not be misconstrued, however. Arp was not an intensely subjective artist in the sense that he indulged in explorations of the depths of his own mind with little or no relationship to the real world outside. His "dream-

ing" is to be interpreted in terms of an arbitrary and imaginative vision of reality itself, an interaction between a sensitive individual and his natural environment, but in no way as the outpourings of a tortured lyrical self.

In 1905 Arp embarked on a course of study at the Weimar school of art which lasted some two years; thence he moved to Paris, where he took lessons at the Academy Juan. In 1908 he left Paris[9] and joined his parents who were living near Weggis in Switzerland. It was during the years he spent there (between 1908 and 1910), that he "battled with abstract art like Jacob with the angel,"[10] ultimately arriving at a new art form—"concrete art"—suited to the expression of the ideas he was to continue to convey through his works for the rest of his long life. He put the date of his discovery as "1910 or 1911."[11]

In 1911 Arp exhibited with the *Moderner Bund* in Lucerne, Switzerland, and from this time on he was in constant touch with members of the European *avant-garde*. In 1911, too,[12] he met Kandinsky and members of the Blaue Reiter in Munich, and exhibited with them. He contributed to the Expressionist periodical *Der Sturm* and participated in the famous Erster Deutscher Herbstsalon exhibition in Berlin. Among many others, he met Max Ernst, with whom he collaborated on the Fatagaga pictures, and Modigliani, who produced the well-known and acutely observed portraits of him in the unmistakable Modigliani style.

In 1914 Arp was in Paris once more. Dada legend has it that he traveled in the very last train leaving at the outbreak of war and that hostilities commenced at the precise moment he was crossing the frontier, just as the border was underneath his very compartment, and that this was the cause of his split personality. And, in fact, Arp found himself in a somewhat difficult situation, because he was German by birth. So he moved on, this time to Switzerland, where another widely quoted Dada legend has it that he persuaded the German consular officials of his unsuitability for military service by reacting in a somewhat idiosyncratic fashion when summoned: he crossed himself before Hindenberg's portrait, and when asked about his age, he wrote his date of birth down several times, added the figures up and submitted the total. This caused more than suffi-

cient doubt to be cast upon his mental powers and stability, and he was no longer bothered by the military, who turned their attention elsewhere.

In November, 1915, at an exhibition in the Tanner gallery in Zurich, Arp met Sophie Taeuber. This young teacher and artist exercised a crucial influence upon both his emotional life and his development as an artist. They subsequently married in 1922. Very little has been written either about Sophie Taeuber herself, or about her impact on Arp. Hence it is important to interrupt this survey of Arp's life in order to arrive at a picture of this fascinating woman.

Sophie Taeuber was born in Davos in 1889. When she met Arp, she was teaching textile making at the local art school. She was also an artist in her own right, and a gifted dancer, who had studied under Rudolf Laban. Their meeting "was decisive for [Arp]: it marked the beginning of an ideal collaboration, with designs for tapestry and collages."[13]

Sophie Taeuber-Arp is described as an extremely quiet, withdrawn and sensitive creature. Arp clearly regarded her almost as an ethereal being:

Wie die Blätter eines Märchenbaumes sanken die tiefen Farbenträume Sophies in mein Dasein nieder. Schon wenige Tage nachdem wir uns kennengelernt hatten, führten wir gemeinsame Arbeiten aus. Wir entwarfen große Bilderbauten.[14]

(Like the leaves of a fairy-tale tree the deep colorful dreams of Sophie sank into my being. Only a few days after we had met, we were producing works together. We sketched huge constructs of images.)[15]

Hans Richter records that she spoke little and "usually obviated the necessity for speech with one of her shy or thoughtful smiles."[16] She was even less interested in the wilder, more raucous public outbursts of Dada than Arp, who was himself hardly anxious for the limelight. In "Wegweiser," he had written that "even in the early days I did not frequent the literary cafés. On my very first visits I had been repelled by the childish presumption and grotesque exaggeration of their own importance on the part of the habitués."[17] Sophie Taeuber was most gifted

in the field of applied art, but the materials she designed and her work with beads, for example, are scarcely known. Her collages, paintings, and other works have about them a rather chill simplicity and severity, particularly when seen alongside works by Arp; Michel Seuphor defines her work in a lecture given in Liège in 1953 on the occasion of an exhibition of work executed by the couple:

> On the surface, we are witnessing a game of lines, surfaces, colors. These games do not relate to any form outside themselves which call to mind tangible reality; thus they are pure creation, pure invention. However, being the free product of a human mind, they are evidently transcribing something or other. They are the reflection of a silent life within a human creature, one endowed with instinct, but also with the power of reflection, determined but in command of a certain range of choice.[18]

Or perhaps it would be more honest to say that she was a designer rather than an artist. Arp stresses the "clarity" of her work and her oneness with nature. If the moral and social context were not hopelessly wrong, one might be more than tempted to call her the archetype of the Schillerian naïve.

The opening of a poem dedicated to Sophie stresses, in one of Arp's most memorable images, her tranquillity and bonds with nature: "das pianopedal der blumen wird niedergetreten"[19] (the soft pedal of the flowers is pressed down). Still, her work does seem to lack the spontaneity and humor of Arp's creations. Her *Dada Head* oil paint on wood, head-shaped and to be found in the Musée National d'Art Moderne, is brightly colored against a black ground, but like the print accompanying a limited number of copies of Seuphor's lecture, the color, however gay, is contained within a strictly defined framework, in this case a series of juxtaposed rectangles. Her marionettes, made for a Zurich marionette theater production in 1918, are whimsical rather than convincing; and their most attractive quality, as in the rest of her work, is the skill of their design and the quality of their craftsmanship. In 1964 a modest exhibition of her work was held at the Musée National d'Art Moderne; and the question remains whether, on strictly artistic grounds, she would have

received even this measure of attention if it had not been for her association with Arp.

One of her activities which is given little attention is the periodical *plastique,* which she—perhaps somewhat uncharacteristically—founded and edited from their house in Meudon. It described itself as "a magazine devoted to the study and appreciation of Abstract Art; its editors are themselves painters and sculptors identified with the modern movement in Europe and America. Articles will appear in English, French, or German."[20] Five issues appeared between early 1937 and 1939. The first number is described as "Malewitsch in memoriam," and many of the famous names of the *avant-garde* figure in its pages: Hausmann, Kandinsky, Max Ernst, Schwitters, Duchamp, Eluard, and others.

The illustration in *plastique* of "Formes désaxées" (1928)[21] by Sophie Taeuber bears an uncomfortable resemblance to Max Ernst's series of Loplop paintings.

It is clear that, although Sophie Taeuber's enormous influence on Arp may have been due in part to her technical knowledge of materials unfamiliar to him, such as fabrics, and to her interest in, for example, symmetrical shapes, such as can be seen in Arp's illustrations to the *Phantastische Gebete* of Huelsenbeck,[22] the central impact derives from her personality, her qualities as a human being, which attracted Arp on the personal, even more than on the artistic, level. Artistically, he was drawn to her evident ability to communicate with the world of nature, to be at one with the natural universe; and on the personal level, Arp, who had never been particularly adept at managing his affairs in the world of everyday, came to be dependent upon her. Her tragic accidental death in January, 1943, was a devastating blow to him. There is nothing more desolate and wretched than the series of poems entitled "Sophie," an elegiac sequence in which Arp is even found to be openly seeking death: he thanks every passing day, for each day brings him closer to her. The poet compares Sophie to a rose and laments her passing in lines of unparalleled simplicity and directness.[23] For a long period after her death, Arp found it impossible to sculpt, paint, and write with anything like the confident fluency of the preceding years, and he never regained

his former poise (although this is essentially attributable to a general shift in attitude on his part). It is almost as if he had lost a "medium" through whom he was able to communicate with nature and exercise his art.[24]

To return to Zurich in World War I: at the invitation of Hugo Ball, Arp joined the Cabaret Voltaire. His involvement was peripheral, however; he was not one of "the great matadors of the Dada movement."[25] In 1919 Arp went to Cologne, where he continued his Dadaist activities, together with Baargeld and Ernst. He also came into contact with El Lissitzky[26] and Kurt Schwitters.

After a period spent in Paris, 1921 found him in Tirol collaborating on the famous Tirol Dada pamphlet.[27] In the Galerie Pierre in Paris, the first general exhibition of Surrealism took place in 1925. Arp participated in the company of artists like Giorgio de Chirico, Ernst, Klee, Man Ray, Picasso, and Mirò. In the following year, Arp settled down in Paris, and in 1927 he and his wife occupied their house in Meudon. There then followed what Herbert Read calls the "years of patient self-exploration, of technical discovery, of formal development."[28] In 1936 Arp was represented at two important exhibitions in the Museum of Modern Art, New York. He was gradually establishing an international reputation, as a visual artist at least.

Then came World War II. In 1940 Arp left Paris for the south of France, but again the occupation forced him to take refuge in Zurich. When the war was over, he returned to Meudon, where he remained for the rest of his life, with the exception of visits abroad and sojourns in his second house at Solduno, acquired in 1959. It was in the same year that he married Marguerite Hagenbach.

The closing years of Arp's life were marked by exhibitions and honors, notably exhibitions of his work held at the Musée National d'Art Moderne in 1958 and 1962, the international sculpture prize at the Venice Biennale (1954), the award of the Chevalier de la Légion d'Honneur (1960), the Grand Prix National des Arts (1963), and honorary citizenship of Lucerne (1965). Arp died on June 7, 1966 in Basle.

Two observations will serve to summarize Arp's life and

achievement. Many of his works are, in the words of one critic, "already classics of art of this century."[29] And as a man and artist Fritz Usinger wrote of him: "Arp was a wonder as a man and a wonder as an artist. Do we not stand here like poor deserted children? A piece of the divine being manifested itself when he came among us, and vanished when he departed."[30]

II *The Works and Their Chronology*

For reasons which will become clear in the next section, it is not appropriate, in the case of Arp, to undertake a study of his works in a strictly chronological order. Nonetheless, it is important to have a broad indication of the range, scope, and sequence of his creative output.

What immediately strikes one's attention is the large variety and enormous complexity of Arp's *œuvre*, and also the extreme lack of consideration for the scholar and classifier. It is a refreshing fact that, even in his later years when Arp had become wealthy and famous, he did not work with one eye toward posterity and compiled no correspondence with careful annotations and sounding phrases for the delight of the researcher. Nor did he meticulously date and label all his productions. Marguerite Arp-Hagenbach records that "Arp has never kept records of his artistic production or his sales."[31] He worked for himself, and in a real sense, when he had sculpted, painted, or written to his satisfaction and turned to a different medium or subject, what he had been working on became a thing of the past, one of the building bricks of his current work in progress, which, in turn, was to be basic material for the next subject, and so on.

By the very nature of things, it is among the drawings, collages, and reliefs that the least order is to be observed. The catalogue of the Klipstein and Kornfeld gallery exhibition of Arp's drawings, collages, and reliefs contains some 150 items, but this is no more than a convenient round figure and represents only a fraction of his output in this (largely uncatalogued) area.[32] The Carola Giedion-Welcker catalogue of sculptures,[33] continued in the Trier book[34] by Arp's brother, François, lists nearly 400 sculptural items, and these represent only works

which have been finalized and usually produced in editions of three or four, mainly in granite, marble, or bronze. The chief landmarks in Arp's career as a visual artist were exhibitions in major European capitals and in the United States from the end of the 1940's onward. Perhaps the most important of these exhibitions was the large 1962 retrospective held at the Musée National d'Art Moderne in Paris.

Arp's written work—at least, that part of it which has been published—has been meticulously documented by Marguerite Arp-Hagenbach. The problems relating to the date of actual composition are of extreme complexity because of the multiple reprintings and modifications, but it is possible to follow the principal publications themselves in broad outline.

Arp wrote in both French and German, mainly poetry, some occasional essays and an exceptional venture into narrative fiction. His first attempt at publishing poetry was not a great success, although the fault was hardly his. This was the *Logbuch* volume whose loss by the publisher has already been mentioned. These early poems are of no particular merit, nor do they give any real indication of the new direction Arp's work was to take in the coming years. It is perhaps a little unfair to judge the entire lost volume on the strength of the three remaining poems, but there is no reason to doubt that they were selected and printed as representative samples. The odd flash of imagery gives some promise for the future, but, that apart, there is little more to be said of them than that they are verses of charm and simplicity, not to say naïveté.

Arp next appears as a contributor to *Der Sturm*, some years before Schwitters became Walden's protégé (although the two did subsequently collaborate on a contribution in 1923).[35] His most substantial contribution was the prose poem "Von Zeichnungen aus der Kokoschka-Mappe" with its *Jugendstil* overtones.[36] At the same time, in December, 1913, there appeared the poem "Von der letzten Malerei."[37] In Zurich, he became involved with the publication *Dada*, and in Cologne with *Die Schammade* and *W/3*. He was also represented in *De Stijl* and *La Révolution Surréaliste*, as well as being one of the co-authors of *Dada Intirol Augrandair Der Sängerkrieg*.

Arp's first volumes of poetry appeared in 1920. *Die wolken-*

pumpe is a collection of prose poems and represents the nearest approach Arp ever made to automatic writing. *Der vogel selbdritt* is also composed of prose poems, fantastical, but far more conscious and deliberate in tone. It contains an early form of Arp's most famous and most anthologized poem, "kaspar ist tot."[38] By contrast, *Der Pyramidenrock* presents a series of regular rhyming poems, although their content, at first sight, seems to be as devoid of sense as that of the two previous collections. Other volumes followed, in both French and German, and in 1939 *L'Homme qui a perdu son Squelette* was serialized in *plastique* in collaboration with Marcel Duchamp, Paul Eluard, Max Ernst, Georges Hugnet, Henri Pastoureau, and Gisèle Prassinos.

In the period after World War II, Arp's publishing activities can broadly be divided into two main areas: new collections of verse and retrospective volumes, some of which contain essays as well as poetry. The first of these, *On my Way*, contains contributions by other hands and amounted to the first monograph of any substance on Arp.

In 1955 there appeared *Auch das ist nur eine Wolke*, poems with four hand-colored prints, one of the many books Arp produced for the specialist fine-art market. The last of these was the magnificently printed large format *Le Soleil recerclé* (not *recherché*, as one catalogue unfortunately misconstrued the title),[39] French poems with woodcuts—actually cut, in this case, with a saw.

The most important retrospective volume published in German, apart from the rather incomplete *Gesammelte Gedichte I* (a survey of poems 1903-39), is *Unsern täglichen Traum*. Apart from extracts from many collections of poems, it contains essays on Sophie Taeuber, Huelsenbeck, Richter, among other subjects. The crucial essays are "Konkrete Kunst,"[40] which enunciates the basic principles underlying Arp's work, and those on Dada,[41] which offer important source material on the personalities and attitudes of the time. And, together with "Wegweiser" (published two years earlier in *wortträume und schwarze sterne*),[42] the essay "Einsam am Fuße der Rigi"[43] completes the picture by giving an insight into Arp's early days and his discovery of new art forms. In French, *Jours*

effeuillés, nearly 700 pages in length, offers a comprehensive collection of Arp's published work in that language.[44]

Three important new volumes of poetry appeared in the last three years of Arp's life. In the late 1950's, Brigitte Neske asked the poet to contribute a poem to a planned anthology, her *Mondbuch*, and "this idea encouraged me to write a whole series of poems to the moon,"[45] which he entitled *Mondsand*, and which appeared in 1959. There is clear evidence in *Mondsand* of the beginnings of a distinct streak of pessimism in Arp's poetry,[46] which is further intensified in *Sinnende Flammen* (1961) and in his last collection in German, *Das Logbuch des Traumkapitäns*, which dates from 1965. With *Das Logbuch des Traumkapitäns* the wheel has come full circle: the first lost manuscript also bore the title *Logbuch*.

Arp consistently illustrated his own poetry, and the illustrations to his last two collections offer a particularly relevant commentary on the text;[47] one aspect of his *œuvre* which has received virtually no attention is that Arp was illustrator not only of his own texts but of those of other writers and poets as well. This is an activity which he was engaged in throughout his life, from the seven woodcuts to Huelsenbeck's *Phantastische Gebete*[48] to the evocative cover illustrations to Fritz Usinger's retrospective collection of poetry entitled *Pentagramm*[49] and the new poems, *Canopus*.[50]

III *The Creative Personality*

In 1958, Arp together with his friend Camille Bryen, published a little book "to greet a new year."[51] Arp provided the poem—"Notre petit Continent"—and the volume was illustrated by Bryen. This was a typical act of collaboration—Arp had previously worked with Sophie Taeuber, Schwitters, Ernst, Francis Picabia, and many others—and contained a typical Arpian joke: the year was 1958, and 58 copies were produced, one for each year of the century so far elapsed. True to character, too, was the modesty of the venture; less than three score copies of a book were hardly designed to produce a major impact on the contemporary poetic world.

These three qualities—friendship, humor, and a rare but

genuine modesty—are central to both Arp, the man, and Arp, the artist. All who knew him speak with unqualified affection and admiration for this quiet, humble figure, who was never fully aware of the fame and wealth his sculptures, paintings, and poems had ultimately brought him. In an age of publicizing and publicity, Arp scorned "the famous work, the masterpiece,"[52] preferring to work quietly in the seclusion of his studios in Meudon and Solduno. And to these qualities should be added a fourth, which both complements and expands upon them: his profound insight, as aptly summarized by Camille Bryen, who sent Arp a copy of his book *L'ouvre-Boîte: Colloque abhumaniste*,[53] with this dedication on the flyleaf written round the printed title (which appears here in capitals):

Pour Jean Arp qui a ouvert la boîte Dada et qui est toujours L'OUVRE-BOITE-Arp

Son ami Bryen.

(For Jean Arp who opened the tin of Dada and who will always be THE CAN-OPENER-Arp

His friend Bryen.)

Almost in spite of himself, Arp became a great sculptor and poet of the modern age; yet it is remarkable that the vast majority of secondary sources concerning him is either in the form of brief introductions in exhibition catalogues, or in short articles or monographs which are descriptive rather than interpretative, and lean heavily on Arp's own essays about himself and his work. Unlike Picasso, Kokoschka, or Ernst, Arp has attracted no extended critical studies worthy of his standing in contemporary art. Only occasionally does a critic—like Rimbach in his article on the meaningfulness of Arp's poetry,[54] or Trier's regrettably short introduction[55] to the updated catalogue of sculptures—offer a pathway toward a deeper understanding, and the reader or gallery visitor seeking to come to terms with the immense range and richness of Arp's imagination and his awareness of, and sensitivity toward, the natural world is hardly helped by comments like the following, taken from a not untypical review of the 1962 Arts Council retrospective exhibition:

Certainly, individual works are highly original, and organised with subtlety. The shapes may be simple, but they create a complex effect. . . . The final effect is, however, of insuperable fatigue. The giant fruit are overripe, and flaccidly submit to gravity. . . . The blobs of protoplasm slither helplessly down their vertical panels, distorted not by effect but by inertia. We are in a drab submarine world in which dying invertebrates sink like pancakes to the seabed, and the tendrils of fleshy plants are wafted involuntarily in the tedious movement of an oily swell.[56]

This is pretentious stuff, and hopelessly wide of the mark. And Arp, the poet, is subjected to an even more extreme degree of critical circumlocution and bafflement. The 1962 Musée National d'Art Moderne exhibition catalogue even goes so far as to exhort the reader to leave his judgment and intellectual faculties behind when approaching Arp's poems: "All the reader has to do is to let himself be carried along by the enchantment of his inexhaustible inventiveness, like—let us say, by a romantic enchantment."[57] But to treat his poetry as escapist—or merely decorative, even[58]—is to do it criminal injustice. Its apparent absurdity, the strong sense of play and childlike innocence, and the deceptive simplicity of outline all lend the impression of an arbitrary, self-indulgent anti-intellectualism. No serious artist, it appears on the surface, could spend his whole life writing poems with titles like "Die Wolkenpumpe," (Cloud Pump) or "Schneethlehem" (Snowthlehem) or paint a series of "dolls," or, again, give his sculptures ingenuous titles like *Deux petits sous un arbre* (Two Little Ones Beneath a Tree) or *Mangeur de la rose* (Rose Eater). Such works must either be the product of a Dadaist word-juggler who has never outgrown the artistic romps in Zurich and Paris during World War I and in the years immediately following, or of a mystical vision so private and so profound that it defies all attempts at comprehension. There is even the feeling that to seek to understand might destroy, for Arp himself attacked "the rabies of reason."[59] According to this view, the poems and sculptures should be absorbed uncritically, by some emotional, quasi-religious osmotic process.

Two major difficulties stand in the way of any attempt to come closer to Arp's work. The first is that only a relatively

small portion of his *œuvre* is widely known and generally available: most of the collections of poetry are in limited editions—for example, only 170 copies of *Le soleil recerclé* were produced for sale,[60] and a mere hundred of *Auch das ist nur eine Wolke*[61]—while his plastic work is so vast that it would be impossible to exhibit it in one place, let alone assimilate it at one visit. In addition, there is much that has never been publicly shown.

The second, related, difficulty is that Arp's work defies all attempts at neat and orthodox categorization. Thus it is impossible to set up a rigid line of demarcation between pictorial and written works. Arp's important paintings, sculptures, and other visual work are usually named, and these titles direct and enhance the impact on the eye: for example, in the collage *Regierungsmitglieder*, the marble *Feuille se reposant* (Leaf Resting), or the bronze *Oiseau-tripode* (Bird Tripod). In a few cases, such as the marble *Etoile* (Star) or the bronze relief *Araignée* (Spider) they could, with some justification, be regarded as self-explanatory or even superfluous, but, for the most part, Arp's titles serve as an indispensable verbal bridge across the gulf between the observer and the created work.

Similarly, the illustrations which accompany collections of Arp's poetry perform a guiding function in the opposite direction. On occasion, as in *Le Soleil recerclé* (The Sun Recircled), they can rival rather than complement each other, but at their best, in the last three German collections for example—*Mondsand* (Moon Sand), *Sinnende Flammen* (Pensive Flames), and the *Logbuch des Traumkapitäns* (Dream Captain's Logbook)— they direct the images of the highly visual poetry into new and richer channels.

As these mutual exchanges between verbal and pictorial imply, Arp himself did not rigidly separate his activities; he moved freely from typewriter to chisel and on to brush and scissors, bringing every medium of expression at his disposal into play, urged on by an irrepressible flow of inspiration. Hence the impracticality, if not impossibility, of seeking to segregate even Arp's plastic works into sculptures, reliefs, *papiers déchirés*, and the rest, although this is precisely what is done by nearly all exhibition catalogues, which regard the medium as being almost

entirely conditioned by the message—for example, the 1967 *Hommage à Jean Arp* in Strasbourg, or the 1962 exhibition at the Kunsthalle, Basel. Such a traditional division is, of course, acceptable in the case of small selling exhibitions by, say, Denise Renée or Sidney Janis, but it cuts against the grain of Arp's work when a significant and broadly representative selection is on display. The organizer of the Musée National d'Art Moderne exhibition, by contrast, was aware of the problem and attempted a qualified regrouping:

In order to do justice to the way in which Jean Arp's *œuvre* developed, the works exhibited here have not been grouped in this catalogue by chronological order nor by material and technique, but by "families" associated with certain themes to which the artist returned on several occasions in the course of his career, at times using different techniques: concretions, for example, or "seuils," constellations, etc. The only exception to this pattern has been made in the case of his youthful works and the Dada and Surrealist periods on the one hand, and the tapestries and book illustrations on the other.[62]

Given the inevitable restrictions on such a compilation, this represents a step in the right direction, except for the separation of early works, and of the Dada and Surrealist periods. For the chronological approach to Arp is no less doomed to failure—on practical, if no other, grounds—than attempted division by technique, material, and medium. In this respect, the poetry is in a particularly chaotic state: *der vogel selbdritt,* for example, was first published in 1920, but its contents date back over several years. The same applies to his last German collection, *Das Logbuch des Traumkapitäns* and, indeed, to nearly everything he published.

One of the poems from *der vogel selbdritt,* now known under the title of "kaspar ist tot," has had a particularly chequered career, but it is possible to trace its development in some detail. The poem originally appeared in 1919 in the periodical *Dada* as a prose poem; then in the *Dada-Almanach* as the first two of five texts; in *On My Way;* and in *wortträume und schwarze sterne.* On each occasion it underwent changes and revision.[63]

A French version of another poem from *der vogel selbdritt,* "im januar," appears under the title "La Pompe des Nuages,"

whereas the German version of that title—namely, *die wolken-pumpe*—stands at the head of a totally different collection of poems. Again, "die edelfrau" from *der vogel selbdritt* can be found reprinted many years later in *Auch das ist nur eine Wolke,* where each line is subjected to a lengthy exegesis.

Arp's poems often reappear in different forms, in both French and German, so that the situation becomes hopelessly entangled. Even if it were possible to establish a pedigree for all the poems, they could, in the vast majority of cases, be traced back only to the date of their first publication, rather than to the actual time of composition.[64]

A more general chronological issue seems to enhance the confusion further. The myth persists that a division of Arp's poetry into two broad groupings—namely, the Dada works on the one hand, and all subsequent poetry on the other—is possible. Liede, for example, supports this view, deploring the passing of the "fairy-tale world"[65] so much in evidence in *der vogel selbdritt.* After 1920, however, Liede argues, the unalloyed magic of Arp's songs of innocence shifts into the more contrived, cynical, and self-conscious mode of the *Pyramidenrock.* However, this interpretation does not reflect the facts, for even in *der vogel selbdritt* darker tones are to be detected among the supposed fairy fancies:

> schwarze winde hängen wie ketten von den sternen.
> enterhaken greifen schwarze lackwände an.
> .
> wer trägt unser säaglein vorüber unter dem kühlen morgenstern.[66]

> (black winds hang like chains from the stars.
> grappling hooks grasp black lacquer walls.
> .
> who will carry our little coffin past under the cool morning star.)[67]

And, on the other side of the coin, it is far from the truth to assert that the magical quality of Arp's imaginative powers passed with the close of the brief Dada outburst. The poems lamenting the passing of the poet's first wife in 1943 certainly recapture the supposedly lost enchantment of the early years,

although inevitably the tone is elegiac as it is composed in a
mood of grief:

> Verloren wie der alte Mond,
> der schon viel tausend Jahre stirbt,
> ist dieser arme Tränenmensch,
> der um die tote Rose wirbt.[68]

> (Lost like the old moon,
> that died many thousand years ago,
> wooing the departed rose,
> is this poor man of woe.)[69]

Even *Le Soleil recerclé*, which appeared in the year of Arp's
death, includes lines like these:

> Un mur dans une lettre.
> Un voilier dans une forêt
> Une flamme dans une cage.
> Une clé dans une bouche.
> Un mât d'ivoire aux fruits de neige.[70]

> (A wall in a letter.
> A sailing ship in a forest
> A flame in a cage.
> A key in a mouth.
> An ivory mast with snow-fruits.)

And, in his last German collection, the *Logbuch des Traum-
kapitäns*, Arp furnishes ample evidence that his ability to trans-
form the commonplace and lift it on to a new plane has not
waned since the Dadaist days:

> der Niagra in tadellosem Zustand
> ferner leicht beschädigt Kap Horn
> das jedoch zum Glück
> über zahllose
> Ersatzhörner verfügt.[71]

> (the Niagara in perfect condition
> in addition Cape Horn slightly shopworn

but fortunately it has
countless substitute horns
at its disposal.)[72]

Thus it is that Eluard's dedicatory poem, which prefaces *Le voilier dans la forêt*, holds good for the whole of Arp's work:

Tes mains découvrent le soleil
Et lui font de nouveaux berceaux.[73]

(Your hands reveal the sun
And cradle it anew.)

Critical reactions to Arp's poetry tend to extremes. Some observers are so blinded by the poet's imagination and perception, his ability to discover new life in the drab and familiar, that they see nothing else. Thus, the diametrically opposed view to Liede's emerges in Pörtner's review of the *Logbuch des Traumkapitäns*, which opens with a quotation from *Unsern täglichen Traum*:

"We were drawn on by the gleaming light of mystic poetry, in which man is released from joy and sorrow. . . ." The new cycle of poems *Das Logbuch des Traumkapitäns* also belongs under this watchword; for in it the "gleaming light of mystic poetry" finds . . . its reflection. Arp here comes full circle and after a long voyage upon many seas the "dream captain" returns to his mystical point of departure.[74]

Although not entirely in error, this assessment is at variance with the prevailing mood of the collection; and, in particular, with the despairing quality of poems like "Das Kind eines Punktes," "Who is who," and "Ich du er wir ihr sie," in which such humor as is present coexists, not with seriousness, but with world-weariness or even tragedy.

The *Logbuch des Traumkapitäns* is, indeed, a voyage of discovery, but it is inward-looking, a vain attempt—for all the continuing presence of the early magic—to establish the nature of the self in a hostile world from which the angels have long since taken flight:

Wer bin ich?
Ob ich ich bin
ist nicht leicht zu sagen.
Zur Zeit bin ich eher
müde müde müde
und möchte lange
in ewigen Schlaf verfallen.[75]

(Who am I?
Whether I am I
is not easy to say.
At present I am more
tired tired tired
and would like to sink
for ages into everlasting sleep.)

Clearly the truth must lie somewhere between these critical extremes; but the very existence of violent discord and confusion on this issue suggests that here is hardly the place to seek for a meaningful and satisfactory definition of the nature and extent of Arp's achievement as a poet, let alone as a sculptor.

Such is the consistent variety of mood in Arp's poetry—and this applies with equal force to the rest of his *œuvre*—that, with very few exceptions, it is virtually impossible to date one of his works on internal evidence alone, even allowing a margin of a decade in either direction. An extract from *Zweiklang* can serve to demonstrate this fact:

Führt dieser Weg in den schwarzen Himmel?
Führt dieser Weg in das Schwarze?
Wer kennt die Gewalt der Blumen?
Wer kennt nicht die süße Strenge, die süße
 Unerbittlichkeit der Blumen.[76]

(Does this road lead to the black sky?
Does this road lead to blackness?
Who knows the power of the flowers?
Who does not know the sweet rigor, the sweet
 severity of the flowers.)

These lines instantly call to mind two passages from *Sinnende Flammen*:

Wer kennt nicht
die süße Strenge
der Blumen Gottes
der Engel![77]

(Who does not know
the sweet rigor
of God's flowers
the angels!)

—with its reference to the "gentle law" of the natural world, and:

Führt dieser Weg
zu dem gekreuzigten Kreuz?
Führt dieser Weg
zu dem kranz aus lichten Blicken?[78]

(Does this way
lead to the crucified cross?
Does this way
lead to the garland of luminous glances?)[79]

—where one of the dominant themes of *Sinnende Flammen,* that of a search for a pathway back to the realms of nature, echoes the repeated question in the *Zweiklang* extract. However, this technique of repetition, together with the juxtaposition of a natural object with its negation, blackness, can be traced as far back as *der vogel selbdritt*:

der schwarze wagen ist vor den berg gespannt.
die schwarze glocke ist vor den berg gespannt.
das schwarze schaukelpferd ist vor den berg gespannt.[80]

(the black coach is harnessed before the mountain.
the black bell is harnessed before the mountain.
the black rocking-horse is harnessed before the mountain.)[81]

Moreover, this poem—"die nachtvögel"—ends with the words:

die fische ergreifen den wanderstab und rollen in sternen
dem ausgang zu

(the fish put on their walking shoes and roll in stars
 toward the exit)

—and the search for an "exit" is almost identical with the search
for a pathway back into nature. The only difference is one of
viewpoint: in *der vogel selbdritt,* the magical spheres of nature
strive to reestablish contact with man, whereas in the *Zweiklang*
poem and the lines from *Sinnende Flammen,* it is a man who is
straining toward nature. The significance of "dem ausgang zu"
is highlighted by the fact that a modified version of "die nacht-
vögel" in *wortträume und schwarze sterne* uses these three words
as the title of the poem.

The extract from the *Zweiklang* poem could have been com-
posed at almost any period in Arp's creative life-span. The most
likely time of composition seems to be around 1960, when the
compact and thematically unified *Sinnende Flammen* was being
prepared, because there is a high degree of correlation between
the two, both in viewpoint and in the actual wording. However,
the subject of the unpublished poems is, in fact, Arp's first wife
Sophie Taeuber, on her death in 1943, and it was only in the
years immediately following that the poet apostrophized her in
a series of simple laments.

Doubt now centers on *Sinnende Flammen*: perhaps it is not
a case of the *Zweiklang* poem anticipating this collection, but
rather the reverse. In this case, *Sinnende Flammen* may have its
roots in the middle 1940's. But once again the scholar seeking
to date Arp's poems falls foul of yet another complication; for
with the exception of the deliberately retrospective *Gesammelte
Gedichte I* and its French counterpart, *Jours effeuillés,* nearly
all collections of poetry by Arp offer a coherent artistic statement
growing out of the time during which the given collection was
in preparation. This applies not only to very short volumes like
Auf einem Bein[82] or *poèmes sans prénoms,*[83] but, with equal
force, to more substantial productions, such as *Unsern täglichen
Traum,* where, by a process of selection and revision, older poems
are rejuvenated and harmonized with more recent material, that
is, everything is "new" whatever the date on which it appeared
in its original form.

In any event, *Sinnende Flammen* is a small, closely knit collec-

tion with only one updated poem, namely "O wie freut sich der Stern,"[84] which is a variation on "Er verschwebt, er verschwebt" from *Mondsand*.[85] (Regarding the latter collection, there is external evidence that all the poems in it were composed within a relatively short span of time.)[86] Thus a chronological approach to the unpublished extract quoted above, which would seek to assign the poem to a specific creative "period," becomes virtually meaningless.

There remains the argument that World War II and the death of his wife produced such a shattering impact upon Arp that his whole world view was shattered. On a personal level, this event indeed created a terrible vacuum in his life, but there is no evidence that the resulting gap in sculptural creativity or the temporary concentration on bereavement in the poetry had an enduring and clearly recognizable effect on his work as a whole after the end of the war.

Arp's work is curiously free from specific personal experience, that is, it is not confessional in the traditional sense, and, on the rare occasions on which events in his own life have resulted in works of art, they have been lifted from the personal and immediate plane to a far more generalized level. "Von Zeichnungen aus der Kokoschka-Mappe" is one such poem that came into being during a cabaret performance in the Wintergarten in Berlin, as Arp was observing Kokoschka sketching the performers, notably a certain Archie A. Goodale walking on the high wire.[87] The drawing was later reproduced in *Der Sturm*. Even the original version of this prose poem transcends the immediate scene in order to offer a generalized commentary on the false glitter of city life, where the only stars are the artificial lights of the chandeliers, and the only signs of natural objects are the potted geraniums lining the boxes.

It is even difficult to find reflections of everyday experience or locations which can be directly related to Arp's life. One exception, Strasbourg cathedral, has already been mentioned; but it is very rarely that specific events or locations are referred to elsewhere in his poetry. Only occasionally does the most tenuous link between life and art emerge, as in "Reif zum Aussteigen," which comes from *Auf einem Bein*:

In dem Zuge der von A. nach B. fuhr
einer kurzen Fahrt von ungefähr dreiviertel Stunden
befand sich kaum ein echter Aussteiger im Wagen.
In B. der Endstation
stiegen wie notgedrungen
drei Reisende aus.
Die übrigen saßen traurig da.
Die meisten behaupteten
daß sie wenigstens noch drei- bis viermal
von A. nach B. fahren müßten
um reif zum Aussteigen zu sein.[88]

(In the train which went from A. to B.
a short trip of about three quarters of an hour
scarcely one of those in the coach was genuinely ready to get out.
In B. the terminus
three travelers got out
as if under some compulsion.
The others sadly remained in their seats.
Most of them maintained
that they would have to go from A. to B.
at least another three or four times
in order to be ready to get out.)

The place names alluded to in this poem remain initials, and the train journey motif—which could have originated in Arp's observation of the commuters leaving Meudon Val-Fleury station for central Paris every morning—becomes a symbolic voyage through life. Precisely the same happens to those poems which are addressed to specific individuals. Thus, in the Sophie sequence of lyrics in *wortträume und schwarze sterne*, personal grief is translated into a general statement on the widening gulf between man and the natural world, and the consequent sense of loss, emptiness, and disorientation.[89] Thus, the specific situation in time and place can offer little, if anything, by way of illuminating Arp's work.

It might be argued that Arp's practice of updating his poems demonstrates some kind of progression, some advance upon a previous stage of artistic development. Numerous poems underwent extensive alterations as the years went by, and the two prose poems "Von Zeichnungen aus der Kokoschka-Mappe" and

"Weltwunder" can serve to illustrate the kind of process actually at work. Both poems began as spontaneous, "semiautomatic" creations, the one sparked off by Kokoschka at work, the other by words and phrases from newspaper clippings. The second version of each poem retains the original wording but interpolates whole new sections. As in the case of many other modified poems, these two grew substantially in length. The first paragraph of the earlier "Weltwunder" runs:

Weltwunder sendet sofort karte hier ist ein teil von schwein alle 12 teile...[90]

(Wonder of the world send card by return here is a part of the pig all 12 parts...)

The revised version begins thus (words taken over from the original poem have been italicized):

sendet sofort die schnellsten boten zu den traumwolken. sendet flugwelle zeug*karte* drahttaube briefäther. wer kann in diesem finsteren land ohne eine morgenrote traumwolke leben. *hier ist* in jedem und allem *ein teil* undurchdringlicher finsternis. *vom* tageslicht bleibt nur ein dürftiger kranz übrig. die finsternis ist eine quallige spinne ein stummes *schwein* eine widerliche schlange ein gewaltiger blutegel.[91]

(*send at once* the swiftest messengers to the dream clouds. send flight wave identity *card* wire dove ethereal letter. who can live in this dark land without a dawn-red dream cloud. in each and every one *here is* in each and every thing *a part* of impenetrable darkness. *of the* light of day only a paltry garland remains. the darkness is a medusoid spider a silent *pig* a repulsive snake a prodigious leech.)

"Weltwunder" itself has become the title of the poem. The difference between the two versions is neither one of maturity nor is it a matter of stylistic "improvement," nor can it be attributed to any technical or personal advances in Arp's art. What Arp has done is to go over the same ground as before, working at a more conscious level. The dehumanizing din of "press radio and television,"[92] a discordant fusillade of aural and visual stimuli, to be forgotten as soon as new ones hustle them aside, is cleverly

observed in the first version, where an almost random sample of words and phrases brilliantly expresses the seven-days'-wonder world of modern mass communication, ending with the poet himself inserting a small advertisement in defense of humanity:

ARP ist da keiner versäume es erstens ist es staunend billig und zweitens kostet es viel obwohl der okulierte bleivogel des regattentages mit tausend knoten schnelligkeit in die esse fuhr dies beunruhige die werften nicht[93]

(ARP is here no one should miss it firstly it is amazingly cheap and secondly it costs a great deal although the inoculated lead bird of the regatta day with a thousand knots speed sailed up the funnel let this not upset the docks)

In the second version, Arp's interpolations underline the dangers lurking beneath the surface glitter and the promise of the good life. They act as a gentle whispered admonition against the lure of profit, the busy racket of urban society.

Thus, in modifying his poems, Arp was doing no more than bringing to the surface the hidden part of the iceberg, and this is emphasized by the perfect reduplication of the style of nearly forty years earlier. "Weltwunder," in its second 1946 version, is so close in spirit, style, and vocabulary to a collection like *die wolkenpumpe* (1917) that, once again, any suggestion of artistic development in the conventional sense is not very helpful in attempting to interpret his poetry. Despite the fact that Arp was active as an artist for close to sixty years, it is clear that he was preoccupied, throughout, with the exploration of the same problems with very nearly the same means. In the visual arts, he occasionally changed the technique of the material, but without a parallel shift in subject matter. Herbert Read may seem to exaggerate when he states that "the sculpture of the remaining twenty-five years of Arp's active life does not show any violent departure from the prototypes established in the thirties";[94] but, in fact, his words are something of an understatement.

One of the most striking illustrations of this fact is provided by an early painting of a bowl of flowers with a figurine, dating from 1903. There is evidence that the figurine is one of Arp's own works, or at least an imaginative representation of his own

sculpture. A green-painted plaster head from this period is in existence. The texture and shaping of this figure and head, more intricate and involuntary than is normally encountered in Arp's work, closely resembles the late group of sculptures produced on a journey to Italy.[96] It is as if the time spanning the two sets of sculptures had never existed. Arp's style is unified and unmistakable.

IV The Nature of the Created Object

Arp worked in an apparently random fashion: he would sculpt for a while, then go across to his painting studio, or to the typewriter. In thus alternating between one medium and another, his mind was constantly active: even while out walking he would create and sometimes dictate poems; and in his social life, he left a long trail of anecdotes behind him, each bearing witness to his restless and fertile imagination, as well as to his modesty, humor, and genius.

But Arp was no mere virtuoso performer on the varied instruments of his art; his works are not merely formal creations but mouthpieces of his vision. Some are so unobtrusive as to be almost invisible, but Arp was, in any case, incapable of declaiming his view in the manner of a propagandist. It is significant that many of his sculptures are designed, quite literally, to be "looked down on"; that is, they are placed on the ground, like the *Forest Wheels,* or on low stands. Most are very modest in size, and even the full-sized version of the *Shepherd of the Clouds* was originally a tiny plaster model which, Arp felt, could be increased in scale for the campus of the University of Caracas.

His poems, too, tend to fall into small units, and the best collections are so designed as to permit the printed word to shrink against a vast background of blank paper. In *Le Soleil recerclé,* for instance, use is made of a large typeface in order to lend the impression of a very simple, unsophisticated poetic line against an outsized page format; and in *Mondsand,* the type is clear and completely devoid of ornament, as if it were a children's book. Two further devices of presentation stress this simplicity and modesty in the poems.

First, many words are printed exclusively in lower case, partly

in order to stress that the poems, like the sculptures, are not screaming for attention, but are humbly and politely waiting to be observed by the discerning eye. In this respect, *Mondsand* is particularly successful; the poems are aligned with the foot of the page, suggesting that they are growing upward in the same way that the sculptures grow from the ground.

The second device is very much an Arpian trademark, which he uses also in his manuscripts, and which appears in print in several collections of his poetry. He marks one poem off from another with three dots arranged one beneath the other, as in this example from *Mondsand*:

.

.

.

Ein weißer Mond,
weiß auf weiß
ein neues Relief
von mir.

.

.

.

(A white moon,
white on white,
a new relief
of mine.) [97]

These dots are not only a further indication of the way in which the poem grows out of the page and subsides back into it, but they are also a salutory reminder of the fact that the poems in Arp's collections are cyclical—the dots serve as links in the chain holding the volume together in a single unit.

This combination of modesty and smallness of scale easily conveys the false impression of a riot of unrelated little objects, each having about as much substance and durability as an epigram. But, although Arp prefers to work in small units, each of these does relate positively and organically to the totality of his creative output.

The crucial factor in this relationship is that it is not static and predetermined, but dynamic and flexible. By the same

token, the individual unit is not fixed and unambiguous, but depends for its effect on plurality of meaning and the simultaneous existence of different possibilities of interpretation. In an *œuvre* like Arp's, the individual work, if taken in isolation, is likely to confuse and alienate the reader, because it has been forcibly severed from its proper context, as a result of which the bonds holding the poems together are lost and other, secondary, elements are brought into undue prominence. This was recognized by Carola Giedion-Welcker, whose pioneering anthology of what might be termed early underground poetry prefers to present cycles of poems rather than individual poems supposedly "representative" of his work.[98]

The single quatrain from *Mondsand* quoted above is a clear illustration of the fact that Arp's poetry is essentially cyclical: if the poem is taken by itself, its meaning does not become apparent, and the idea seems contrived and simplistic. An Arp poem deprived of its context usually tends to appear more aggressively "Dadaistic" and, hence, is more liable to confirm prejudice and received ideas than to heighten our receptivity and understanding. There is one overriding reason why this is so: the poems depend not only upon each other but also on their general environment. This relates to the somewhat intangible sphere of the reader's attitude and responsiveness and is perhaps best explained in terms of Arp's plastic *œuvre*.

Even the large *Shepherd of the Clouds* appears drab and rather bewildered in the aseptic surroundings of the Musée National d'Art Moderne in Paris; but in the garden of Arp's Meudon home the sculptures are allowed to react not only to each other but also to their natural environment. They clearly belong in this setting, and thus not simply because a technological ambience overpowers these rather frail and defenseless structures.

Arp's poetry and his visual works are not designed to abstract the formal or intellectual content of the physical world. Arp is perfectly serious when he states that his art is not abstract, but concrete. This is no willful playing with terminology.

Wir wollen nicht die Natur nachahmen. Wir wollen nicht abbilden, wir wollen bilden. Wir wollen bilden, wie die Pflanze ihre Frucht

bildet, und nicht abbilden. Wir wollen unmittelbar und nicht mittelbar bilden. Da keine Spur Abstraktion in dieser Kunst vorliegt, nennen wir sie konkrete Kunst.[99]

(We do not want to imitate nature. We do not want to re-create, we want to create. We want to create, as the plant creates its fruit, and not re-create. We want to create, not indirectly, but directly. As there is no trace of abstraction in this kind of art, we call it concrete art.)[100]

Arp is not taking, say, a leaf and stylizing it by extracting its "leafness"; and he is certainly not reproducing patterns generated from within his own mind which have little or no direct relation to the world outside the self. It is crucial to an understanding of his work, both visual and written, to recognize that the sculptures seek, instead, to represent and give physical—concrete —form to the "basic shapes" of the natural universe.

Each of the infinite variety of constituents of the natural universe grows according to a specific pattern which, in turn, reposes upon a more deep-seated "basic shape." Arp does not restrict his definition of "natural universe" to flora, fauna, and natural objects like rocks, stars, and the moon; he also includes certain human constructs—such as the amphora—and even mythical, traditional, or religious figures—for example, Snow White and angels.

The particular form which any one of these objects adopts depends on hidden factors; all that is known is that it can be traced back to a "basic shape" common throughout the universe.

In one sense it is most welcome that Arp refuses to indulge in intellectual speculation about his work. His essays tend to become works of art themselves rather than being explicatory in nature. Statements by an artist about the principles according to which his own works operate are not always infallible. But in Arp's case it can be particularly frustrating for the reader bent on understanding his poetry to be confronted by a totally strange world which seemingly refuses to extend a welcoming hand to the uninitiated beholder. It seems that Arp and other Dadaists form part of an exclusive group whose rules of membership and purpose are revealed only to those who are already members.

In the same way that the sculptures flourish and gain full meaning only in a natural environment, the poems depend on the receptivity and attitude of the reader. What this state of mind is can best be illustrated in negative terms:

> Ein Fährtenleser
> will nicht mehr
> ein Maschinenleben führen.
> Er will nicht mehr im Flugzeug reisen.
> Er will wieder
> im Traum reisen.[101]

> (A tracker
> no longer wants
> to lead a machine life.
> He no longer wants to travel by plane.
> He wants to travel
> by dream once more.)

Scientific and technological advances are unable to reflect or illuminate the true nature of the universe, because they function according to mechanical principles which are not only totally divorced from the natural world, but which represent a positive and ever increasing threat to it. The machine is strident, violent, and destructive; the natural world is defenseless and in a delicate state of balance, all too easily disturbed and frightened away like "das idyllische reh" ("the idyllic roe") in "kaspar ist tot,"[102] or the withdrawal of the angel and the rose in *Sinnende Flammen*:

> Der Engel und die Rose
> sind fortgezogen
> flußaufwärts der Träume
> in das Innere ihrer selbst.[103]

> (The angel and the rose
> have gone away
> up the stream of dreams
> into their secret hearts.)[104]

Once nature has retreated into its shell, it becomes increasingly difficult to persuade it to venture forth again.

The machine flourishes on the heresy of progress. But progress to Arp is an illusion; in one poem he compares it to an insane human pyramid: the higher it grows, the more ponderous, complex and unstable it becomes, until a dead end is finally reached (if it does not collapse under its own weight first):

Le lendemain grimpe sur les épaules de la veille tandis que le surlendemain se perche sur les siennes, et ainsi de suite jusqu'à ce qu'un beau jour vienne buter contre le plafond noir.[105]

(Tomorrow climbs on yesterday's shoulders while the next day climbs on its shoulders in turn until one fine day collides with the black ceiling.)

Progress is illusory because it means moving further and further away from harmony with nature until the point of no return is reached, until man is no longer able to reestablish contact with the natural world—that is, if any natural world is left after technology has drained and destroyed the resources of the universe. The increasing domination of the machine has been brought about by the isolation of one of man's powers, namely, reason, and by its adulation as the sole arbiter of human destiny. Man is caught in the grip of the "rabies of reason," which has alienated him from the world, set him in conflict with it and has caused him to try to make himself greater than the rest of the universe, instead of being one part of a great and infinitely complex totality. This self-aggrandizement is man's gravest blunder, and Arp, the mildest of men, pillories this grotesque human affliction mercilessly.

Ich bin der große Derdiedas
das rigorose Regiment
der Ozonstengel prima Qua
der anonyme Einprozent.[106]

(I am the great I am I am
the rigorous regiment
the ozone stalk prima qua
the anonymous one per cent.)

He points an accusing finger at the Renaissance as the source of man's present plight:

Der Renaissance hat die menschliche Vernunft überschätzt. Die Neuzeit mit ihrer Wissenschaft, ihrer Technik hat den Menschen größenwahnsinnig gemacht. Die schauerliche Verwirrung unserer Zeit ist die Folge dieser Überschätzung der Vernunft.[107]

(The Renaissance placed too much value on human reason. The modern age with its science, its technology, has turned men into megalomaniacs. The frightening disorientation of our times is the result of this excessive emphasis on reason.)[108]

The Expressionists, too, laid the blame at the door of science, the industrial revolution, Darwinism and the rest; but what marks Arp off from many Expressionists is that he does not see aspiration toward a probably unattainable ideal as the answer, but rather a simple retreat to life within nature, life as it was designed to be lived, a kind of Primitivism perhaps, but one which places the principal stress on the interrelatedness of all things and the submersion of the individual self. Arp's statement about concrete art underlines his convictions about the power of art to effect this reversion to sanity, although in his later years he became increasingly less optimistic:

Die konkrete Kunst möchte die Welt verwandeln und sie erträglicher machen. Sie möchte den Menschen vom gefährlichsten Wahnsinn, der Eitelkeit, erlösen und das Leben der Menschen vereinfachen. Sie möchte es in die Natur einfügen.[109]

(Concrete art seeks to transform the world and render it more tolerable. It seeks to save man from that most dangerous brand of madness, vanity, and to simplify his life. It seeks to merge it into nature.)[110]

This is why Arp remained a lifelong Dadaist. He found that despite all the much-vaunted iconoclasm and nihilism of Dada, he was able to break through and discover a positive side: he found his mysticism, his new faith, not outside the movement, like Ball or Schwitters, but within Dada itself.

V *The Growth of the Work of Art*

The overwhelming majority of Arp's poems derive their initial impetus from one of two sources: the positive, spontaneous power of the natural world or the negative, contrived constructs of science and technology. These two sources can either appear singly or in combination, and the poems they generate are spontaneous or contrived or a blend of the two, as the case may be. The collection *der vogel selbdritt* offers an excellent illustration of the extreme of the natural mode:

auf flammenden speichen rollen vögel über den himmel.
sterne niesen aus ihren wachsnasen blumengarben.
betrunken sind mann und maus und schwimmen an weichen fingern.
brennende löwen sausen über zitternde birken.[111]

(on flaming spokes birds roll across the heavens.
stars sneeze sheaves of flowers from their waxen noses.
drunken are man and mouse and swim on soft fingers.
burning lions rush over trembling birches.)[112]

A series of images from the natural world flashes past the inner eye; there is no inherent sense of deliberate form nor inevitable progression from one image to the next. Each image has its own independent existence; each is a superb, self-sufficient vignette drawn from a rich imagination. There is no necessary relationship between one image and its neighbors. The result could so easily be a self-indulgent proliferation of hermetic and largely private imagery; but it is greatly to Arp's credit that his genius controls the dimensions and direction of these poems. For the images are not, in essence, unrelated. Although the links between any one image and the next may be tenuous in the extreme, each does refer to a common base, namely, the world of nature and the imagination.

This is not the effete world of the dabbler in the decorative prettiness of nature; it is red in tooth and claw, and there are real dangers for the man who embarks on voyages into the unknown territory of the imagination, as has been seen all too clearly in the case of Hugo Ball and his incantations at the Cabaret Voltaire. The imagination can offer no escape from

reality: it *is* reality, for it is there that the last refuge of man's true self, forced underground by the might of civilization, is to be found. The dangers derive partly from a clash between civilization and nature and partly from man's inability to comprehend and apply the power of the natural world. But it is only through an awareness and acceptance of nature that it will prove possible to refashion the links between man and his origins.

In Ascona zeichnete ich mit Pinsel und Tusche abgebrochene Äste, Wurzeln, Gräser, Steine, die der See an den Strand gespült hatte. Diese Formen vereinfachte ich und vereinigte ihr Wesen in bewegten Ovalen, Sinnbildern der ewigen Verwandlung und des Werdens der Körper.[113]

(In Ascona I drew with brush and ink broken-off branches, roots, grasses, and stones which the lake had washed up on the shore. I simplified these forms and unified their essence in fluid oval shapes, symbols of unceasing metamorphosis and evolution on the part of physical entities.)

As this passage demonstrates, Arp sees nature as a complex, ever evolving organism which, nonetheless, remains essentially unaltered in its basic outline. This concept bears a superficial resemblance to Goethe's notion of change and permanence, but it is a concept which is both nonrational and infinite, rather than a blend of reason and emotion or a composite of specific qualities or components. Nor does it embrace the entire universe, in the sense of making it transparent and totally comprehensible. One of the key features of Arp's natural universe is that it is capable of rejecting any element which, for any reason whatsoever, ceases to perform its normal role and begins to pose a serious threat to the cosmic eco-system. Instead of creating an imbalance, the rogue element is allowed to perish—and even man is not immune from this fate. It is for this reason that Arp's warnings become ever more insistent, because, once a point of no return has been reached, it will no longer be possible for man to bridge the gulf and seek reinstatement. Art and the artist are still capable of achieving this goal, but time is against them. Man's greatest difficulty is that it is only possible to

recognize the point of no return when it has been reached and passed.

The passage about Ascona just quoted also underlines the fact that Arp does not operate entirely spontaneously, but that, on the contrary, a measure of conscious application is essential to his *modus operandi*. The "basic shapes" discussed in the previous section may emerge by chance, but it is very much assisted chance. This is not intellectual application but artistic instinct which collaborates with the material—whether plaster, paint, or words—in a kind of simulation of the natural growth and developmental processes.

There is in Arp's writings no complex theoretical or philosophical superstructure, and the presence or absence of such theorizing is often the source of misunderstanding and, at worst, an excuse to dismiss Dadaists as men of shallow thought dabbling with concepts and materials they did not truly understand. This may be apt criticism in the case of Man Ray or Kurt Schwitters, but Arp refrains from theory because the system which he sees operating in the natural universe is not a practical manifestation of a scientific or philosophical blueprint; it is an entirely self-sufficient and self-maintaining system which is meaningful because it is in existence and alive. Its meaningfulness resides within the fact of its success as a system and in the sense of purposefulness and pleasure which it transmits throughout the system.

Arp's poems which are directly inspired by this natural system grow like living organisms to a certain point of maturity. Each poem has its place within a given collection; and each collection, by the same token, has its position within the totality of the poet's work. But at any time any part or parts of his work may be taken up again, revised, modified, restructured. Art reflects nature; and since no natural object is definitive, fixed for all time, no work of art either is final in itself—it never reaches the limit of its development—nor can it constitute a final statement about the natural universe. In such an *œuvre*, it is the interrelations between individual works, not the individual works themselves, that are crucial.

Arp has such a keen awareness of form and structure that his poems, however meaningless and arbitrary they may appear at

first sight, do have a sense of rightness in their length and pattern. Certain basic shapes generate poems of a clearly defined range of length and outline. The poems in *die wolkenpumpe* and *der vogel selbdritt*, for instance, certainly exhibit a remarkable coherence and family resemblance in their general structural pattern. Yet the nonspecific nature of these basic shapes has been the source of some misapprehension. It is simply untrue to assert that "Arp has rejected existing objects altogether,"[114] although individual works taken in isolation may indeed give such an impression. The outer appearance is only a minor part of the object, and Arp succeeds in penetrating the superficial layers to the essence of each object, by "an intensive listening to the central stillness of the inner world."[115]

Arp does seek to give the impression of a totally spontaneous creator, but he is too much of a craftsman to allow unbridled spontaneity to overwhelm esthetic standards. Equally, it could be asserted that Arp's subject—nature—is itself so impervious to the possibility of "ugliness," and his own creative ability so sure-footed, that it is impossible for him to write or sculpt badly. Middleton Murry expresses it in these terms: "If a story or poem is really well conceived, it is immune from the danger of being badly written; for to conceive a work of creative literature is to conceive it in its particularity."[116] This does not mean that Arp was immune to error, but his lapses are relatively infrequent. But in Arp's case it can be said, without any special pleading, that these lapses are not necessarily attributable to any weaknesses in his craftsmanship or artistic sensibility, for in an approach which is in essence both experimental and open-ended, failures are inevitable, in the sense that growth may not yield viable results, and also that the overall pattern may be prejudiced by an unduly extended series of "growth points." Murry's assertion postulates a system in which the creative parameters are established in advance, before the creative process is initiated. In the case of Arp's work, these two factors are both coeval and coextensive. This is, typically, no sense of a predictable progression which is "rounded off" at the end, polished and finished to as near perfection as lies within the artist's powers.

Wellek and Warren characterize the literary work as being "compounded of the sense of novelty and the sense of recog-

nition."[117] In Arp's work, the former element seems to predominate, and the best example of the way in which this operates is afforded by the system of word plays in his poems, which will be discussed in the next section.

The welcome element of surprise may, however, lead to distortion and unintended grotesqueness of appearance. Nature—like the created object that parallels it—is fragile and easily deflected from its path. The advent of the industrial and technological age has imposed such enormous tensions on the environment that the entire word is now at stake. Like Ball, Arp takes as one of his principal themes the present danger to mankind that civilization constitutes and the bleak prospects for the future; and like Ball, Arp is deeply concerned about the irreversible effects of pollution. But it is significant that Arp's poetry is not filled with references to dying rivers and squandered resources. Unlike so many contemporary conservationists, he does not limit his perspective to physical deprivation, but goes a stage further back in an attempt to isolate and identify the root causes of the present situation.

Arp is concerned with spiritual causes, the factors which originated man's accelerating shift from what he regards as normality, and the increasing threat of man's elimination from and by nature itself; for alienation contains within itself the seeds of its own destruction.

Arp traces the source of present ills to the Renaissance, when man began to lose his due humility as an insignificant speck in a vast and divinely ordered cosmos and regarded himself as the center of all things, as the peak of creation and the glory of the universe. It is this spiritual arrogance which underlies the malaise of the civilized—or rather, industrialized—nations of the world; it is this state of mind which must be altered if the current mindless pillage of the earth's limited resources is to be halted in time, if the entire life-support system of the planet is to escape exposure to irreversible damage. This arrogance finds poetic expression in Arp's writings in terms of the prefixes "sur" and "super" in French, in German "über."

In a poem, dated 1962, Arp writes in terms of

un de ces surhommes
un de ces commis-voyageurs du super-progrès[118]

one of those supermen
one of those commercial travelers of superprogress

Sinnende Flammen, published in the previous year, contains several references to the blight of progress, to "Übermaschinen," and "Überroboter";[119] and one poem is entirely devoted to a campaign against these supermanifestations of the supermachine age. Arp expresses his opposition and then makes this significant declaration:

> Wir sind für die heiligen Märchen
> weil sie die einzige Wirklichkeit sind.[120]
>
> (We are for the holy fairy tales
> for they are the only reality.)[121]

The machine is not "real," for it represents an aberration from reality, being incapable of natural growth and metamorphosis. It has all the superficial luster of the pearl within the oyster, but it is turning against the natural world and "growing" in a distorted fashion like a cancer which will ultimately destroy the whole organism.

VI *Humor and the Pun*

In his poetry, Arp expresses the opposition between machine and nature, between mechanical simulation of life functions and the reality of life, through the medium of the pun. For him, word play is not a gratuitous exercise indulged in for its own sake, but is central to his whole concept of growth and inter-relatedness.

Arp's use of word play has been much misunderstood; it has been assumed that his idiosyncratic approach to the meaning of words signifies that he is no longer interested in words as carriers of meaning at all, but simply as building bricks in an abstract pattern. Karl Krolow talks of the word in Arp's poetry as a "combinatory element";[122] Reinhard Döhl regards it as no more than "linguistic material" in a "textual world";[123] and Liede seems to see Arp's poetry in terms of isolated individual images: "His poetry is totally lacking in symbolism, a

pure game of metaphors with indeterminate associations."[124] When confronted with a puzzling body of poetry, it is always tempting to take the line of least resistance and to rest content with eliciting only that fraction of the poetry's significance which readily reveals itself. This fraction—in the case of Arp, the fact that words are employed as part of a linguistic jigsaw puzzle—is then assumed to be the key to the meaning of the work or works in question. Particularly in the case of Dadaist poetry, the circular argument sets in at a relatively early stage. The poetry under discussion, critics assert, exists as a pattern and nothing more; therefore, to seek for possible lexical meaning would destroy the "meaning" of the poetry itself. In his study of nonsense, Sewell aptly expresses the problem in relation to the song "The Twelve Days of Christmas":

Here, as far as the five gold rings, we are in a world of poetry, but after that Nonsense starts to come in . . . and we end in Nonsense proper because partridges and pear trees will not fuse completely in the mind, and a sense of incongruity allows the mind to slip back into its double series, the two running parallel, numbers here, things there.[125]

If a strong formal pattern exists, the reader seeks refuge in recognition of the structure and is content first to ignore and then even to expect discrepancies in the meaning. In the case of some writers, the loss may not be all that serious, but with Arp's poetry it deprives the reader of any real insight into the heart of his work.

It must be recognized that the Dadaists were "not just charlatans flinging a pot of vowels and consonants in the face of the public,"[126] to use Forster's well-turned phrase, and Arp, of all the Dadaists, is the last who should be accused of such literary vandalism.

The finest compact illustration in all of Arp's work of the concept of word play in operation is a little French poem that succeeds in conveying a great deal in less than ten words:

> des vestiges
> de vertiges
> sur des tiges
> d'étoiles.[127]

(some vestiges
of vertigos
on the stalks
of stars.)

The English rendering, it must be stressed, can be little more than an approximation of the original.

The poem grows from its basic idea of "des vestiges." It is a characteristic opening for Arp: poem after poem begins with this kind of starting point for a chain reaction, that is, with an indefinite article followed by a noun which describes a tangible object or objects. The purpose of the starting point is to effect a breakthrough into the natural universe and to achieve insight and understanding. It is not an easy experiment: it is rather like trying to push the jug in Rilke's sonnet into the flow of the fountain from the marble mouth without interrupting the splashing of water, which is the "code" language of the natural world in conversation with itself.[128]

The syllables "des" and "tiges" are set in new relationships in a string of associations culminating in the last line with its unexpected change of sounds in "étoiles." The key to the progression "vestiges—vertiges—tiges—étoiles" is Arp's contention that the word, when embedded in its conventional mold, has, in a real sense, "died," for it has ceased to be part of the living natural universe and has become a mechanical thing capable only of a predetermined and invariable set of limited functions. When the word becomes cliché it loses its richness of associations which otherwise would allow it to live and grow like any other organism. One means of breathing new life into a moribund word is to set it in an unexpected context by interrupting a familiar pattern and propelling it into a different direction. For example, if a well-worn expression from a nursery rhyme like "three blind mice" is changed to "three blind drunk," the phrase refuses to settle down to a fixed meaning and acquires a new existence because of the verbal double vision, so to speak, which it generates. But Arp is concerned with more than an arbitrary exercise which will do little more than amuse or irritate; it is his hope that by bringing words and phrases together on the basis of criteria other than the conventional sense patterns of language he will be able to exploit

the spark thus generated, in that a chain reaction which will bring about some degree of insight will be initiated into the natural universe. This does not mean that Arp is trying to penetrate into an unknown and alien sphere, but rather seeks to articulate and bring to a conscious level what he feels and knows instinctively.

Once the poet sees that the poem is progressing in a promising direction, he is able to complete the pattern by inserting "étoiles."[129] Thus, he is able to demonstrate that a pattern which initially depended on sound relationships for its coherence and progression has acquired a meaning which expresses his notions of growth, interaction, and the interrelatedness of all things. The star on its stalk is a tall plant grown from a basic shape ("des vestiges") which, given other circumstances, might have become an animal or a human being. Again Arp is not differentiating between inanimate and animate objects. He is an artist, not an astrophysicist. For him the moon, the sun, and other heavenly bodies are alive, as his sculpture *Etoile*, a flowing ring of budlike growths, demonstrates.[130] Nor is there any sense of remoteness in the star—although "vertiges" underlines the scale of the universe—for it is linked to the earth by a stalk.[131] Thus, in a handful of words Arp conveys many of his central themes and preoccupations.

VII *The Personalities of the Poems*

The hybrid "three blind drunk" cited in the last section fails to inject any new life into the two phrases of which it is compounded because the associations simply oscillate from one side—"three blind mice"—to the other —"blind drunk"—without generating any further associations or a wider range of references. The ambiguity of "des vestiges" is, by contrast, quite different. Such is the richness of the poem that it is possible to read it in a quite different and almost contradictory manner without in any way prejudicing the validity of the first interpretation. The enormous gulf between star and earth could be seen as a warning of the ever widening gap between man and his natural origins. The stalk, an umbilical cord holding man and nature together, becomes longer and longer, until an irreparable break is threatened.

The concept of such a break is central to Arp's poetry and to the characters who people his poems and whose function it is to express various aspects of this threatened rupture. They fall into two main groups: those who are part of nature—Kaspar, Sophie, the angels—and those who are cut off from their origins and are in a state of disorientation (the figures here are usually referred to by a personal pronoun rather than by name).

The members of the first group are constantly threatened with destruction and ultimately withdraw into nature, abandoning man to his fate. They are figures who emerge from nature and return to it, leaving man to ask what can be done now that Kaspar is dead, or where the angels have flown to, or again what can be done but grieve over the departure of Sophie. Man thus abandoned is utterly disorientated:

> Was da so hinflattert
> sind Menschen
> die Gott verloren haben.[132]
>
> (Fluttering away up there
> are men
> who have lost God.)[133]

The result of this rupture is made clear in the poems in which unnamed individuals indulge in strange antics:

> er kommt abhanden mit der hand
> er kommt abfußen mit dem fuß...[134]
>
> (he cometh off-hand with his hand
> he cometh off-foot with his foot...)[135]

This is foolishly described by Krolow as "pure verbal existence,"[136] a result of "imagery turned autonomous,"[137] whereas the "he" of the poem is clearly caught in a dead world of mechanical clichés, acting out formulas which have become meaningless because he and they have been cut off from their origins and have turned into lifeless objects. As Maier expresses it in his study of this phenomenon in modern poetry: "Man hovers and finds that there is no ground under his feet; his way

back is gone, the tie is severed."[138] In a situation such as this, all actions become meaningless (which is not the same thing as saying that the poems which express this meaninglessness are themselves bereft of sense). All things lose their validity: the "faith that moves mountains" becomes "a comma that moves mountains."[139] The disoriented individual finds himself falling through an endless void, from nowhere to nowhere:

> den kopf nach unten
> die beine nach oben
> stürzt er ins bodenlose
> dorthin woher er gekommen ist.[140]

> (his head down
> his legs up
> he plunges into the abyss
> to the place from whence he came.)[141]

Arp's later years particularly are marked by this pessimism, but he has always recognized the danger which finds its most chilling expression in a remarkable and untypical poem "Das Fibelmeer" (a corruption of "Fabelmeer," sea of fable), which consists of three four-line stanzas, of which the following are the opening and closing couplets:

> Im Meer beginnt es langsam schwarz zu schneien.
> Das Euter läutet an dem Wasserast.
> .
> Der Wind spitzt sich von neuem seine Krallen
> und hängt sich Kapitäne ins Geweih.[142]

> (In the sea the black snow slowly starts to fall.
> The udder rings upon the water bough.
> .
> The wind sharpens its talons once again
> and decks out its antlers with captains.)

The udder is one of Arp's favorite images of life and the unceasing bounty of nature. The poem offers a horrific picture of a dead world, controlled by blind anonymous forces, a world

destroyed by pollution or atomic fallout (black snow). The sense of impending doom is overwhelming.

VIII *Conclusion*

Arp's intentions as a creative artist are relatively straightforward: he seeks to demonstrate the infinite wealth, variety, and essential oneness of the natural universe and the deadly peril which man's spiritual arrogance and technological advancement represents. Nature itself will not perish, but it may, in time, desert this planet altogether and leave it empty and lifeless.

Thus, Arp is concerned with reality, claiming only that the reality of nature is superior to that of a dead existence enslaved to reason and progress. Perhaps it is the very obviousness and immediacy of his message that leads to such critical utterances of extreme tortuosity about him and his work as the following: "Arp's gaze is forever turned to things beyond the visible: his is the look of a man who can make his way along the thousand roads of a multiple life, a life receptive to celestial contemplation and terrestrial discovery, under the sign of the constellations invented by his imagination."[143] Confronted with such a gnarled statement, Arp would probably have smiled politely and turned back to his work. For him the act of creating poetry, painting, and sculpture was all that mattered; for in so creating he was reflecting the constant creativity of the natural universe and sharing in it.

Only one evaluation of Arp's work, itself couched in the form of a poem, aptly expresses the true nature of his creativity. It is called "Großer Dankgesang für Hans Arp," and its author, Fritz Usinger, is a poet, critic, and friend of Arp who has had a common interest in unlocking and exploring the mysteries of the natural universe. In his poem he draws attention to Arp's two chief materials:

> Der Stein und die Sprache,
> Die beiden Enden der Welt,
> Zutraulich nähern sie sich dir.[144]

> (The stone and language,
> The two ends of the world,
> Approach you trustingly.)

Arp is able to converse with the stone and the word, to draw out the basic hidden forms from within the stone, to renew language, and make it reveal its mysteries:

> Nun aber kommt, Worte!
> Hier ist einer,
> Ein Heiland der Worte,
> Der legt euch die Hand unter das Kinn
> Und hebt euer Gesicht, es anzuschauen,
> Und sagt: Steht auf!
> Die Freiheit schenke ich euch. . . .[145]

> (But now, come words!
> Here is one,
> A Savior of words,
> Who places his hand beneath your chin
> And raises your face, to observe it,
> And says: Arise!
> I grant you your freedom. . . .)

CHAPTER 5

Conclusion

THIS study has explored the works of the three major
German Dadaists as defined in the introduction in some
depth, rather than indulging in yet another general survey of
the various facets of the German branches of the Dada move-
ment. The motive was partly to call the attention of a wider
audience to works that have hitherto been ignored or neglected;
but the principal reason has been to examine the work of
substantial individual Dadaists in the light of the contention
that "Dada" does not exist as an abstract set of rules or prin-
ciples—save in the most general and nebulous terms—but is
inextricably bound up with the personality and convictions of
the individual artist. In a real sense, there are as many "Dadas"
as there were Dadaists.

Indeed, the trio examined in the preceding chapters could
hardly be more different. Schwitters seeks at every turn to
take the elements of the society in which he finds himself,
render them harmless, and translate them into abstract structural
elements in a self-contained artistic sphere. Ball, on the other
hand, strives to detach himself from the world about him and
plumb the depths of his own being, in the hope of discovering
there the ultimate experience, the mystical union which his
Nietzschean rejection of the divine denies exists outside the self.

Schwitters succeeds only because his objective is a severely
limited one; and Ball fails primarily because he finds that his
own personality is incapable of coping with the forces unleashed
by his experiments.

What links them both and what renders Arp infinitely greater
as an artist than either is a common concern with reality.
Schwitters sees life in terms of two levels of reality and fabri-
cates a higher reality by employing the discarded fragments

162

of the everyday. Ball aspires toward ultimate reality within his own self, which is also a negation of life.

Arp, on the other hand, does not seek to insulate himself from the world about him either by building artistic castles in the air or by setting himself up as the center of the universe. He is not concerned with private, subjective issues, but with the nature and destiny of the entire created universe, particularly the world of nature and its function and status within the context of accelerating industrialization and the consequent shift of human attitudes to the physical and spiritual environment.

For Arp, reality is the world of nature which functions according to its own inner laws; and technological progress is only an illusion of reality, one that perverts and destroys mankind. It is a negative life principle. If any one element of the complex, interconnected pattern of the universe sets itself up as greater than the whole it will ultimately forfeit its own life and perish. Arp seeks to show, through his art, the richness and beauty of reality. He does not seek either to escape from or deny reality. He seeks to protect it from the ravages of man.

Dada had only a brief hour in the limelight of the European *avant-garde*; but it is hoped that this study of its three major German literary figures has demonstrated some of the enduring quality, interest, and significance of their work, much of which still remains almost totally unexplored, but which needs to be examined in order to correct the image of Dada as a fleeting, impermanent and entirely negative phenomenon that lasted only for as long as it remained in the public eye, and to accord it its proper place in the history of contemporary literature.

Notes and References

Chapter One

1. Hugo Ball, *Gesammelte Gedichte* (Zurich, 1963), p. 26.
2. Hans Richter, *Dada. Art and Anti-Art* (London, 1965), p. 12.
3. Hans Arp, *Unsern täglichen Traum . . .* (Zurich, 1955), p. 48.
4. See the chapter on the precursors of Surrealism in S. Alexandrian, *Surrealist Art* (London, 1970), pp. 9-26.
5. P. Thody, "Lewis Carroll and the Surrealists," *Twentieth Century*, CLXIII (1958), 433.
6. S. H. Williams and F. Madan, *The Lewis Carroll Handbook*, 2nd ed. (London, 1962), p. 280. The quotation is taken from an appendix on the sources of the poems (pp. 278-87).
7. Thody, 428.
8. Thody, 430.
9. A sixteenth-century portrait, one of a series.
10. Paris, 1934.
11. *Max Ernst* (Museum of Modern Art, New York, 1961), p. 18.
12. *Quelques Ancêtres du Surréalisme. Deux cents Gravures de Raphaël à Redon* (Paris, 1965), p. i. The exhibition was held at the Bibliothèque Nationale in Paris.
13. Hugo Ball, *Die Flucht aus der Zeit* (Lucerne, 1946), p. 47.
14. M. Prosenc, *Die Dadaisten in Zürich* (Zurich and Bonn, 1967), pp. 35-36.
15. H. Kreuzer, "Exkurs über die Bohème," in *Deutsche Literatur im zwanzigsten Jahrhundert I,* ed. O. Mann and W. Rothe (Berne and Munich, 1967), p. 231. This brief survey offers a useful introduction to the growing importance of the bohemian in German art and literature in this century.
16. This cartoon, which bears the title "Zürich im Zeichen der Fremdenhochflut," is reproduced in a special issue of the journal *du-atlantis* for September, 1966, p. 672.
17. Hans Arp, *Unsern täglichen Traum . . .* (Zurich, 1955), p. 40.
18. Emmy Ball-Hennings, *Hugo Ball. Sein Leben in Briefen und Gedichten* (Berlin, 1930), p. 27.
19. For a discussion of this point, see the useful introductory article on Dada by R. Döhl in *Expressionismus als Literatur,* ed. W. Rothe (Berne and Munich, 1969), pp. 719-39.

20. Mary Ann Caws, *The Poetry of Dada and Surrealism* (Princeton, 1970). This statement is made without in any way seeking to undermine the merits of the book as a study of the French poets, but the book does give the impression that Dada is an almost exclusively French phenomenon. Strangely, Arp, who composed a great deal of French poetry in addition to his German work, is studiously ignored by this and other French studies of Dada and Surrealism. And an awareness of German Dada might encourage French scholars to take a less negative view of the movement.

21. General studies on Dada are listed in the Selected Bibliography. The best and most accessible is that by Richter.

22. Richter, p. 16.

Chapter Two

1. S. Themerson, *Kurt Schwitters in England* (London, 1958), p. 10.

2. Hans Arp, *Sinnende Flammen* (Zurich, 1961), p. 16. The lines referred to are "kleine niedliche Atombomben / für den Hausgebrauch."

3. London, 1970.

4. The catalogue is fully illustrated, contains illustrations of, and extracts from, Schwitters's work, and includes brief commentaries on his life and work by important critics in the field.

5. W. Schmalenbach, *Kurt Schwitters* (Cologne, 1967), p. 11.

6. Schmalenbach, p. 13.

7. Käte T. Steinitz, *Kurt Schwitters. Erinnerungen aus den Jahren 1918-1930* (Zurich, 1963), p. 28.

8. Steinitz, pp. 28-29.

9. F. Lach, *Der Merz Künstler Kurt Schwitters* (Cologne, 1971), p. 14.

10. See the discussion of this short story (for want of a better title) in the next section.

11. See Lach, p. 24.

12. Steinitz, p. 29.

13. Lach, p. 26.

14. For an account of *PIN* see J. Reichardt, "The Story of *PIN*," in R. Hausmann and K. Schwitters, *PIN* (London, 1962), pp. 2-18.

15. *Der Sturm*, X, 99.

16. *Der Sturm*, X, 99.

17. "a little bit of soap too (Sunlight)," *Der Sturm*, X, 99.

18. See Lach, pp. 88 ff.

19. *Der Sturm*, X, 99.

20. *Der Sturm*, X, 100-102.

21. *Der Sturm,* X, 102.
22. *Der Sturm,* X, 102-103.
23. *Der Sturm,* X, 103.
24. This is the name he gave his typewriter.
25. *Der Sturm,* X, 99.
26. *Der Sturm,* X, 35.
27. *Der Sturm,* XI, 24.
28. K. Schwitters, *Anna Blume und ich* (Zurich, 1965), p. 193.
29. See Lach, pp. 85-89. As Lach points out, and as will be seen in the case of Arp, Schwitters is not alone in starting out by writing poems in the neo-Romantic vein. Even more striking is the gulf between the *avant-garde* visual works and the early paintings of a whole range of artists, from Schwitters to Ernst, Duchamp to Arp.
30. This journal appeared in 1918-19. References subsequently given will be to issue number and page number (the pagination is separate for each issue).
31. The poems in *Der Sturm* which are written after Stramm are concentrated in volume X, but continue up to volume XII.
32. *August Stramm. Das Werk,* ed. R. Radrizzani (Wiesbaden, 1963), p. 86.
33. *Der Sturm,* X, 140.
34. *Der Sturm,* X, 35.
35. For example, "Die Schwüle gleißt" ("Mairegen," p. 110); "wenden zagen schauen langen" ("Zwist," p. 22). There are also several references to the poem "Blüte," p. 29. Comparisons are based on *A Computer-Assisted Concordance to the Poetry of August Stramm,* ed. and compiled R. W. Last, Department of German, Hull University, 1972.
36. P. 22.
37. P. 34.
38. *Der Zweemann,* No. 1 (1919), p. 18.
39. *Der Zweemann,* No. 3 (1920), pp. 15-16.
40. "Statt einer anonymen Kunst herrscht heute das berühmte Werk, das Meisterwerk." *Unsern täglichen Traum . . .* (Zurich, 1955), p. 80.
41. M. S. Jones, "Kurt Schwitters, *Der Sturm* and Expressionism," *Modern Languages,* LII (1971), 159.
42. *Der Zweemann,* No. 1, p. 18; *Der Sturm,* X, 60.
43. "Der Künstler schafft durch Wahl, Verteilung und Entformung der Materialien."
44. *Der Sturm,* X, 76.
45. R. Hausmann, *Am Anfang war Dada,* ed. K. Riha and G. Kämpf (Steinbach, 1972), p. 66.

46. Hausmann, p. 64. He also states "Er war im Innersten unverletzbar und unangreifbar" (p. 68).

47. *Der Sturm*, X, 72.

48. Now reissued, edited by Ernst Schwitters, under the title *Anna Blume und ich* (Zurich, 1965).

49. C. Heselhaus, *Deutsche Lyrik der Moderne* (Düsseldorf, 1961), p. 319.

50. P. Thomson, "A Case of Dadaistic Ambivalence: Kurt Schwitters's *Stramm-Imitations* and 'An Anna Blume,'" *German Quarterly*, XLV (1972), 52.

51. Thomson, p. 47 and p. 48, respectively.

52. J. C. Middleton, "Pattern without Predictability, or: Pythagoras Saved. A Comment on Kurt Schwitters's 'Gedicht 25,'" *German Life and Letters*, NS XXII (1969-70), 349.

53. C. Giedion-Welcker, *Anthologie der Abseitigen. Poètes à l'Ecart* (Zurich, 1965), pp. 169-70.

54. Schmalenbach, pp. 214-15.

55. Lach, p. 99.

56. Lach, p. 102.

57. Compare Ball's poem "Totenklage," which is discussed in the Ball chapter in the section "The secret Alchemy of the Word."

58. *Der Sturm*, XIII, 158-66.

59. For this and other versions, see the excellent bibliography in Schmalenbach, pp. 381 ff.

60. J. Elderfield, "Schwitters's abstract 'Revolution,'" *GLL*, NS XXIV (1970-71), 256. This article concludes with a diagram of the structure of the *Revolution in Revon*.

61. Schwitters did, in fact, write and illustrate his own *Märchen* for children. See Lach, pp. 140-41.

62. *Der Sturm*, XIII, 159.

63. *Der Sturm*, XIII, 160.

64. *Der Sturm*, XIII, 162.

65. *Der Sturm*, XIII, 162-63.

66. *Der Sturm*, XIII, 165.

67. *Der Sturm*, XIII, 166.

68. Elderfield, p. 257.

69. *Jean Arp. Jours effeuillés*, ed. Marcel Jean (Paris, 1966), p. 62.

70. They are a play on "Summe" and "summen," *Der Sturm*, XIII, 162; and "PRA" (anagram of Arp), *Der Sturm*, XIII, 164 f.

71. *Der Sturm*, XI, 3.

72. Elderfield, p. 260.

73. Published by the Sturm Verlag in 1923.

74. See Lach, pp. 158-77.

75. *Der Sturm*, X, 61.

76. *Der Sturm*, X, 140.

77. *Kurt Schwitters. Anna Blume und ich*, ed. Ernst Schwitters (Zurich, 1965), p. 182.

78. J. C. Middleton, 348. See also the commentary on this article: M. McClain, "Kurt Schwitters's 'Gedicht 25': a musicological Addendum," *GLL*, NS XXIII (1969-70), 268-70.

79. *Anna Blume und ich*, p. 190.

80. See, for example, *Der Sturm*, XI, 2 ff.

81. See Themerson, pp. 43 ff.

82. *Der Sturm*, XII, 201-4.

83. *Der Sturm*, XIII, 71.

84. *PIN*, p. 34.

85. H. Kreuzer, "Exkurs über die Bohème," in *Deutsche Literatur im zwanzigsten Jahrhundert I, loc. cit.*, p. 231.

86. A. Liede, *Dichtung als Spiel II* (Berlin, 1965), pp. 221-25.

87. See the chapter "Zur Geschichte des Lautgedichtes" in Hausmann, pp. 35-43.

88. The poem is entitled "Kikakokú!" and appears in P. Scheerbart, *Ich liebe Dich!* (Berlin, 1897), p. 249.

89. The poem is entitled "Das große Lalulā" and was published in C. Morgenstern, *Galgenlieder* (Berlin, 1905), p. 9.

90. Gomringer is supposedly "the acknowledged father of Concrete poetry" (E. Williams, *An Anthology of Concrete Poetry* [New York, 1967], p. vi); but another anthology does nod briefly in the direction of Schwitters and also mentions Arp as a possible ancestor of Gomringer (S. Bann, *Concrete Poetry. An International Anthology* [London, 1967], pp. 7-27).

91. *Jours effeuillés*, p. 334.

92. Themerson, p. 27.

Chapter Three

1. Hugo Ball, *Die Flucht aus der Zeit* (Lucerne, 1946), p. viii. The passage comes from the introduction to these diaries by Emmy Ball-Hennings.

2. Gerhardt E. Steinke, *The Life and Work of Hugo Ball* (The Hague, 1967), p. 18.

3. By Steinke, p. 19.

4. "Um 1908 eine überaus seltene und für einen minderbemittelten Studenten sehr kostspielige Operation." *Hugo Ball. Zur Kritik der deutschen Inteligenz*, ed. G.-K. Kaltenbrunner (Munich, 1970), p. 11.

5. Written in 1908, published Leipzig, 1911.

6. *Die Flucht aus der Zeit*, p. 5.

7. *Die Flucht aus der Zeit,* p. 5.
8. R. Siurlai, "Emmy Hennings," *Die Aktion,* I (1912), 726-27.
9. *Die Flucht aus der Zeit,* p. 14.
10. *Die Flucht aus der Zeit,* p. 14. P = Pfemfert.
11. *Die Flucht aus der Zeit,* p. 37.
12. *Die Revolution* (November 1, 1913), unpaginated.
13. *Die Flucht aus der Zeit,* p. 3.
14. *Die Aktion,* III, 645.
15. Hugo Ball, *Gesammelte Gedichte* (Zurich, 1963), p. 20. The poem dates from 1914.
16. Job 40: 15.
17. *Die Aktion,* III, 811.
18. *Die Aktion,* III, 811-12.
19. It appeared in the first issue.
20. October 15, 1913, unpaginated.
21. From the scene "Mariens Kammer": "Jeder Mensch ist ein Abgrund; es schwindelt einem, wenn man hinabsieht."
22. Steinke, p. 108.
23. *Die neue Kunst,* no. 2 (December, 1913), pp. 116-17.
24. *Die neue Kunst,* no. 2 (December, 1913), p. 120.
25. From about 1959 until his death in 1966.
26. Compare with "Die weiße Qualle."
27. *Die neue Kunst,* no. 2 (December, 1913), p. 121.
28. Probably an intentional pun on "lüstern" and "Lüster."
29. Steinke, p. 79.
30. *Die Flucht aus der Zeit,* p. 4.
31. J. G. Robertson, "Germany," *The Britannica Year-Book 1913* (London, New York, 1913), p. 206.
32. P. U. Hohendahl, "Hugo Ball," in *Expressionismus als Literatur,* ed. W. Rothe (Berne and Munich, 1969), p. 740.
33. *Die Flucht aus der Zeit,* p. 7.
34. Steinke, pp. 79 ff.
35. These images are all depersonalizing in effect; instead of intensifying the physical presence of the beloved, they divert attention away from the beloved as a human being.
36. Written in 1910.
37. *Die Aktion,* IV, 824.
38. *Die Aktion,* III, 453.
39. *Die Aktion,* IV, 267.
40. *Die Aktion,* IV, 548.
41. See, for example, "Der Tod des Menschen," *Die Aktion,* IV, 594-95.
42. "Die Sonne," *Die Aktion,* IV, 478-79.

43. *Die Aktion,* IV, 479.
44. Steinke, p. 84.
45. *Die Aktion,* IV, 785.
46. *Die Flucht aus der Zeit,* pp. 98-100.
47. C. Heselhaus, *Deutsche Lyrik der Moderne* (Düsseldorf, 1961), p. 316.
48. R. Brinkmann, " 'Abstrakte' Lyrik im Expressionismus und die Möglichkeit symbolischer Aussage," in *Der deutsche Expressionismus,* ed. H. Steffen (Göttingen, 1970), pp. 105-6.
49. Steinke, pp. 175-76.
50. The most accessible locus of these poems is the 1963 *Gesammelte Gedichte.* They appear on pp. 24-33. References in the text to exact page numbers will be given only in specific instances when it is not clear which poem the quotation derives from.
51. *Die Flucht aus der Zeit,* p. 99.
52. Hugo Ball, *Tenderenda der Phantast. Roman* (Zurich, 1967), p. 99.
53. See note 50 to this chapter.
54. This "word" comes from "Karawane," *Gesammelte Gedichte,* p. 28.
55. *Gesammelte Gedichte,* p. 28.
56. *Gesammelte Gedichte,* p. 27.
57. *Gesammelte Gedichte,* p. 26.
58. *Gesammelte Gedichte,* p. 27.
59. *Gesammelte Gedichte,* p. 24. The word appears on two occasions in the poem: the first time it takes the form "lefitalominal," which could be a misprint, or merely an arbitrary variation.
60. *Die Flucht aus der Zeit,* p. 100.
61. *Gesammelte Gedichte,* p. 27.
62. *Gesammelte Gedichte,* p. 26.
63. *Die Flucht aus der Zeit,* p. 100.
64. *Tenderenda,* p. 99.
65. *Die Flucht aus der Zeit,* p. 79.
66. *Die Flucht aus der Zeit,* p. 100.
67. *Die Flucht aus der Zeit,* p. 178.
68. Again most accessible in the *Gesammelte Gedichte,* pp. 34-40.
69. See R. W. Last, " 'Schneethlehem': Four 'nonsense' poems by Arp," *Etudes Germaniques,* XXIV (1969), 360-67.
70. *Tenderenda,* p. 26.
71. *Tenderenda,* p. 37.
72. *Tenderenda,* pp. 48-49.
73. *Tenderenda,* p. 55.
74. *Tenderenda,* p. 57.

75. *Tenderenda,* p. 53.
76. "Im dem Maße, in dem sich das Grauen verstärkt, verstärkt sich das Lachen." *Tenderenda,* p. 65.
77. "Man beachte, wie sich in dieses Hymnusses zweiter Hälfte aus der Buffonade eine Litanei loslöst." *Tenderenda,* p. 81.
78. "Verwesungsdirigent." *Tenderenda,* p. 89.
79. *Tenderenda,* p. 117.
80. *Die Flucht aus der Zeit,* p. 100.
81. *Die Flucht aus der Zeit,* p. 264.
82. Hugo Ball, *Flametti oder vom Dandysmus der Armen* (Berlin, 1918), p. 43.
83. *Flametti,* p. 49.
84. *Flametti,* pp. 57-58.
85. *Flametti,* p. 104.
86. *Flametti,* p. 102.
87. *Flametti,* p. 124.
88. *Flametti,* p. 128.
89. Leipzig, 1911.
90. Munich, 1923.
91. Berne, 1919.
92. Munich, 1924.
93. *Die Flucht aus der Zeit,* p. 162.
94. Steinke, p. 235.
95. Munich, 1931.
96. *Die Folgen der Reformation,* p. 86.
97. *Die Folgen der Reformation,* p. 134.
98. *Die Folgen der Reformation,* p. 141.
99. Steinke, p. 239.

Chapter Four

1. In a letter to me dated April 25, 1970, Marguerite Arp-Hagenbach wrote that "he signed in every country with another Christian name, and so he would agree to be called 'John Arp' in England." (Original text in English.)
2. Letter to me dated July 10, 1968. (Original text in German.)
3. *Jean Arp. Jours effeuillés,* ed. Marcel Jean (Paris, 1966), p. 13. See also p. 8, where Jean further discusses the influence of his mixed language background on Arp.
4. *Jours effeuillés,* p. 13.
5. Hans Arp, *Das Logbuch des Traumkapitäns* (Zurich, 1965), pp. 7-8.
6. Jean Arp, *L'Ange et la Rose* (Forcalquier, France, 1965), p. 20. See also the references to Strasbourg cathedral on pp. 22 and 23.

7. *Jours effeuillés*, p. 443.

8. Hans Arp, *Unsern täglichen Traum*... (Zurich, 1955), p. 25: "Nur wenige Träumer opfern heute noch ihr Leben, um nach dem rechten Weg zu suchen."

9. This date has been inaccurately given as 1906. For an explanation of the source of the confusion see Herbert Read, *Arp* (London, 1968), p. 191 (note 8).

10. *Unsern täglichen Traum*..., p. 7. The translation is taken with permission from R. W. Last, *Hans Arp. The Poet of Dadaism* (London, 1969), p. 71. All translations from this book will be duly acknowledged.

11. *Jours effeuillés*, p. 444.

12. There is an (unresolved) difference over the date. It is given as 1911 by Reinhard Döhl, *Das literarische Werk Hans Arps 1903-1930* (Stuttgart, 1967), p. 31 (note).

13. Giuseppe Marchiori, *Arp* (Milan, 1964), p. 11.

14. *Unsern täglichen Traum*..., p. 24.

15. *Hans Arp. The Poet of Dadaism*, p. 78.

16. Hans Richter, *Dada. Art and Anti-Art* (London, 1965), p. 45.

17. Hans Arp, *wortträume und schwarze sterne* (Wiesbaden, 1953), p. 10.

18. Michel Seuphor, *Mission spirituelle de l'Art* (Paris, 1953), p. 35.

19. Hans Arp, *Gesammelte Gedichte I* (Wiesbaden, 1963), p. 161.

20. *plastique* (1937). This statement appears on the inside back cover of both 1937 issues, and that for 1938. Thereafter a curt note in French is substituted.

21. *plastique*, 5 (1939), 23.

22. Richard Huelsenbeck, *Phantastische Gebete* (Zurich, 1916). The book is described on the front cover as "Verse von Richard Huelsenbeck mit 7 Holzschnitten von Hans Arp."

23. *wortträume und schwarze sterne*, pp. 72 ff.

24. "... und niemand ruft/ und zeigt mir eine Blume/ oder einen Stern." *wortträume und schwarze sterne*, p. 74.

25. *Unsern täglichen Traum*..., p. 53. The reference is to Ball and Tzara.

26. Arp and El Lissitzky were co-editors of *Die Kunstismen* (Erlenbach, 1925).

27. *Dada Intirol Augrandair Der Sängerkrieg.*

28. Herbert Read, p. 51.

29. Fernand Hazan, *Arp. Sculptures* (Paris, 1964), unpaginated. The reference is to works like *Shepherd of the Clouds* and *Owl's Dream*.

30. *In Memoriam Jean Arp* (privately printed, 1966), p. 36.

31. Carola Giedion-Welcker, *Jean Arp* (London, 1957), p. 108. The quotation comes from an introductory note to the bibliography compiled by Marguerite Arp-Hagenbach.

32. Hans Arp. *Zeichnungen und Collagen Papiers déchirés und Reliefs* (Klipstein and Kornfeld, Berne, January 11-February 24, 1962).

33. See note 31 above.

34. *Jean Arp Sculpture 1957-1966*, introd. by Eduard Trier (London, 1968).

35. *Der Sturm*, XIV (1923), 184, 186.

36. *Der Sturm*, IV (1913), 151. For a discussion of this poem see Hans Arp. *The Poet of Dadaism*, pp. 22-28.

37. *Der Sturm*, IV (1913), pp. 188-89.

38. For a discussion of this poem see Hans Arp. *The Poet of Dadaism*, pp. 35-40; Reinhard Döhl, pp. 115-31; R. W. Last, "In Defence of Meaning: A Study of Hans Arp's 'Kaspar ist tot,' " *German Life and Letters*, NS XXII (1969), 333-40.

39. This appears (p. 9) in the biography in the Hans Arp exhibition catalogue from the Galerie im Erker, St. Gallen (November 5, 1966-January 31, 1967).

40. Zurich, 1955, pp. 79-83.

41. In this respect, see part of the essay "Sophie Taeuber" (pp. 10 f.); "Dada war kein Rüpelspiel" (pp. 20-28); the paragraphs following the "Schnurrmilch" poems (pp. 40-47); the "Dada-Sprüche" (pp. 48-50); and "Dadaland" (pp. 51-61).

42. Wiesbaden, 1953, pp. 5-11.

43. Pp. 7-8.

44. There is a very useful introduction by Marcel Jean (pp. 7-26). The book also contains a large number of woodcuts and other drawings by Arp.

45. H. Domin, *Doppelinterpretationen* (Frankfurt am Main, 1966), p. 283. Arp's observations on his poem "Ein großes Mondtreffen" is followed by an interpretation by Fritz Usinger (pp. 284 ff.).

46. For a detailed discussion of this aspect of Arp's last three German collections, see Hans Arp. *The Poet of Dadaism*, pp. 48-64.

47. Hans Arp. *The Poet of Dadaism*, pp. 59-60.

48. Collection Dada, Zurich, 1916.

49. Wiesbaden, 1965.

50. Wiesbaden, 1968.

51. Alès, 1958, unpaginated. The back of the text contains the explanation: "De ce poème de Jean Arp illustré par Camille Bryen il a été tiré 58 exemplaires pour saluer une année nouvelle."

52. *Unsern täglichen Traum* . . . , p. 80.

53. Paris, 1952. This copy is in the possession of Madame Marguerite Arp-Hagenbach.

54. G. C. Rimbach, "Sense and Nonsense in the Poetry of Jean Hans Arp," *German Quarterly*, XXVI (1963), 152-63.

55. Eduard Trier, *Jean Arp: Sculpture 1957-1966* (London, 1968).

56. *Yorkshire Post* (November 30, 1962).

57. P. 9. Translated from the French.

58. As does Denys Sutton, "The Sensuality of Arp," *Financial Times* (November 27, 1962): "His conception of art as a process of growth also allies this to the *Art Nouveau* aesthetic which set much emphasis on plant life. His art is basically decorative and naturally charming."

59. *Sinnende Flammen* (Zurich, 1961), p. 64.

60. Paris, 1966.

61. Pfullingen, 1951.

62. P. 33.

63. Reinhard Döhl, pp. 115 ff.

64. *Mondsand* (Pfullingen, 1969) is perhaps the only substantial exception to this rule.

65. Alfred Liede, *Dichtung als Spiel I* (Berlin, 1965), 387.

66. *Gesammelte Gedichte I*, p. 32.

67. *Hans Arp. The Poet of Dadaism*, p. 84.

68. *wortträume und schwarze sterne*, p. 74.

69. *Hans Arp. The Poet of Dadaism*, p. 97.

70. P. 33.

71. P. 42.

72. *Hans Arp. The Poet of Dadaism*, pp. 119-20.

73. Paris, 1957.

74. *Neue Zürcher Zeitung* (July 4, 1965). Quoted on the inside flap of *Logbuch des Traumkapitäns* (Zurich, 1965). The quotation from *Unsern täglichen Traum* . . . comes from pp. 23-24.

75. *Logbuch des Traumkapitäns*, p. 35.

76. *Zweiklang*, p. 43.

77. P. 55.

78. P. 39.

79. *Hans Arp. The Poet of Dadaism*, p. 109.

80. *Gesammelte Gedichte I*, p. 34.

81. *Hans Arp. The Poet of Dadaism*, p. 85.

82. Wiesbaden, 1955.

83. Grass, 1941.

84. P. 25.

85. Poem 5. (The collection is unpaginated.)

86. See footnote 45.
87. See footnote 36.
88. Limes, 1955, p. 17.
89. Pp. 72-75.
90. *Gesammelte Gedichte I*, p. 47.
91. *Gesammelte Gedichte I*, p. 48.
92. *Sinnende Flammen*, p. 64.
93. *Gesammelte Gedichte I*, p. 47.
94. Herbert Read, *Arp*, p. 98.
95. Herbert Read, *Arp*, p. 98.
96. Trier, pp. xvii-xviii.
97. *Hans Arp. The Poet of Dadaism*, p. 104.
98. A new, revised edition has appeared: Carola Giedion-Welcker, *Anthologie der Abseitigen. Poètes à l'Ecart* (Zurich, 1965).
99. *Unsern täglichen Traum* . . . , p. 79.
100. *Hans Arp. The Poet of Dadaism*, p. 74.
101. *Sinnende Flammen*, p. 34.
102. See *Hans Arp. The Poet of Dadaism*, p. 38. See also note 38.
103. *Sinnende Flammen*, p. 43.
104. *Hans Arp. The Poet of Dadaism*, p. 109.
105. *Jours effeuillés*, p. 439.
106. *Gesammelte Gedichte I*, p. 80.
107. *Unsern täglichen Traum* . . . , p. 80.
108. *Hans Arp. The Poet of Dadaism*, p. 75.
109. *Unsern täglichen Traum* . . . , p. 81.
110. *Hans Arp. The Poet of Dadaism*, p. 76.
111. *Gesammelte Gedichte I*, p. 37.
112. *Hans Arp. The Poet of Dadaism*, pp. 85-86.
113. *Unsern täglichen Traum* . . . , p. 12.
114. M. Hamburger and C. Middleton, *Modern German Poetry 1910-1960* (London, 1963), p. xxxix.
115. C. Giedion-Welcker, *Jean Arp* (London, 1957), p. xiv.
116. J. Middleton Murry, *The Problem of Style* (Oxford, 1960), p. 60.
117. R. Wellek and A. Warren, *Theory of Literature* (3rd ed., Harmondsworth, 1963), p. 235.
118. *Jours effeuillés*, p. 550.
119. *Sinnende Flammen*, p. 50. "Übermaschinen" also occurs on p. 60.
120. *Sinnende Flammen*, p. 44.
121. *Hans Arp. The Poet of Dadaism*, p. 110.
122. K. Krolow, *Aspekte zeitgenössischer Lyrik* (Gütersloh, 1961), p. 140.

123. Reinhard Döhl, p. 141.

124. *Dichtung als Spiel I*, p. 385.

125. M. E. Sewell, *The Field of Nonsense* (London, 1952), p. 69.

126. L. Forster, *The Poetry of Significant Nonsense* (Cambridge, 1962), p. 38.

127. *Jours effeuillés*, p. 568. Also appears as part of another poem on p. 620.

128. This poem is the fifteenth sonnet in Part II of "Die Sonette au Orpheus."

129. For a discussion of a similar approach to the theme of falling through the sound "fällt—Fall . . ." see R. W. Last, " 'Schneethlehem': Four 'nonsense' poems by Arp," *Etudes Germaniques*, XXIV (1969), 360-67.

130. 1939-60. Compare with the two related forms of *Crown of Buds I* (1936) and *Preadamic Fruit* (1962).

131. A similar metamorphosis is performed by "un mouton à quatre tiges," *Jours effeuillés*, p. 626, and by "Der vierblättrige Stern," *wortträume und schwarze sterne*, p. 76.

132. *Sinnende Flammen*, p. 14. The text incorrectly gives "Was da so dahinflattert" in direct contradiction to a facsimile of the manuscript on the facing page.

133. *Hans Arp. The Poet of Dadaism*, p. 106.

134. *Gesammelte Gedichte I*, p. 105.

135.. *Hans Arp. The Poet of Dadaism*, p. 90.

136. Krolow, p. 127.

137. Krolow, p. 124.

138. R. N. Maier, *Paradies der Weltlosigkeit* (Stuttgart, 1964), p. 29.

139. "Der Glaube der den Berg versetzt" and "Ein Komma das den Berg versetzt," *Gesammelte Gedichte I*, p. 102.

140. *Gesammelte Gedichte I*, p. 235.

145. *Hans Arp. The Poet of Dadaism*, p. 92.

142. *Gesammelte Gedichte I*, p. 117.

143. Marchiori, p. 77.

144. Fritz Usinger, *Canopus. Gedichte* (Wiesbaden, 1968), p. 20.

145. *Canopus*, p. 24.

Selected Bibliography

Kurt Schwitters:

PRIMARY SOURCES

Anna Blume. Hanover: Steegemann, 1919.
"Die Merzmalerei." *Der Sturm*, X, 60.
"An Anna Blume." *Der Sturm*, X, 72.
"Die Zwiebel." *Der Sturm*, X, 99-103.
"Selbstbestimmungsrecht der Künstler." *Der Sturm*, X, 140-41.
"TRAN Nummer 7. Generalpardon an meine hannoverschen Kritiker in Merzstil." *Der Sturm*, XI, 2-4.
"Aufruf! (Ein Epos)." *Der Sturm*, XII, 201-4.
Anna Blume. Hanover: Steegemann, 1922. New edition.
Elementar. Die Blume Anna. Berlin: *Der Sturm*, 1922.
Memoiren Anna Blumes in Bleie. Freiburg: Heinrich, 1922.
"Tragödie. Tran No. 22." *Der Sturm*, XIII, 72-80.
"Tran 25." *Der Sturm*, XIII, 84-92.
"Franz Müllers Drahtfrühling. Erstes Kapitel: Ursachen und Beginn der grossen glorreichen Revolution in Revon."
Der Sturm, XIII, 158-66.
Tran Nr. 30. Auguste Bolte (ein Lebertran). Berlin: *Der Sturm*, 1923.
Merz I. Hanover, January 1923. (The series continues until Merz 24, which appeared in 1932.)
Anna Blume und Ich. Die Gesammelten Anna Blume-Texte. ed. Ernst Schwitters. Zurich: Arche, 1965.

SECONDARY SOURCES

Döhl, Reinhard. "Kurt Merz Schwitters" in *Expressionismus als Literatur*. Ed. W. Rothe. Berne and Munich: Francke, 1969.
Elderfield, J. "Schwitters's abstract 'Revolution,'" *German Life and Letters*, NS XXIV (1970-71), pp. 256-61.
Hausmann, Raoul. "Kurt Schwitters wird MERZ" in *Am Anfang war Dada*. Steinbach: Anabas, 1972.
Hausmann, Raoul and Kurt Schwitters. *PIN*. London: Gaberbocchus, 1962. Contains an introduction by Jasia Reichardt and the text of PIN.

179

JONES, M. S. "Kurt Schwitters, *Der Sturm* and Expressionism," *Modern Languages,* LII (1971), 157-60.

LACH, FRIEDHELM. *Der Merz Künstler Kurt Schwitters.* Cologne: Du Mont Schauberg, 1971. A good account of Schwitters's life supported by the first real investigation in any depth of his written work.

LIEDE, A. "Der Surrealismus und Kurt Schwitters' Merz" in *Dichtung als Spiel I.* Berlin: de Gruyter, 1963, pp. 124-41.

McCLAIN, M. "Kurt Schwitters's 'Gedicht 25': A Musicological Addendum," *German Life and Letters, NS* XXIII (1969-70), 268-70.

MIDDLETON, J. C. "Pattern without Predictability, or: Pythagoras Saved. A Comment on Kurt Schwitters's 'Gedicht 25,'" *German Life and Letters, NS* XXIII (1969-70), 346-49.

SCHMALENBACH, WERNER. *Kurt Schwitters.* Cologne: Du Mont, 1967. A general survey of Schwitters's life and work. Descriptive rather than interpretative, but fully illustrated and with excellent bibliographies.

SCHREYER, LOTHAR. "Der Lumpensammler" in *Erinnerungen an Sturm und Bauhaus.* Munich: List, 1966, pp. 65-70.

SCHWITTERS, KURT. Catalogue of traveling exhibition which toured Germany from January 15, 1971—November 21, 1971. Well illustrated, contains extracts from Schwitters's work and critical comment on him.

STEINITZ, KATE T. *Kurt Schwitters. Erinnerungen aus den Jahren 1918-30.* Zurich: Arche, 1963. Contains useful biographical material and some interesting observations.

THEMERSON, S. *Kurt Schwitters in England.* London: Gaberbocchus, 1958. A short account of Schwitters's life in England, with extracts from his works.

THOMSON, P. "A Case of Dadaistic Ambivalence: Kurt Schwitters's Stramm-Imitations and 'An Anna Blume,'" *German Quarterly,* XLV (1972), 47-56.

HUGO BALL:

PRIMARY SOURCES

Die Nase des Michelangelo. Leipzig: Rowohlt, 1911.

"Der Henker." *Revolution,* no. 1, 1913.

Der Henker von Brescia. Munich: Rowohlt, 1914.

Flametti, oder von Dandysmus der Armen. Berlin: Reiss, 1918.

Zur Kritik der deutschen Intelligenz. Berne: Freier Verlag, 1919.

Byzantinisches Christentum. Drei Heiligenleben. Munich and Leipzig: Duncker and Humblot, 1923.

Die Folgen der Reformation. Munich and Leipzig: Duncker and Humblot, 1924.

Hermann Hesse. Sein Leben un sein Werk. Berlin: Fischer, 1927.

Die Flucht aus der Zeit. Lucerne: Stocker, 1946.

Gesammelte Gedichte. ed. Annemarie Schütt-Hennings. Zurich: Arche, 1963.

Tenderenda der Phantast. Roman. Zurich: Arche, 1967.

SECONDARY SOURCES

BALL-HENNINGS, EMMY. *Hugo Ball. Sein Leben in Briefen und Gedichten.* Berlin: Fischer, 1930.

––––––. *Das flüchtige Spiel.* Einsiedeln: Benziger, 1953.

––––––. *Hugo Balls Weg zu Gott.* Munich: Kösel and Pustet, 1931.

BRAUN, FELIX. "Geistige Führung." *Der neue Merkur,* VIII (1925), 326-36. Article on *Byzantinisches Christentum.*

HOHENDAHL, PETER UWE. "Hugo Ball" in *Expressionismus als Literatur.* Ed. W. Rothe. Berne and Munich: Francke, 1969.

LIEDE, ALFRED. "Hugo Balls Anarchie" in *Dichtung als Spiel I.* Berlin: Gruyter, 1963, pp. 224-29.

STEINKE, GERHARDT EDWARD. *The Life and Work of Hugo Ball.* The Hague: Mouton, 1967. The only full-length study of Ball, and therefore indispensable, although it does not cover the later years in detail, and the coverage of the main period is patchy.

HANS ARP:

PRIMARY SOURCES

der vogel selbdritt. Berlin: private printing, 1920.

die wolkenpumpe. Hanover: Paul Steegmann, 1920.

Der Pyramidenrock. Erlenbach-Zurich and Munich: Eugen Rentsch, 1924.

Des Taches dans le Vide. Paris: Librairie Tschann, 1937.

Sciure de Gamme. Paris: Parisot, 1938.

Muscheln und Schirme. Meudon-Val-Fleury: private printing, 1939.

poèmes sans prénoms. Grass: private printing, 1941.

Le Siège de l'Air. Poèmes 1915-1945. Paris: Vrille, 1946.

On my Way. Poetry and Essays 1912-1947. New York: Wittenborn and Schultz, 1948.

Onze Peintres vus par Arp. Zurich: Girsberger, 1949.

Auch das ist nur eine Wolke. Basel: Vineta, 1951.

wortträume und schwarze sterne. Wiesbaden: Limes, 1953.

Auf einem Bein. Wiesbaden: Limes, 1955.
Unsern täglichen Traum. . . . Zurich: Arche, 1955.
Worte mit und ohne Anker. Wiesbaden: Limes, 1957.
Le Voilier dans la Forêt. Paris: Louis Broder, 1957.
Mondsand. Pfullingen: Günther Neske, 1959.
Vers le Blanc infini. Lausanne-Paris: La Rose des Vents, 1960.
Auch das ist nur eine Wolke. Pfullingen: Günther Neske, 1960.
Sinnende Flammen. Zurich: Arche, 1961.
Gesammelte Gedichte I. Gedichte 1903-1939, eds. Marguerite Arp-Hagenbach and P. Schifferli. Zurich: Arche, 1963.
Logbuch des Traumkapitäns. Zurich: Arche, 1965.
L'Ange et la Rose. Forcalquier: Robert Morel, 1965.
Jours effeuillés. Poèmes, Essais, Souvenirs 1920-1965. Paris: Gallimard, 1966.
Le Soleil recerclé. Paris: Louis Broder, 1966.

SECONDARY SOURCES

DÖHL, REINHARD. *Das literarische Werk Hans Arps 1903-1930*. Stuttgart: Metzler, 1967. This is a disappointing study, particularly in the section which deals with the poems. One is hardly likely to produce positive critical results if the poems are considered essentially not to be susceptible to interpretation.

FORSTER, LEONARD. "Un 'Wackes' cosmique: Weh unser guter kaspar ist tot," *Saisons d'Alsace*, no. 22 (1967), pp. 209-12.

GIEDION-WELCKER, CAROLA. *Jean Arp*. London: Thames and Hudson, 1957. An invaluable source book, both for cataloguing the sculptures and for a laudably thorough bibliography up to 1957. See Trier below.

LAST, R. W. *Hans Arp: The Poet of Dadaism*. London: Oswald Wolff, 1969. Half of the text is devoted to a monograph which examines several of the important poems and collections; the rest consists of representative translations of Arp's German poetry. Also published by Dufour (Chester Springs, 1969).

————. "In Defence of Meaning: A Study of Hans Arp's 'kaspar ist tot,' " *German Life and Letters*, NS XXII (1968-69), 333-40.

————. " 'Schneethlehem': Four 'nonsense' poems by Arp," *Etudes Germaniques*, XXIV (1969), 360-67.

————. "Arp and Surrealism," *Symposium* (1970), 354-63.

LIEDE, ALFRED. "Hans Arp und der Tod" in *Dichtung als Spiel I*. Berlin: Gruyter, 1965, pp. 365-99.

MARCHIORI, GIUSEPPE. *Arp: Cinquante Ans d'Activité*. Milan: Alfieri, 1964. The text (which is of general rather than specialist interest)

is in Italian, English, and French. The main strength of the volume is the wealth of illustrations.

MATTHEWS, J. H. "Jean Arp" in *Surrealist Poetry in France*. Syracuse, N. Y.: Syracuse University Press, 1969.

READ, HERBERT. *Arp*. London: Thames and Hudson, 1968. Pictorially, this is the best survey of Arp's creative output to date. The text is disappointing, particularly in the context of the poems.

RIMBACH, G. C. "Sense and Nonsense in the Poetry of Jean Hans Arp," *German Quarterly*, XXVI (1963), 152-63. A fine pioneering essay on Arp's thought and poetry.

TRIER, EDUARD. *Jean Arp: Sculpture 1957-1966*. London: Thames and Hudson, 1968. Trier's brilliant introductory essay is followed by a comprehensive pictorial representation of Arp's later sculpture. The catalogue of sculpture and bibliography are a continuation of Giedion-Welcker's book and equally detailed.

USINGER, FRITZ. "Die dichterische Welt Hans Arps," *Akademie der Wissenschaften und der Literatur, Abhandlungen der Klasse der Literatur*, no. 3 (1965). Wiesbaden: Steiner.

————. "Hans Arp" in *Expressionismus als Literatur*. Ed. W. Rothe. Berne and Munich: Francke, 1969.

WATTS, HARRIETT. "Numbers for the Birds: On Hans Arp's Poem 'Er nimmt zwei Vögel ab,'" *German Life and Letters*, NS XXII (1969), 341-45.

Index